We've Been Trumped!

DARKHOUSE
BOOKS

WE'VE BEEN TRUMPED!

Anthology copyright © 2016 by Darkhouse Books
ISBN 978-1-945467-05-9
Published September, 2016
Published in the United States of America

Darkhouse Books
160 J Street, #2223
Niles, California 94539

We've Been Trumped!

We've Been Trumped!

We've Been Trumped!

Exceptional

by Michael Guillebeau

The Bluetooth headset in my ear was stuck and wouldn't come out.

"Crap," I said. Madeleine had probably put glue on the headset last night, after we broke up again.

"I'm sorry," said the headset, "I don't know 'crap'."

I was sure I'd hung up after calling into the company's time card system to enter my time while driving in to work. You were supposed to wait till the end of the day to enter your time, but what the hell. Besides, every day was a new war with the Trump National company phone system.

"Please say the number of hours you have worked today," the phone lady had said, cool and professional, and then added a new wrinkle: "If you'd like to enter the standard eight hours for today, say 'seven'."

"Seven."

"Thank you, you will be credited for seven hours today."

"No, damn it, change that to eight."

"Changing your time after it has been entered is unethical. If you would like to be connected to the ethics hotline, say 'jail'."

I parked and went to my desk and logged on, still tugging at the headset. Still wouldn't budge. My task list was empty: the last of my tasks had been assigned to a couple of Trump National automated systems. Instead, I was assigned to training classes all day, beginning with one that started five minutes ago. Good. Being late was the one thing I was still great at.

I went to the bathroom, went to get coffee, went to talk football with a friend, then went to the conference room. Milling around the door to the conference room were at least three times as many people as the room would hold, all shouting at each other.

"My team's got a design review in there, now," shouted a mid-level manager who nobody listened to anymore, waving a gun today and now the crowd listened. "So we're taking the room. Take your training classes somewhere else. Not my fault the online scheduler is messed up again. Call it in."

I shrugged and walked off toward my office. The voice in my ear said, "Associates should be grateful for training opportunities. Your lack of attendance has been noted." I pulled the damned phone out of my pocket and turned the thing off, at least until I could get to a doc-in-a-box at lunch and get the damned headset removed.

The young kid, the one wet behind the ears who still called everybody sir was standing at the big window looking out over the airport.

"Something's wrong, sir," he said.

"Something's always wrong. That's why God invented coffee and drugs. And why smart people like me voted Il Donald dictator for life to kick ass and fix things."

The boy said, "Yes, sir. But the rest of the world turned on us after that."

"We don't need them. Remember when Trump nuked Panama because South America refused to take 'America' out of their name."

"Yes, sir. That was kind of the tipping point. The whole world turned on us after that. Then the animals. Remember the Chihuahua attacks of 2021?"

"Yeah. Had to build a wall around my house for that one. Boy, was it fun to pick those bastards off with the explosive bullets in my M-15."

"Yes, sir, but look at the airport now. Nothing's flying. I come here sometimes for inspiration, to see all the planes we build here taking off and landing, think of all the happy people flying home to visit Grandma, being served gourmet meals by smiling flight attendants."

"Flown much lately?"

"No, sir, but I watch the Trump company's ads in the training classes telling us our products are great because we say they are. But look, nothing's flying anywhere. Today, there's smoke pouring out of the building across the street, but no fire trucks."

"So call it in."

The boy hesitated, "No one there. We stopped funding firehouses when we built a wall to keep all of our troubles out."

He paused. "We turned our back on the world, and it's turning its back on us. First countries, then animals. I think the machines are turning on us now. Good thing we've still got Clint Eastwood on our side." The kid walked off with his shoulders slumped down.

Screw him. This young generation just wants free stuff like jobs and a future and that's not the American way anymore. Toughen up, kid. The world may not like it, but this is a great country now, because we say so, and say it loudly.

My computer was off when I got back to my desk, and I couldn't find a way to turn it back on. The voice in my ear said, "All training classes have been cancelled. You may now go home. You will be credited for your full six hours today."

"Damned right," I said. I slammed down my coffee cup and picked up my keys thinking, where will I go, and stood there with no answer.

"More crap," I said, and headed to the garage.

I was fumbling for my keys, sitting in the driver's seat already, when the car started on its own. The radio turned on and said, "Enjoy the Days of Rage network," and started playing screaming kick-ass Southern rockers intermixed with outraged bloviaters and politicians shouting threats in faintly Germanic accents.

The doors locked. Lemon-scented exhaust fumes filled the car and the headset said, "Thank you for your valuable service to the Trump National Corporation."

I laughed for the first time in a long time.

"Good joke, finally. I didn't know you had a sense of humor," I said to the phone lady.

"Thank you," she said, with real tenderness, "For making America great."

Ivanya Figures it Out

by Kaye George

Ivanya slipped from one shadowy doorway to the next, making her way home from her job, as usual. She had been washing dishes and bussing tables at Doyle's Diner for three years now, since she was nine. The place was indoors, sheltered, and she was well fed, so she loved her job. It was the journey to and from work over the cracked and crumbling sidewalk every day that scared her.

Her mother, Alice, would tell her stories of how it used to be, before The Imperial Regime was established in 2017. People were named after their own families, or just named with made-up names. Children would go to school and study out of books. Her mother had one book that had escaped the roundup and burning, *Goodnight, Moon*. They brought it out every night, sometimes to read, sometimes to just touch. But most of the time they kept it hidden.

Ivanya was looking forward to the evening—if she could just make it home before it got dark. Cars roared by, spewing toxic fumes, some with working lights, some driving in the gathering dusk with their lights all burned out. A hot wind whipped her skirt

around her legs. It was Fall, which she could tell because of how early it got dark. It was hot all year long in New York, though her mom said there used to be times when it would get cold and people would have to wear warm clothing.

She slunk to the next doorway, then peered out. No roving gangs of men, for now. Finding the coast clear to cross the street, she ran as fast as she could and made it to the door of her apartment building. She didn't dare be out after dark. That's when the gangs took complete control of the streets. There had been police to keep the violence down until about a year ago. They hadn't been paid in so long, most of them had to quit and find other ways to feed themselves and their families.

Her new best friend, Melonia, was coming over for dinner. Another girl her age, Ivanda, had been her friend before she met Melonia, but Ivanda's family had finally found a way to get to Canada and leave The Imperial Regime. She wished her mother would do that! There weren't that many people left here, but so many of them were mean and ruthless. It was as if, in addition to the Naming Decree, the one that said everyone had to be named after a member of the Imperial Family, there was a Behavior Decree, a law that said people had to behave like them.

Ivanya ran up the stairs to the second floor and rapped her secret code on the door.

Her mother threw the door open and hugged her. "You're home! And look, Melonia's here." Ivanya grabbed her friend's hand and they disappeared into Ivanya's room where they talked and giggled. They speculated a bit on who they would marry and what their children would be like. They always did that. It was hard to find kids their own age, but they knew a few boys. Two named Erich, one named Dinald, and one named Donard. They would name their firstborns after each other. Melonia's would be Ivanta and Ivanya's would be Melanta. They both knew girls with those names. There were only so many variations you could do with the allowed names, ones *like* the Imperial Family, but not *exactly* like them.

Melonia loved to hear about the very wealthy people who ate at Doyle's Diner, so Ivanya saved up her stories about them. Sometimes she embellished a bit, but mostly she didn't have to.

Tonight she told about clearing up after a most distinguished party that included the Young Imperial Ruler, as he was called.

"The old man one we used to call Junior."

"Right. You remember when the Old Imperial Ruler died four years ago?"

Melonia nodded. "He died peacefully in his sleep. About a gazillion people came to see his dead body. That's what everyone was saying. I don't know anyone who did, though."

Ivanya smoothed her bedspread, shaking her head. "I know that's what they said, but I don't think that's what happened. Once I heard the Young Imperial Ruler—" they both giggled.

"I know we shouldn't laugh," Melonia said. "But it's so funny! The 'Young' Ruler is at least sixty, isn't he?"

"Maybe seventy. He's ancient. All bent over and wrinkled, and so fat."

"So what did the 'Young' (a brief stop for them to giggle again) Imperial Ruler say."

"He used some bad words, but he said that his father got his hair tangled up and wrapped around his throat and it choked him."

"How could it? His neck was so fat!"

"It's that way in all the pictures, but he was in his nineties and it was skinny then."

Melonia pondered that. "Shouldn't the 'Young' (giggle stop) Ruler be getting skinny now, too?"

"I don't see how he can. All the cookies and fat food he eats. And he never gets exercise because of his walker. He's used that for years, ever since an elephant mangled his left foot on a safari. It doesn't work right."

Most of the customers tipped, some tipped well, but the Imperial Family never left a penny. Never even bought their own meals. No one expected them to. They were above paying for anything. However, a guest of the Family had slipped her a few bills that afternoon. She was about to tell Melonia about that when her mom

knocked on the door. The girls both knew why, because they could smell the chocolate chip cookies.

Ivanya flew out the door and they ran to the kitchen table where all three munched the cookies with some milk.

"You're so lucky your mom is a famous cook," Melonia said. "My mom would love to be able to get chocolate chips."

"I can give her some," Alice said, patting the girl's shoulder. "I don't need to use them all. There are always a few left over after I bake for The Imperial Leader's family."

Alice used to write cookbooks, but now published recipes online, since there were no more books. After her cookies had caught the attention of the First Family, she and Ivanya hadn't had to worry about being hungry any more. If there were groceries in the store, they had a card that entitled them to quite a few. Of course, the stores didn't always have anything to sell.

"Do you know when you're leaving?" Ivanya asked. She hadn't wanted to ask right away, but she wanted to know. She dreaded losing another friend.

"Mom and Dad think it will be soon. Maybe within the week. My uncle made it out last month and knows an underground route."

Ivanya and her mother looked at each other. Alice shook her head. "I don't see how we could leave, darling. They would notice right away that I had stopped baking cookies for them."

"They could go without them for a day or so." Ivanya pouted. "They're all so fat they could probably live for a month without eating."

"Shush, now," her mother whispered. "You never know who's listening."

Ivanya frowned. She was pretty sure no one was. At first, in the 2020s, the effort was made to track everyone and everything, but since there weren't even enough government workers now, in the 2040s, to collect taxes, how could "they" be listening to everyone? There weren't any history books, of course, and the history online was all false, but people talked and lore was handed down. Ivanya had a prime listening position at the Diner, where the few who kept the wealth gathered.

The girls finished their cookies, then retreated to the bedroom again.

"I have to know more about how you're going to get out." Ivanya took Melonia's hands in hers. They were cold.

"I'm so scared. What if we don't make it? What if we get caught?" Melonia shivered.

The rumors were that The Imperial Family, who were all fond of hunting, used captured escapees for target practice on their vast estates. No one knew for sure if that was true, since none had ever escaped from any of the estates after being apprehended trying to escape.

"You won't get captured!" Ivanya squeezed her friend's hands. "Your mom and dad are so smart. They won't get caught. And your uncle made it."

A dreamy look came over Melonia. "Just think. In another country, I could change my name. I could be Susie or Jane."

"I want to be Lavender. I love that name." She looked up at the ceiling, as if an answer were there. "I want to go with you. I want to figure out how to get me and my mom out."

"How can you do that? She has to deliver the cookies three times a day."

"I know, but… I'm not sure, but there has to be a way."

"There's also your job."

Yes, she had to show up for her job every day. She only had the job because of her mom. Still, there had to be a way.

"I'm going to think about this. When do you leave?"

"I don't know if I should say."

"You can tell *me*, can't you?"

Melonia took her hands back and hugged herself. "Okay, we're leaving in three days. At midnight. I'll ask if you and Alice can come with us. I know, you walk me home before your work tomorrow and I'll ask then."

Melonia sewed buttons on shirts in a factory near the Diner.

Ivanya lay awake for hours, even though she was tired from her job, as she always was. But she *had* to figure out how to escape. No one could be on the streets after dark. That wasn't a law, but

everyone knew it was a bad idea. She spent most of the daylight hours at work, especially now that it was autumn and the days were shorter. Her mother had to be home when the baking supplies were delivered in the morning, and had to run the cookies to the New York Mansion at ten, two, and four. Everyone but the current Imperial Wife ate them. Whoever was Wife at the moment was never allowed to. A limo picked Alice up for this and the driver grew impatient if she was the least little bit late.

So… they couldn't get away during the day. No one was supposed to be out at night, but nothing was stopping them from doing it. People *did* go outside. Mostly people who were up to no good, as her mother said.

But wait. Melonia's family was going to leave at midnight. They just had to get to her apartment building. It was three blocks away. So her family would be out at night. She had another part to her plan, too.

She had settled what to do and when. She would discuss the details with her mom. And she would hope that Melonia's parents would let them go along.

The next day, before she left for work, she checked with Melonia on her TPad. Her friend said they hadn't decided yet if they could take Ivanya and her mother with them. All day long at work, she dropped things, even broke two cups clearing a table. Luckily, none of the Imperial Family was in the diner. Her hands shook as she swept up the shards. Her boss asked her if she was sick.

That gave her an idea. She put on a woebegone expression and made her hands shake a bit more.

"I'm not sure. I might be coming down with something."

"You'd better stay in the kitchen then," her boss said. "Don't come out to clear tables until you feel better."

So that didn't work. She had thought maybe he would send her home early and she could drop by Melonia's apartment. It didn't happen often, but she could remember wait staff being sent home a couple of times, and the cook once, for being ill. There was a lull in the afternoon when she wasn't needed for a few minutes, so she

visited the restroom and pulled out her TPad again. Melonia had answered! Her parents agreed!

She and Alice were to be there by 11:30 PM sharp tomorrow night. She typed in a message, asking what they should bring.

—Not very much. You have to carry what you bring.

—Something to eat?

—Yes, but not too much.

Ivanya asked how long the journey would take. Melonia answered that it should only be half a day. They would have to walk through the Holland Tunnel from New York to Newport, New Jersey. Then they would be picked up by a van and taken to Montreal. The total trip shouldn't take more than 8 hours, Melonia said.

That didn't sound so bad. The hardest part would be getting to the tunnel. Getting through it would be easy since no one would look for them there. It wasn't used for vehicles anymore since the pavement was crumbling and parts of the ceiling had caved in. Her mom said it used to be very busy, filled with cars all day and night. And people worked to keep it up regularly. There weren't many cars any more. And there were no road maintenance workers.

Melonia texted to let her know that she had to work an extra hour, so Ivanya went straight home. When she got there, she started telling her mother about the trip, talking so fast her mother couldn't understand her.

"Slow down," Alice said. "Let's go into the bathroom for a moment, shall we?"

She always wanted to talk in the bathroom with the water running full blast, speaking in whispers, when they talked about taboo topics.

"I have it all figured out. I think this will work. We should wear dark clothing," her mother said. "That way, we'll be harder to see at night."

Her mother's eyes glowed as she whispered and her smile was as wide as Ivanya had ever seen it.

"Should we take something to eat?" Ivanya asked. "We might get hungry." The water hissed and swirled down the drain, masking their voices.

"We'll last for a day."

"I want to take some of your cookies."

Her mother thought for a moment. "True, I don't know when I'll be able to bake them again. Okay, tomorrow I'll make as many extra as I can and we'll bring them with us."

Ivanya didn't sleep much at all that night. She made a huge effort to concentrate at the diner the next day, but her boss again sent her out of the dining room to work. She left on the dot, maybe a few minutes before her shift was up. She made herself walk home, but she wanted to race the searing wind. There weren't many trees in the city, but a few stray fallen leaves swirled around her feet. She ducked into doorways when she heard someone coming, as she always did, and kept to her normal routine. When she reached her building, though, she scrambled up the stairs as fast as she could. Her mother was waiting in the doorway.

They dressed in their darkest clothing right away, even though they weren't leaving for hours. Ivanya put on a pair of black slacks and a navy blue shirt and her mother wore a dark brown pants outfit. Pant suits had been banned after the 2016 election, her mother had told her, but they were allowed about twenty years later and now a lot of women wore them.

Ivanya packed a few pieces of clothing, secreting *Goodnight Moon* between two pair of shorts. Her mother packed even less clothing and they both filled the remaining space in the satchels with cookies.

Her mom even smeared something dark on both of their faces before they left the apartment. When Ivanya gave it a lick, she discovered it was gooey syrup, probably made from chocolate chips.

At 11:00 they tiptoed down the stairs, not making a sound. Alice opened the outside door inch by inch and they crept out. The streets were quiet and dark. Very dark. Ivanya had never been out at this time of night. The noise from a car that had lost its muffler long ago startled them. It was a few blocks away, giving

them plenty of warning. They huddled in a doorway until it was past. Ivanya thought their camouflage was working well. Nighttime insects hummed and flitted about her face, wanting to feed on the chocolate syrup, she was sure. She tried to ignore them.

They made it to the end of the first block, then the second one. One block to go.

Three young men shuffled up behind them before they knew they were there.

"Hey, where you sweet things goin' this time of night?" A tall, thin young man in a black leather jacket spoke, probably their leader. He took the cigarette out of his mouth and sprinkled ashes on Alice's shoes.

"We're taking these to a sick friend," Alice said, reaching into her bag. "But you can have some of them." She handed him three cookies.

He squinted at her and took them. After the first bite, he reached into her satchel. "Yeah, I can have some. I can have all of them." He grabbed most of them, passing them to his friends.

They left, chewing and smacking their lips with moist sounds, and leaving a trail of crumbs. Ivanya let out the breath she was holding. The next block presented no problems and they fell into the door of Melonia's first floor apartment with relief.

Melonia hugged Ivanya, then wiped her own face. The syrup had smeared onto hers.

"What *is* that?" she asked putting a finger into her mouth tentatively. "Mm, it tastes good."

They both laughed, a welcome break to the tension that hung in the bright kitchen.

"This gang stopped us and stole our cookies," Ivanya said, frowning. "But I have more in my bag." She reached inside and gave one to each of them—her mother, Melonia, Melonia's mother and father, and her little brother Donald.

"We can do this," Melonia's dad said. "My brother has a fail-safe route after we get through the tunnel. He made it there, and we can, too."

"Can we leave now?" Melonia's little brother asked.

"No," her father said. "We can't get to the rendezvous too early. We need to get there just as the van does. None of us can afford to stand around. Alice and Ivanya, your clothing is perfect."

His whole family was dressed in dark clothing also.

"We're going to use shoe polish on our faces. Would you like to touch yours up?"

Melonia's family had dark skin, but it would be good to make it even darker, Ivanya thought.

"Where on earth did you get shoe polish?" Alice asked. "I haven't seen that for years."

He snorted. "I just got a job last week. Polishing shoes for the Imperial Family's servants. Since today was my last day, I helped myself to a can of it."

Alice laughed and Ivanya was thrilled to see that.

At 11:45, they all left as quietly as was humanly possible. It was about ten blocks to the Holland Tunnel. Ivanya realized she was once again holding her breath. They walked briskly over the disintegrating pavement, but not too fast, the constant scorching wind pushing them on their way from behind. Ivanya wanted to run, but knew she didn't dare. Someone might notice a person running through the night. Moving more slowly was less likely to attract attention. At least that's what Melonia's dad had said before they left.

They had only half a block to go when a rusty pickup truck stopped beside them. Two skinny guys climbed out and ambled toward them up the broken sidewalk. The one in front held a knife that glinted in the truck's headlights. Melonia's father stepped forward and stood between the rest of them and the hoodlums, a fierce look on his face.

Just before the pair reached the small group, a shiny BMW pulled up behind the truck. The two men jumped back in and roared off.

When Ivanya saw who got out of the passenger door of the car, she froze inside. It was the Young Imperial Ruler. His hair, dyed bright orange, glowed in the car's dome lights. An aide scrambled out of the back seat and handed him his walker.

"Where are you folks going this nice night? Out for a stroll?" Ivanya pushed in front of Melonia's father.

"We were on the way to bring you these. When my mother saw how many we had left over, she wanted to bring them to you. These friends came with us to make sure we would be safe. We all dressed so that maybe the gangs wouldn't find us."

The Young Imperial Ruler frowned, thinking hard. "You're not going the right direction."

Ivanya looked around. "Oh dear, I think you're right. It's so dark out, we must have gotten confused." She dipped into her satchel. "Here, take these." She handed some cookies to his aide, but the Imperial Ruler grabbed one.

"I'm so glad we ran into you," Ivanya said. "Now we can go back home."

The Young Imperial Ruler didn't say another word. He stuffed half a dozen cookies into his mouth, shoved the walker at the aide, and got back into the car chewing as noisily as the gangsters had.

After the sleek car drove off, the group ran the rest of the way to the tunnel.

Six months later, Alice sat in her new kitchen in Ottawa and fanned herself. It was hot, even in Canada. She had just baked a week's worth of cookies. These were not all chocolate chip. Some were peanut butter, some snicker doodles, and oatmeal raisin.

Lavender was glad her mother could bake whatever she wished to now. The bakery a block away sold enough of Alice's cookies for them to live comfortably. Lavender sat in the front room, gazing out the window at the pleasant front yard, full of the flowers her mother had planted. Beyond the sidewalk, a car would come by every few minutes. Nice, quiet, well-kept cars, driving on the smooth pavement.

Lavender's friend Susie came up the sidewalk, stooping to pick a daisy to bring inside. Lavender ran to the door to let her in. Susie's family lived two blocks away in another neat, tidy house, similar to hers.

They hugged and went into Lavender's room. After they had eaten a few cookies, Susie wanted to talk about who they would marry and how many children they would have. They had their pick of many boys now that they were in school. Their class had twelve boys and ten girls.

"I might not get married," Lavender said.

"Why not? Don't you want a husband to take care of you?"

"Mom says you don't have to have one. She doesn't."

Susie thought about that for a moment. "Did you ever have a dad?"

"I did when I was really little. But he died in the war with Mexico."

"My dad hated that war, he says. It was stupid to fight over who paid for a wall that nobody ever built."

"What do you mean?"

"I don't know. Dad says it all happened a long time ago and everyone should just forget about it. He went to that war, too, but he came home."

"I'm glad about that." She was, too. Without Susie's dad knowing her uncle's route, they might never have made it out of the Imperial Nation.

"So," Susie said, sprawling on Lavender's bed and finishing her cookie, "what do you want to do if you don't get married?"

"I've been thinking about that a lot. I even talked to my teacher about it. I think I want to be the President of the United States."

"What's that?"

"It's something they used to have a long time ago."

A Feast for Fools

by JoAnne Lucas

Early spring, 2017
Fresno, CA

The lights went out and I went down hard. I'd been pushed in the face by some lime-scented clown. I felt my skirt catch on something and rip.

Oh, that's just great, I really needed that tonight.

In our restaurant there were the usual crashes and cries you get from people plunged into sudden darkness, but after I made body contact with the carpet, I also heard the tinkling of bells.

An eerie glow caught my eye and disappeared; I groped for the wall, fingered my way to the main light switch, and pushed the toggle up.

The scenario was bad for business.

Throughout our dining room, customers in their costumes resembled revelers at some mad Mardi Gras. As if that weren't bad enough, any one of them might be the unknown newspaper columnist I feared; the one who delighted in reporting any little

factor that might contribute to a poor dining performance. And our big headline-maker right now featured Trevor Sorenson, sprawled backwards in his chair on the floor. A knife handle skewered the large boutonniere on his breast.

Boy, this is a tough way to make a buck. I'd told Jeff earlier there'd be trouble...

———————

Earlier that evening:

"It's a blasted setup, that's what it is. I can smell it." My brother didn't respond, but kept right on working. So I slapped a wooden spoon down hard against the kitchen counter top, then waved it under his nose.

"Look, who else would make such a screwy reservation? First he picks our busiest night in six weeks, next he demands that particular table in the alcove and only that table in the alcove. Then the main course must be finished before eleven-fifteen, and you have to come out of the kitchen precisely then to receive your accolades. Accolades! That's the word the turkey buzzard used. This *has* to be a sneak review by that blasted Eccentric Gourmet!" I whacked the spoon again, and it broke.

"Dorothy, Dorothy, don't get so worked up." Jeff took the ruined utensil from me and shook his head. "Here, try the pat□, it's Lucullan."

I stuffed my mouth with chopped liver on toast and watched him perform magic with his knife. In two minutes flat he'd abracadabra'd one basket of whole limes into neat slices for the salmon's court bouillon and carved another basket of limes into the entrée's side garnishes.

I swallowed my last bite. "All I'm saying is that everything must be perfect. No, better than perfect. Everything must be marvelously magnificent tonight."

"You are beginning to sound like our new president. You need to watch it. As for me, I am always magnificent. Tonight will only be more of the same."

I sniffed. *Now who sounded like President Trump?*

He pointed his knife at me. "You fuss too much."

"Yeah, well I'm not the one who swoons over a bruised banana."

The gods of the gene' pool must have been feeling frisky when they wafted their wands over us. Jeff is Hercules-huge but gentle as mothers' love and is profoundly passionate about foods, fine wines, and country music. I am younger, smaller, and prettier, with an appetite for bookkeeping, business, and bank accounts.

I argued some more, but I couldn't get beneath Jeff's culinary concerns. He checked ovens, washed greens, and worried pots on the gas range. He slowed his choreography long enough to say, "The Eccentric Gourmet will not be dining here tonight, so no bad review. We *will* be late seating our first diners, and that will be your fault. Move it, girl. Go charm the customers and leave the kitchen to me. I promise I will be magnificent… as always."

I slammed the swinging door behind me so it flapped a few times and heard Jeff's three sous chefs laughing. Arrogance is all very well for the master chef, but it doesn't guarantee the bank balance. So I swallowed my swear words and put on my best hostess smile.

The swanky Ben Barajian Country Club up the road always holds an All Fools' Ball the Saturday night nearest April first, and tonight was a biggie—March 31st. It was one of the few nights during the year our restaurant stayed opened for dinner until one in the morning. Discerning country club members dined here first, then joined the festivities there later. All dressed as clowns and crowned a King of Fools there at two A.M.

In keeping with the fancy dress event I wore the feminine version of a Pierrot costume, a sexy powder-puff number with legs. My irritation with the neck ruff competed with my worry about the mysterious restaurant reviewer. Also this year half of the clowns came as President Trump, complete with The Donald's hair flop wig and expansive gestures, which proved disastrous for the hurrying wait staff and their trays of food. Worse, the clowns thought it all *hugely* funny and started trying for one-up-man-ship and keeping score. The waiters retaliated by ditching the trays and carrying in one dish at a time. This put extra time on the serving

and clearing of dishes, cleaning the floor, and the extra food to be prepared… at our expense. Plus a round of drinks on the house while they waited for their new meal. So I looked the other way when the wait staff would evade the flinging arms and dump the meal on the exuberant faux President, adding a certain cachet to the hair flop. All were accompanied by constant light flashes as people sent pictures out on the social media. Okay, I'm happy with the free publicity, but the most annoying thing about the Presidential clowns was when one smart ass used the theme music from The Lone Ranger and sang, "To the Trump, to the Trump, to the Trump, Trump, Trump."Soon everyone picked up on it, and it became thunderous. And then they ended it with, "Tr-ump Tri-umph-ant! The whistles and cheers became deafening.

I sighed. It was going to be a long night.

With Donald Trump as President for four years, I needed to lay down some ground rules for the next year's April ball. Rules like all mishaps of food and broken dishes would be charged to the Trump at hand. I also noted that those future Trumps could try and recoup their losses by sending the bill to President Trump for reimbursement, and good luck with that.

And as if it weren't getting its share of the spotlight, the month of March decided to remind everyone that it was still winter outside, no matter what the calendar said. Tonight's fierce storm made me shiver whenever the front door was opened. I sought warmth behind the reception desk and cursed eighteenth-century clowns for not being brighter about Thermals. The only thing good about my position was it backed into the bay alcove.

In between writing the new rules notes I worked my trouble-shooting bit on all manner of clowns – the Bozos, the Harlequins, the amorous buffoons – your typical Saturday night crowd. I was worn out by the time my suspicious reservation of four arrived at ten. I took their dripping umbrellas then led these clowns to their table in the alcove while I studied each: an Emmett Kelly hobo, a pudgy Pagliacci, Batman's Joker, and Rigoletto, the hump-backed court jester in motley dress and bells. A clown class act, not a Trump among them. Acting as the spokesman, Pagliacci introduced

the nattily dressed Joker as Trevor Sorenson, our famous local syndicated talk-show host who raked his guests live over their burning goals and served them up as toast. The little hobo clown wrote for the show, surly Rigoletto directed it, and hefty Pagliacci produced it.

Hmmm, I thought, *there seems to* be *no reviewer here. But they could be faking that they're the Sorenson group. Hard to tell with that heavy makeup.*

Theirs was the last reservation for the night, and I personally waited their table. I eyed Trevor Sorenson again. With his white makeup and green wig he positively oozed evil glee.

I poured wine for all with a lavish hand and sent up "Please, please" prayers for everything to go right. A verbal basting of us on Sorenson's show would be far worse than any old nosy newspaper report. His aired opinions often contained poisoned slashes, seldom grounded in fact. Jeff's friend and former employer, Auguste Georges, had to close down after just such a blast. I decided I would pray and I would please, but I would not grovel.

Which posed the question of how to deal with him on a personal level. He was Hollywood-handsy. Usually I left some slapped male anatomy behind me as a hint of my displeasure. This time I opted for sweet talk and fast footwork and between courses I kept my ears on them from my desk.

Like a Greek chorus came another crash, cheers, and "To the Trump. To the Trump. The Trump, Trump, Trump."

I closed my eyes.

Trevor Sorenson toasted the crowd with a bow and a smile, but he was a horrible host to his tablemates. He taunted Rigoletto about keeping his hands wrapped around a bottle and letting wife number four slip through his fingers. The jester responded by knocking back a full glass of wine. Next he lashed the sad little hobo for being a wimp, a hanger-on, and a loser. The Emmet Kelly clown remained speechless. I felt so sorry for him, I tried to lighten the uneasy ambience by acting cutsey and making a big production with the main course. I served Pagliacci poached salmon and tempted the Emmett Kelly with our apple-and-sage stuffed capon. I placed wild boar stew in front of Rigoletto and presented a superb *boeuf*

Wellington to Joker Sorenson. Each dish was a masterpiece of taste, aroma and appearance, and I anticipated their compliments.

But Rigoletto brushed his dish to the side and gestured for more wine. From my desk I watched the Emmett Kelly hobo merely push his food around the plate. Pagliacci, the opera clown, wolfed his dinner, played with the garnishes, and eyed Rigo's neglected stew. However, Sorenson ate with appetite and enthusiasm and filleted Pagliacci about his latest reversals of fortune. Pagliacci's face and white clown costume matched; he burped his indignation.

When Ramon cleared the dishes, the clock showed twenty minutes to midnight. Later than had been directed, but the constant floor show by the Trumpettes had slowed things down.

"What's for dessert, doll?" Sorenson asked as his arm snaked around my waist and drew me closer.

"Gooseberry Fool, of course," I said.

"Perfect. Before you bring it out, babe, I want the bottle of champagne opened, and bring six glasses. I'm going to make an important announcement, and I want you to stick around. Oh, and, honey, tell the cook he can come, too." He gave my leg a squeeze and my tush a slap to send me on my way.

I was hot enough to boil water, but icy breaths of worry cooled me when I wondered about the champagne's purpose: toast or roast?

I hadn't mentioned to Jeff yet that Sorenson was here. Big brother had really carried on when Auguste was forced to move. Jeff's reactions now to Sorenson's summons made me long to share a Maalox Moment with Pagliacci. Jeff actually looked dangerous.

On my return trip through the dining room I noted the most of the diners left were well into the coffee-and-dessert stage. *Good. Soon as I get rid of my clowns, I'll ace these frou-frou pumps and reintroduce my feet to comfort.* The four men had left the table and stretched. They still stood about, with Sorenson posturing by his chair. I poured the champagne and handed him the first glass.

"Thanks, doll face, pour one for yourself." He waved the others back to their places. The three men stood near the table.

"Gentlemen and lovely lady," he began.

Hmmm, he does have an oily charm, I'll give him that.

Sorenson nattered on about how he was born on the first day of April and how April had always been his lucky month. Rigoletto was pacing and muttered something about it not being April yet. Sorenson ignored him. He went on to say that April first used to be New Year's Day and that he'd always made his important moves on that day.

"... and since this is the end of the last day of March, and – ah, I see the cook is joining us. Pour another glass, sweet lips, and let us all drink –"

I reached for the champagne bottle, and that's when the lights went out.

———— ••• ————

A sheriff's homicide detective dressed as a burlesque clown was among the late diners. This proved to be our one big break of the day. He secured the crime scene, separated suspects and witnesses, and removed his red rubber nose. Because he'd been present and knew the setup, he got right down to the nitty-gritty: Where were you when the lights went out?

I'd been the closest to Sorenson, but the coroner stated I couldn't have shoved the knife that hard into the corpse's chest, left-handed yet. Off the cuff, Dr. Wallis speculated that to have penetrated that deeply, most likely the knife was thrown. But how it hit its mark in the dark was the detective's job to find out.

Fear for Jeff tangled with my thoughts because he was so angry about Sorenson and was very handy with knives. I fiddled with my torn skirt ruffle and had to really concentrate while Pagliacci and Rigoletto told their stories. I closed my eyes to free my senses. Pagliacci burped.

Bingo! My eyes flashed my triumph and connected with the detective's. "All right, Miss Felcher," he said, "let's hear from you."

I moved over by him. "Let's say Sorenson stood where you are, and I'm here, at right angles on your left. Now the lights go out, and at the same time, Mr. Producer here, on *my* left, pushes me down."

Pagliacci protested, but I tell how he's the only one in the vicinity at that time who's had fresh limes to squeeze for the fish entrée, and I had smelled the limes on his hands.

He sputtered that whoever cut and handled the limes would smell, too. No way, I told him; Jeff also dealt with garlic, onions, and herbs, and I only smelled the limes.

The detective sniffed Jeff's hands, then Pagliacci's. He stated for the record his findings to be as I'd said. "But, what's the big deal about pushing you down?" he asked.

"Not so much down," I answered slowly, "more like out of the way. Tinkle Toes over there is the wise guy who threw the light switch. I heard his bells behind me."

"The dame's screwy," Rigoletto said.

The detective paced and recapped, "So, you say the jester turns off the lights, and this guy pushes you out of the way, then that leaves –"

We all turned to the Emmett Kelly clown. The little hobo slowly nodded and stared at his hands. Tears smeared his makeup.

"But," argued the detective, "how could he do it? He'd have to have thrown blind, no light, no target –"

"He had a target," I said, "that big fake flower on Sorenson's lapel glowed in the dark. I remember thinking it must be some kind of gnarly fungus to match his personality."

Pagliacci finally admitted to everything. Trevor Sorenson's present contract with Pagliacci expired today. He was leaving the show and moving to New York and network television. The producer/clown had been a member of the country club for years and experienced the April Fool revels many times. He'd also had been a frequent diner at our restaurant and had noticed where the main power switch was located. I hadn't recognized him as a regular in his getup. So Mr. John Richardson-Smythe, a.k.a. Pagliacci, was the one who had arranged for the costumes and added the glow-in-the-dark boutonniere before he called me to make the reservation. The three men had intended to murder Sorenson at the ball where there would have been more people around. But with our slower service this evening and the fact that Sorenson took too long over dinner

and with his toast, his murder was behind schedule. He had to be killed before April 1. Yes, Sorenson's planned move to New York was a monetary disaster for Pagliacci. However, the producer held a key-man life insurance policy on the television star that lapsed at midnight March 31st.

Surly Rigoletto hated Sorenson for seducing his wife and laughing about it. Rigo wasn't about to let Sorenson move away from him and his revenge.

"And, what about you?" the detective asked the little hobo.

Kelly straightened his shoulders and spoke for the first time. "I loved him."

Whew! I thought, better him than me.

Much later, way after the last echoes of "To the Trump" had died off, I sat in a in a comfortable chair, shoes off, and sipped cappuccino in our office.

Bliss.

Jeff alternated between staring at the wall and writing furiously. I finally fished up enough energy to ask what he was doing.

"Tonight's events make a review by the Eccentric Gourmet necessary to bring the restaurant's reputation back into balance. Sorenson was killed for his deeds, not my food."

I spilled my coffee. "You? You're the turkey buzzard?... But, why?"

He gave that little shrug that makes me want to shake him. "I decided to make dining out seem more adventurous. People became excited by the mystery. It was good for business, right?" Jeff was exactly right, and always being right is what had frightened me about the Eccentric Gourmet.

The wind died, and I listened to rain stamp its tiny feet.

Well, well. So Jeff couldn't keep his fingers out of my end of the pie. Typical older brother stunt. I bet he got a big laugh out of my freaking out earlier.

I poured more coffee and sauntered back across the room to read over his shoulder.

"The column needs punching up," I said, "add some spice to it. Start out with, 'It was a dark and stormy night,' and put in

about the costumes. Oh, and mark your calendar for Tuesday. I want to case Romero's Ristorante for next week's piece. We'll get some good material there."

Jeff threw down his pen and looked affronted, offended, and pushed. Too bad. Brothers everywhere need to be taught that little sisters add the *a l'orange* to life's ducks.

I opened the drapes to a watery dawn. The Day of Fools was going to be a beautiful day.

To the Trump, to the Trump, to the Trump, Trump, Trump...

The Chat

by Paul Alan Fahey

Thank you for choosing TrumpT&T. A representative will be with you shortly.

You are now chatting with Bill G.

Bill G: Hello my name is Bill G. I am your TrumpT&T specialist today for this chat. How may I assist you?

Paul F: Hi, Bill, I'm the authorized ghostwriter of President Trump's autobiography. Has the president mentioned I'd be chatting with him here?

Bill G: Not really but go ahead with your concerns. We at TrumpT&T are here to help you.

Paul F: Thanks, Bill. My agent, Carter Mason, sent me this Internet chat link after finalizing the book deal. Mr. Mason said it was a direct link to President Trump and the Oval Office, but to be honest I'm yet to speak directly with him. I always seem to get a middleman. Sorry I don't mean you.

Bill G: That's quite all right, Paul. We at TrumpT&T under-
stand. The president gets all his news from the Internet. In fact
we are told not to disturb him in the mornings when he's surfing
the net. Perhaps you should try again to reach him a little later
in the day.

Paul F: I'm getting very frustrated, Bill. I feel like I'm going
in circles. I can't move forward with the book until I get some
clarification from the president on certain aspects of his life.

Bill G: What do you need to know about?

Paul F: His many bankruptcies over the years, the thousands
of folks who lost their jobs in the wake of those hotels closing.
I'm sure you've heard of those Atlantic City gaming clubs.

Bill G:I apologize for the inconvenience you have experi-
enced. I assure you TrumpT&T understands. Truly.

Paul F:I just wondered what's going on, why I can't seem to
connect directly with him.

Bill G: Nothing's going on. I can assure you this place is dead
most of the time. We rarely see him around the White House.
Rumor is the president was true to his word and spends most of
his days in Scotland golfing at his new resort in Turnberry. Quite
possibly he's there today.

Paul F: Yes that's all very nice but I need to talk to him before
I move forward on the book. I'm stuck and I'm one of those
writers who can't continue until I get some closure.

Bill G: You need closure. Yes, let me first see if I understand
you correctly. You have questions for the president and need him
to clarify some issues for the book.

Paul F: You're making me crazy here. Yes, that's it in a nut-
shell.

Bill G: Great. I can help you with that.

Paul F: Wonderful.

Bill G: No problem. We are here to help. I will make sure
your issues are resolved today.

Paul F: Thank you.

Bill G: Don't mention it. I am sorry your request wasn't taken care of the first time you contacted us. I understand your frustration. Are you a Muslim?

Paul F: What does that have to do with anything?

Bill G: President Trump will not answer any emails or involve himself in chats with Muslims. You must remember his stand on this issue?

Paul F: Yes, unfortunately I do. Okay, no. I am not a Muslim.

Bill G: I believe you. Are you Hispanic or African American? Are you a woman?

Paul F: I refuse to answer those questions.

Bill G: I completely understand. Even though President Trump refuses to speak directly with these people you must have heard that he absolutely loves all Muslims. He loves all Hispanics, Jews, LGBT folks, and African Americans. He adores and worships all women. Even babies. Some are his best friends. I'm now going to connect you with our specialist department. They will have further questions for you.

Paul F: Oh, please no. This has happened before. Can't you help me? What if I tell you I'm a white, Irish, Catholic male? Does this help. I'm afraid I'll be disconnected.

Bill G: Not to worry. We do not disconnect customers at TrumpT&T. (Not if we can help it.) No need to repeat your problem. The next agent will have complete access to our conversation.

Paul F: Okay. Thank you.

Bill G: Please wait while I transfer the chat to the specialist who will immediately solve your problem.

You are now chatting with Meredith L.

Paul F: Hi, Meredith. Are you aware of my situation?

Meredith L is experiencing technical difficulties. Please wait while we reroute your chat to the next available specialist. Thanks for your patience.

Paul F: Please hurry.

You are not currently connected to a TrumpT&T representative. Please wait while we route your chat to the next available specialist. Thanks for your patience.

You are now chatting with Perry S.

Paul F: Hi, Perry.

Perry S: I'm sorry for any delay in reaching me. I can see you've been chatting with another TrumpT&T agent. Please give me a moment to review your chat and then I'll be more than happy to assist you.

Paul F: Thank you.

Perry S: I apologize for any inconvenience this has caused you. I can see you are a ghostwriter and you are helping the president write his autobiography. Is this correct?

Paul F: Yes, that is correct. I only need a few moments to speak with him. Two or three questions at the most.

Perry S: Now I understand why you were transferred to me. I can help you.

Paul F: Thank you. I'm so happy to hear this.

Perry S: Do you have a FAX machine handy?

Paul F: Yes. What do you need?

Perry S: I need a copy of your birth certificate.

Paul F: What?

Perry S: Your birth certificate. The president wants all folks who chat with him to be properly vetted.

Paul F: That's ridiculous. I thought he was over all that nonsense.

Perry S: It may be nonsense but frankly he doesn't get over anything. Trust me. In fact he holds grudges forever. I should know. Please fax me your birth certificate.

Paul F: I can't. I don't have those kinds of documents just lying around my house. Who the hell does?

Perry S: The president said the previous Commander in Chief made the same claim. Obama was always making excuses about this birther issue. But not President Trump. He has his birth certificate framed and hanging on a well in his office for all to see. Right next to his award from the esteemed national association RAU. They awarded him their highest honor.

Paul F: RAU?

Perry S: Racists Are Us. Surely you've heard of them. David Duke is the current high wizard of RAU and we've heard Mr. Duke is a rather humble soul. Like President Trump.

Paul F: Hmm. Well that's all very nice in some circles I suppose, but I don't have my birth certificate handy at the moment.

Perry S. I'm sorry then. We can't continue further with this conversation until you are vetted properly.

Paul F: What about my journalist credentials? My curriculum vitae that lists my degrees, publications, and writing awards? I can fax those to you.

Perry S: Do I understand you are refusing to take this first, simple step?

Paul F: It's Friday night. It's not simple. The banks are all closed. All of my personal documents are locked away in a safe deposit box.

Perry S: Fine. You can wait and chat back with us on Monday.

Paul F: No, Please. I can't go any further in my work until I talk to the president. I'm on a deadline here.

Perry S: We at TrumpT&T fully comprehend your concerns. We are empathetic, sensitive people. All of us are white Christians. We know what we're doing here. In any case, President Trump doesn't believe in deadlines.

Paul F: Then how does he get anything done in a timely fashion?

Perry S: He doesn't. Paul, I hope I may call you Paul. Like President Trump you have invaded my heart and somehow found a soft spot.

Paul F: So you'll connect me to the president?

Perry S: I'll go one better. I will get all your questions answered today and as quickly as possible. If you don't mind, I'll connect you with President Trump's very private secretary. I'm sure she'll be a great help. Please wait while I transfer this chat to someone better able to assist you.

One moment please.

Welcome to TrumpT&T. You are now chatting with Lola P.

Paul F: Hi. Lola. Will you read the chat so far and see what's been going on for the last fifty minutes?

Lola P: Of course. It will be my pleasure to serve you. Thank you for connecting to TrumpT&T. Is the issue with an account you have with us?

Paul F: What?

Lola P: Are you having problems with your Trump Internet service, phone, or cable TV? We handle everything right here. One stop shop.

Paul F: No, No. Please. I thought you were the president's private secretary.

Lola P: I am. We do everything in private. Is there a question the previous agent was unable to answer?

Paul F. I'm working with the president on his autobiography *Alone I Can Fix It* and I need to talk to him right now!

Lola P: Please, sir. Do not take that tone with me. Now let me ask you a few vetting questions.

Paul F: Oh, no, not the birth certificate again.

Lola P: No, you've made it past that hurdle. I can tell from your voice you're of white descent.

Paul F: You can?

Lola P:Of course. Like I said we are all well trained in these matters, especially those pertaining to race, ethnicity, religion, and sexual orientation. We can spot them a mile away. Ha. Ha.

Paul F: Then why the birth certificate fiasco in the first place?

Lola P: Not to worry. That agent had misinformation.

Paul F: He sounded like he knew the rules. He spoke with such conviction I thought he had all his facts correct.

Lola P: The old rules maybe but not the newest ones. We can skip right over the birth certificate now.

Paul F: Good let's just stick to the pertinent facts. I need to chat with President Trump. Now!

Lola P:We certainly know a fact when we see one and can tell right off which facts are true and which are false.

Paul F: Whatever.

Lola P: That's the ticket. Now let's get on with solving your problems. Are you having trouble with your Trump Internet service?

Paul F: Dear God, no. We're on the Internet and chatting right now, aren't we? How could there be a problem? My phone works fine, and I get all the Trump premium cable channels. Even the five HD educational ones. Happy?

Lola P: You don't need to get huffy about it. President Trump is a very busy man. But I'm glad you have the education channels. President Trump loves the poorly educated but is doing his best to teach the Trump University curriculum to these poor souls. They've been HUGELY successful to the masses.

Paul F: Okay back to President Trump. I understand he's off golfing in Scotland.

Lola P: Who told you that?

Paul F: Bill G.

Lola P: That one's a liar. Some of us don't know how to tell the truth. But if you must know, yes, that's where he is. At Turnberry with Prime Minister Vladimir Putin. I think they're talking about starting a war with China. Some little thing like that. You see now why he can't be disturbed.

Paul F: Oh, this is such a mess. I'm thinking of cancelling my service.

Lola P: Now you're talking. That's something I can help you with.

Paul F: I'm exhausted. I can't think of anything else to do. Can I leave a message for the president?

Lola P: No, not here. This isn't the appropriate venue for presidential messages, but I can transfer you.

Paul F: Oh, no. Please, please don't do that again. I'm practically suicidal here.

Lola P: Thank you for letting TrumpT&T help you with your problem.

Your TrumpT&T representative has closed your chat session. Have a good day!

Alex in Wonderland

by KB Inglee

DAY ONE: *MONDAY*

The white-haired man, as he always did, took the seat across the aisle of the bus from Alex. They nodded their usual greeting to each other. The man pulled out his pocket watch, glanced at it and slid it back into his pocket with another nod. He turned to Alex and said with a smile, "Right on time as always."

The man had never spoken to Alex before. He was one of only a few people in the city who never seemed in a hurry. Alex checked his own watch. As usual he was twenty minutes early.

Alex was the third under-gardener at the White House. He had been hired twelve years ago as the sixth under-gardener. As he changed from his street clothes into his gardener's coveralls, he pondered his situation. His rise had been due in part to his skill, but due more to the firing of three of his colleagues, Juan, Ali, and Amy, in February and March. There was never a reason given, simply "You're Fired!"

Now and then, he caught a glimpse though the windows at the goings-on inside the White House. He gave thanks that he had taken up the spade and the shovel rather than politics. He had long ago decided that everyone on the other side of the glass was stark raving mad. The changes in the last few months only reinforced his belief. Cutting staff while increasing the expectations had been but one of those mad ideas.

Washington was unbearably hot and muggy in the summer, but Alex didn't mind. He was happy with his job and his family. He loved being outside in any weather. He was delighted when a few years ago a kitchen garden had been added to his responsibilities. He loved tending vegetables. Flowers were fine, but they were for show. Vegetables sustained life. Besides he was allowed to help himself.

Things had started to get weird when the remaining gardeners were given orange coveralls a few months after the new president took office, just in time for the spring planting. The old coveralls had been an anonymous dark blue. Behind the bars of the fences, the workers in the new coveralls looked like prisoners. The powers that be said it was not to point out the similarity between the increased workload and Lorton Prison. "We want the public to know that White House employees are happy and well paid." Whose idea was it that orange suits would do that?

Maybe he should put in a request for a transfer to another site. There were plenty of places in DC that had beautiful gardens. He was a good gardener and had a spotless work record.

He was preoccupied as he worked his way through the weeds in the kitchen garden. With all these changes, what was to become of the beautiful White House gardens? When all the rows were up to par, Alex began to trim along the walkways. At the end of the day he went to his locker to change out of his coveralls for the trip home. There was an envelope stuck to his locker door. Another firing? This time his?

No not firing, simply another impossible task.

He thought about the task as he put on his polo shirt and khakis for the bus trip home.

Continued thinking about this new task as he stepped onto the bus, his arms loaded with Swiss chard. He was still thinking of it forty minutes later as he climbed the front steps of his apartment building.

This latest request really took the cake. He alone was to plant1000 red rose bushes, all in bloom, to enclose a rectangular area on the south lawn. The bushes would arrive early the next morning and Alex needed to be prepared to start planting.

Why was it given to him at the end of the day with no explanation? Did the other gardeners know about it? He couldn't possibly plant 1000 rose bushes by himself. And why now? They could hardly flourish if they were torn up from where they grew and replanted mid-summer.

When he arrived home his first daughter was waiting at the door to help him make the rounds of the potted plants that filled every window ledge. They would discuss each plant and give it the care it needed. Maybe when she grew up, Lydia would be first-gardener at the White House. If the White House still had gardeners.

When every plant had been given the care it needed, Lydia fetched the book they were reading. Lydia's mother would listen from the kitchen as she prepared the vegetables Alex had brought home from the garden at the White House.

Alex picked up *Alice in Wonderland*. They had finished the Mad Tea Party yesterday.

"Where are we today?" Alex asked Lydia. She found the page and handed him the book.

"Here," She pointed to a line drawing of a girl, a few years older than herself, holding a flamingo with her foot on a hedgehog.

After they had read for a few minutes and the Red Queen was threatening to lop off the heads of the playing cards that were her wickets, Lydia said, "That's silly. How could that be real?"

"No, my love, we are quite safe from the Red Queen. It's all just a story."

DAY TWO: *TUESDAY*

The white haired man on the bus seemed agitated. His hair was not combed, and the stubble on his chin looked like a covering of frost. He pulled out his watch and muttered about being late. The white hairs on the back of his hands seemed thicker and longer.

Again twenty minutes early, Alex put on his orange coveralls and prepared to head out into the kitchen garden. He was stopped by the first-gardener.

"Did you read the memo?" the first-gardener asked.

"Well, yes, but this is not the time of year to transplant rose bushes. And why so many? This isn't a job I can do by myself."

The first-gardener shrugged. "Someone around here is mad as a hatter. But 'ours not to question why.'"

Alex had a sudden vision of all the remaining gardeners in their orange jumpsuits headed into a line of artillery. He gave the first-gardener a brisk if mocking salute, picked up his shovel and headed for the South Lawn.

The first gardener had already marked off the places where the red rose bushes were to be planted. A trench had been dug with a back hoe overnight. It described a rectangle about 60 feet long and fifty feet wide. All he had to do was set the rose bushes in the trench and refill it.

Somewhere the first-gardener had turned up twenty men to help. All together these men accomplished less than the old third-gardener could have done by himself. They knew nothing of working with plants, not even that roses had thorns. By the end of the day all the bushes had been pushed into the trench and the roots covered with more or less success. Alex surveyed the ragged line of bushes, each with drooping red blooms, and went to fetch a hose to begin watering.

The first-gardener approached Alex as he was trying to make sure the rose bushes didn't succumb to thirst overnight. "Here is the next set of instructions."

Alex had been given so many nearly impossible tasks since he been promoted to third-gardener, that he took this one in stride. He was now in charge of this questionable project. When heads rolled, his would be first. Besides he was far too tired to put up any fuss.

He changed into his street clothes and dragged himself onto the bus without reading the paper he had been given.

DAY THREE: *WEDNESDAY*

The white haired man on the bus kept staring at his watch and muttering about his lateness. Odd, Alex had never noticed his ears before. They were quite large and covered in white fur.

Back on the White House lawn in his orange coveralls, he went first to check on the roses. He found them doing as well as could be expected given the haste with which they were chosen and planted. No preparation of the soil, no time to check on the shade and sunlight in the area. No time to pick out the appropriate strain of roses.

"They should do fine until spring and then they will start to die," said Alex, regarding the poor doomed roses with sympathy. "What's he want it for?"

The first gardener answered, "Croquet lawn."

"But it slopes downhill and it isn't even. If he practices he will have an advantage over the other players. That's not fair."

The first-gardener shrugged and walked away.

That afternoon, the President's aide himself came to see the progress. Alex had run into him from time to time, but didn't know his name. Alex thought of him as the Cheshire Cat, because he always seemed to be lurking about, even if you couldn't see him. He was a minion directly under the thumb of the President, and today he seemed to be responsible for making sure Alex filled the requests properly.

"Is the President thinking of taking up croquet?" asked the first-gardener who escorted him.

"Yes. He's never done it before, but that should be no problem. The south lawn seems to be perfect for a croquet field."

"Very well sir," said the first-gardener. "I will ask the staff if the equipment is here. If it isn't do you want me to order it?"

"The President has drawn up the specifications for the equipment. He has invited a few powerful friends to a match on Sunday."

The Cheshire Cat handed the first-gardener a sheet of paper. The first-gardener handed it to Alex who gave it a quick glance. It was filled with instructions, in tiny print. As he read the demands, he prepared himself for the ritual shaming that followed the inability to complete an impossible task.

Why did Alex keep doing this? All he wanted was to be left alone with his plants.

Alex found many of the requests odd. First thing of course had been the ring of red rosebushes, all in bloom, surrounding the lawn to afford some privacy for the players who otherwise would be in full view of the tourists. Alex still ached from the effort of getting the bushes in yesterday. That alone had been nearly impossible.

Then there was the lawn itself, which the memo referred to as a field. It was nearly twice the regulation size. What Alex had grown up calling hoops were now to be referred to as targets. Instead of bent wire or wooden uprights, the targets were to be staffers dressed in red sweat suits standing, legs spread at proper intervals. How was anyone going to talk them into that?

The balls were to be ten inches in diameter, to suit the bigger lawn, and the bigger targets. The mallets were to be made to scale. Big equipment for big men.

It appeared that all this would have to be hand made in the next three days. At least that was not his problem. Or so he thought.

DAY FOUR: *THURSDAY*

The white haired man on the bus twitched and squirmed in his seat. As he pulled out his watch and muttered about being late, Alex noticed a distinct similarity to the White Rabbit in the story he and his daughter had been reading.

As Alex changed into his coveralls, he wondered about the change in the man over the week. He had ridden the bus with the same man for several years. The man had never shown himself to be any more than a stable, mid-level bureaucrat, like thousands of others in the city. Was the whole world going crazy?

Alex cast a longing glance toward the kitchen garden. He would miss it as he worked on the preparations for the big game.

Throughout the day, the staff brought him updates and additional requests.

The pavilion for the audience was simply a matter of putting up the tents. The court was to be marked off with plastic chain. That was easy enough, since such barriers were frequently used to direct crowds around the grounds. A few of the rose bushes were suffering from the transplanting. They would need a few hours of nurturing.

Besides explaining the specifics to Alex, the Cheshire Cat was responsible for making sure the orders were carried out properly. At one point he mentioned that he sent out invitation to designated invitees to attend at the president's pleasure. One more chore that didn't fall to Alex. How could they in good conscience invite people if the event were not going to be perfect?

Alex tried to engage the sympathy of this man who was clearly as over whelmed as he was. The Cheshire Cat met each attempt with a look that said, "Can't cope? Maybe you need to be elsewhere. The rest of us are getting on just fine."

By the end of the day, everything seemed in order. Alex snuck over to his beloved kitchen garden to see if things were being tended to there. His heart sank as he saw it was showing the signs of three days of neglect.

DAY FIVE: *FRIDAY*

The white haired man, who usually sat across from Alex on the bus, was missing today. In his place was a rather nice looking woman with a cat carrier. Why did Alex think it contained a rabbit? Why did that make him more nervous than all the things that had been going on at work?

As Alex was changing into his vivid coveralls, an attendant brought him another set of instructions. He went to a bench under a tree beside the kitchen garden and read it three times. Things had been getting curiouser and curiouser.

His body ached everywhere. He was so tired he could hardly move. Maybe the Cheshire Cat was right. Maybe he did need to be elsewhere. Maybe he needed to transfer to a private garden rather

than a government site. He had been too tired to read to Lydia for the last two nights.

He sighed and read the memo one more time. He had complied with all the requests so far. His heart went out to the poor rose bushes that would most likely be ripped out once the game was over. Perhaps they would be sent to other locations where they would be properly cared for. Alex folded the memo carefully and slipped it into the pocket of his orange coverall. He stood up with a sigh to try to fulfill the order.

He was a gardener. Why was it his job to get the flamingos and the hedgehogs?

The First White House Costume Ball and Other Trumpery

by Diane A. Hadac

Hi, fellow citizens! Billy-Bob Larrabee, friendly White House beat reporter, here to give you weekly highlights of our new President's plan to Make America Great Again.

Much like DT, I have no experience for this position, but his staff has provided me with a ghostwriter. In addition to my regular job (which I will fully explain later), you can count on me to give you a light-minded look at the current Presidential poop.

1) The first item on the agenda is the First White House Costume Ball. DT wrote the invitation himself. (I've mentioned that he may need to revise; and I offered to lend him my ghost-writer, but he has declined.) Although he's tried to be inclusive, only a select group will be invited to this event. He has graciously allowed me to print the entire invitation for all to read, however.

You can post comments on Twitter using #firstwhitehousecostumeball.

2) The second item on the agenda outlines DT's proposed Job Plan. Since I am a participant in this program (having been frequently unemployed when so much work was outsourced to low-wage, foreign countries), I can explain it easily. You can post comments on Twitter using #simplefivepointplan.

INVITATION—FIRST WHITE HOUSE COSTUME BALL

Hello Folks, DT Here!

Well, I made it to the Top of the Tree! Here I am—your new President! All bow down… *Just kidding!!!* After all, this is a Democracy, not a Dictatorship… *so far.*

I've decided to make the White House a more Fun Place, so I'm instituting the First White House Costume Ball. If you've been invited, this is what your *Exclusive Invitation* looks like. For everybody else, sorry.

RULES OF ENTRY FOR THIS EVENT

1) An American Birth Certificate must be presented at the door. If you don't have an American Birth Certificate, your Naturalization Papers will be accepted.

2) Your *Exclusive Invitation* must also be presented at the door.

3) Your crying babies and other children are not invited. Only my children will be present.

4) All costumes must be purchased through Trump-owned companies and have tags that bear my name. Why? I can't lose my Trade Agreements with China and various Third World countries. My revenue will fall and my lifestyle will crumble. That's just the way it is, folks. If you were as rich as I am, and the President, you could call the shots, too.

5) Accepted Costumes—Refer to sections below titled, "First Family Costumes" and "Other Costumes Not Allowed." These sections will be adhered to strictly!

Please note: You must follow the Rules above to enter this event or the Second Amendment people will find you and hurt you...*Just kidding!!! Maybe.*

FIRST FAMILY COSTUMES

1) Me, Me, Me: I will be attired as myself in a business suit, but I'll also be wearing a large, ornate crown. I have been accused of vanity and narcissism, but this is not true. Trust me. I wouldn't lie to you. The crown is functional. It will hold my hair in place.

2) The First Lady: Many fan letters have asked to see more of my wife than shown in pictures posted on the Internet. Her style is simple, so she's debating between appearing as Lady Godiva or a graduating college student. The only alteration to either costume will be a pink pillbox hat in deference to her idol, Jackie Kennedy.

3) My Elder Sons: They will be dressed as Big Game Hunters. They'll bring along their stuffed lion & tiger trophies so you can see them up close.

4) My Daughters. They've been instructed that their expensive designer clothes are out; so, like my current wife, they can't decide what to wear, yet. That's women for you—they can never make up their mind! I'll check with my two ex-wives and let you know if they have any further information about the girls' costumes.

5) My Youngest Son. No clue as to his costume either. We tried to give him a lordly-sounding name, so maybe he'll dress like royalty. I'll check the status of his attire with my current wife.

Please note: Under NO circumstances, may these costumes be copied or the Second Amendment people will find you and hurt you… *Just kidding!!! Maybe.*

OTHER COSTUMES NOT ALLOWED

1) Anything resembling ethnic garb, such as, Middle Eastern, Latino, Black, Native American, etc. You get the idea.

COSTUMES ALLOWED

1) Any non-ethnic story, movie or cartoon character.

2) Any non-ethnic animal costumes.

3) KKK sheets and hoods—Hey, they're part of our history, and my "good ol' boy" supporters would probably shoot me if I left them out. *(Just kidding, again!!! The boys wouldn't shoot me. Ha, Ha.)*

ITEMS BANNED FROM THE COSTUME BALL

1) Copies of the Constitution—There's no point reading it now.

2) Cameras & Cell Phones—Not allowed as they may conceal a bomb.

EVENING SPEAKERS

1) Me, Me, Me, First. I will spout my usual diatribe: "Trust me—I know everything, I know what's good for everybody and I know what's good for the country." You've heard it all before; but it's so riveting, I'll say it again.

Isolationism is the only way to go. Even though we're not cowards in this country, and have always faced bravely any attacks all the way back to the Revolution, it's now time to bury our heads in the sand and ignore the rest of the world. Trust me. It will keep us safe.

I will also touch on the subject of using nuclear weapons to crush our enemies. After all, what's wrong with this idea? Let's show other countries that we mean business!

2) Next, The First Lady. She's busy gleaning salient facts, comments and quotes from the speeches of former First Ladies. She'll present these with her usual flair and charming foreign accent.

3) Finally, Vladimir Putin—Our Unofficial VP (What the hell, he has the correct initials, so he deserves a title.) He's been an outstanding campaign supporter. Don't believe the Media or the

State Department. He's not involved in the Russian cyber-hacking that's occupied the headlines lately. Vlad will expound on how our countries can achieve World Peace.

GAMES AND ACTIVITIES

1) Target Practice—Just for laughs, full-size targets of prominent opponents and non-supporters will be on display at the new White House gun range. Handguns only at this venue, please. No assault weapons.

2) Wall Construction—A fun-filled activity designed to work off those dinner calories. Innovative techniques will be noted and applied at the *real* Wall site. Bricks, trowels and mortar will be provided.

Please note: During the campaign, my opponent had talked of creating jobs by improving our infrastructure, but that's a waste of time. Although I've never studied Engineering or Climatology, I know this to be true. Our bridges and rail systems are sound, and climate change is a myth. Trust me, folks. I wouldn't lie to you. My Wall is a job-creator, too.

3) Wild Kingdom Movies—My elder sons will be showing interesting flicks of their latest Big Game Safari. Dead animals ready for taxidermy are quite a sight! The White House will supply popcorn and soda for your enjoyment.

4) Fantasy-Land Adventures—Here, you can pose as me. You can pretend to run a campaign, host a reality show, build a hotel, fire people and learn how to send business to Third World countries.

DINNER AND SEATING ARRANGEMENTS

1) Food—Latinos can count on tacos, tamales and burritos. Blacks will have plenty of fried chicken, sweet potato pie and watermelon. I have no idea what Native Americans eat. I'll leave that up to my chefs. There will be no Middle Eastern food as none of these terrorists are left in the country. Regular white people will have steak, baked potatoes and salad.

2) Seating—In the spirit of fun, the few Latinos in attendance will be seated behind a cardboard Wall. The few Blacks and other minorities will be seated in their segregated sections. All other non-important people will be seated on the periphery of the ballroom. Special tables with cushy seating in the center of the room will be provided for Second Amendment and wealthy supporters and lobbyists.

Remember—This is a "Weapons Friendly" event. Your rights will be protected. My philosophy has always been that if you're not happy with people or situations—shoot first and ask questions later. It's not true that more guns promote more violence. More guns equalize the playing field. So, keep your weapons handy, folks, in case a band of non-supporters storm the Ball. *Not kidding this time! We'll need you!*

If you have received this *Exclusive Invitation*, I'll expect to see you at the Ball. If you don't show up, *you'll be found and shot… Just kidding!!! Maybe….*

"Th-th-th-th… That's All, Folks!"

Yours truly,

DT—Your Pres.

P.S. Anybody caught climbing up one of my buildings will be shot. *Not kidding, again!!! Those family lawsuits can bankrupt you!!!*

———————————

Hi, again, fellow citizens! Billy-Bob Larrabee here once more. Hope you enjoyed reading the *Exclusive Invitation* even if you're not invited. Now, let's move on to DT's Job Plan.

Bringing good jobs back to the US was one of DT's campaign promises, and he's sure his Simple Five-Point Plan will do just that.

As DT himself likes to say, "Trust me. This is a simple plan for all those simple people who voted for me. I wouldn't lie to you, folks." He sure has a way of talking to citizens on their own level, don't you think? No deep political mumbo jumbo here; just straightforward bilge (the ghostwriter says to change this word to "eloquence").

The Plan is designed to help the average worker achieve some sense of prosperity and upward mobility. Not too much, though, for good reason as will be explained later on.

The Job Plan—A Simple Five-Point Plan

Step 1) Because the Mexican President adamantly refuses to build and pay for DT's Wall at the Tex/Mex border, your first job begins in construction. Any illegal immigrants will also be rounded up to help with this project before being deported to their own country. (After visiting the Great Wall of China, DT considered importing cheap Chinese labor, but changed his mind in favor of US workers.)

The best part about this job is that you can carry a weapon at all times! You never know when an alien will try to sneak over The Wall and into the country. It's part of your job to see that they don't.

Step 1 works this way: All unemployed and homeless males are trucked to the site with the promise of Minimum Wage, three-square meals a day, and a cot and tent to sleep in at night. Bathroom facilities are primitive, but you can't have everything—a job, money and a cushy environment. The salary may be too low to support a family of four, let alone one, but you can always work two shifts to earn extra money. This is the first step in achieving the up yours (excuse me, the ghostwriter says I mean upward) goal. Of course, if you screw up, *You're Fired... Just kidding!!!* Everybody takes DT so seriously. Lighten up, people!

I've heard some citizens complain about the salary and working conditions (which include toiling ten hours a day in scorching heat), but they're just used to getting something for nothing, and don't understand how the real world works. I, myself, have reached Step 5 in the Job Plan, which I'll outline later. Some people say I've

been brainwashed by DT's, unfathomable speeches, but that's just not so. "Trust me, folks, I wouldn't lie to you," as he often says.

In regard to the salary complaints, you must understand that DT is doing you a big favor by paying you a low wage. If he paid you more, you'd just have to pay higher taxes, like he does. You'll understand this reasoning when he releases his tax returns, which is an event that's due to occur at an undetermined future date. There's no rush on this disclosure as he has plenty of time left in office; unless, of course, some left-wing liberals have their way.

So far, we've only mentioned unemployed men. What are unemployed and homeless women doing, you may ask, since they're not allowed to work on The Wall? Another simple solution takes care of this situation: Women are employed in ancillary (another ghostwriter word) jobs at the site, such as cooks and housekeepers. They receive a few dollars less than their male counterparts, however, as the Minimum Wage only applies to men.

How does the government get away with this? Easy. DT enacted a law to this effect that somehow got passed. There have been complaints in the female sector, but so far, nobody's listening, especially since women in Congress are a thing of the past (another law that DT got passed). Women don't need higher salaries anyway. They have husbands to support them. As stated before, the beauty of the Five-Point Plan is its simplicity.

Once men show that they've mastered wall building (and this is decided by a DT campaign supervisor) they are allowed to move to Step 2. Other supervisors will pass judgment on women's cooking and housekeeping skills. Excellence in these areas will allow them to move to Step 2, also.

Step 2) It's amazing how opportunities abound once you look for them! Here, men and women have a choice, all centered in the restaurant business. Men can work as busboys, waiters or short-order cooks. Women can work as waitresses. Busboy, waiter and waitress gives you the opportunity to collect tips in addition to your salary.

All jobs are in fast food or low-end restaurants not frequented by DT. These were once the positions labeled "Jobs Americans Won't Take," but they are now abundantly available since all the illegals have been deported and reside behind the partially-finished Wall.

In my case, it only took me a few months to make it to short-order cook. The pay was still Minimum Wage, but at least I had a job. Some of my co-workers, however, were disgruntled at the lack of a raise when reaching this step, but that's because they don't understand the system. I repeat—the more money you make, the more taxes you pay, unless you find a tax loophole, and that doesn't happen unless you make millions or billions of dollars, like DT.

I'm happy with my situation and it makes sense to me. These jobs offer the same perk as Step 1—you can carry a weapon at all times in case some ingrate (another word from the ghostwriter) is unhappy with the food or the service you provide.

(Friends have been telling me that I look a little stressed lately, but it's just not true. I do grit my teeth once in a while; but, otherwise, I'm very happy, and I wouldn't lie to you, folks. Trust me, as our Leader says.)

Once you've finished Step 2, you can move on to Step 3, which is outlined below:

Step 3) With this step, you begin to move up in the world. In the interests of the US economy, DT has thoughtfully brought some of his clothing operations back to the US. This is a boon for the American worker, especially women, because most of them already know how to sew.

Men can work as managers in Step 3. Again, the jobs pay only the various male/female Minimum Wages, but that's okay. You should be glad you're employed. As with the former positions, weapons are welcome in all DT facilities.

(Some friends have said I've been brainwashed, but this just isn't so. Trust me! Other friends have mentioned that I've developed an eye tic. Okay—that's true—but let's move on.)

Once you've completed this step in your career, you begin to see progress. Step 4 is designed to put you in the top range of the Lower Class.

Step 4) In this step, you have the privilege of working at a bona fide DT property that is not in bankruptcy. Plus, these jobs pay a whole two dollars more than the standard Minimum Wage for both males and females. In addition, the variety of available jobs is incredible! This step gives you the opportunity to work anywhere in the country or anywhere in the world where DT has established a property foothold.

For instance, at DT's hotels and golf courses, if you're a man, you can be a bellboy, desk clerk, janitor or house detective. In the hotel restaurant, you can be a waiter or a busboy and collect tips in addition to your salary. Also at the golf course properties, you can be a caddy, greens keeper or clerk in the pro shop. The opportunities are practically endless!

If you're a woman, you can be a maid, a laundress or a concierge. However, to qualify for all these positions, both male and female, you must be good-looking. Should DT drop in for a visit, he doesn't want to see ugly faces or fat bodies. It doesn't matter that he hasn't looked at himself in a mirror lately, or that he's packed on a few pounds. Only the gorgeous will be considered for these jobs.

Once you've mastered these positions, you move up to Step 5 in the program. At this point, you will have reached your full potential and are considered to be one of the High Muckety-Mucks. I have finally reached this step, and, believe me, it will be the crowning glory in your career when you make it as far as I have! Your weapon is welcome in these jobs, also.

(My friends seem concerned with my welfare. They've said that, in addition to my eye tic, I've developed an eyebrow twitch. Okay, they're right, but it's nothing to worry about. Trust me!)

Step 5) Here, you'll be eligible to work at one of DT's opulent estates and observe firsthand how the insanely rich live. Do not expect to see DT in person at any of his estates; he's much

too busy. If you screw up, you won't get to hear him say, "You're Fired," in his loud, arrogant voice. One of his lackeys will handle that chore (excuse me, my mistake; the ghostwriter said these people are called aides).

Due to his busy schedule being The Pres., DT spends all his time at the White House making America great again. Although his detractors have said that America is already great, has always been great and will always continue to be great with or without him, DT ignores them. Look how much progress we're making on The Wall.

But again, I digress (thanks to the ghostwriter, I understand what this word means now). A variety of jobs are available at DT's opulent estates. Men can be butlers, chauffeurs, gardeners or pool cleaners. Women can be housekeepers, maids or cooks.

Salaries are higher here, too. You'll earn three dollars more than the standard Minimum Wage for males and females, but don't worry about a tax increase. DT is not paying you enough for that catastrophe to happen.

As in Step 4, the one thing required for all these positions, both male and female, is an attractive appearance. Ugly people do not appeal to DT. Like all the other jobs in the Simple Five-Point Plan, weapons are welcome. As a matter of fact, they are *necessary* at the estates. Should somebody attempt to trespass on the property or break into one of the mansions, you are expected to pop them first and ask questions later. If your aim is good, you'll avoid a lot of court time in the future.

By now, in addition to my work as a White House beat reporter, you're probably wondering what job I have on a DT estate. I'll tell you. I'm a gardener. I love working in the great outdoors. It's very calming, and I have two breaks—one in the morning and one in the afternoon. I've installed full-size target practice figures at the back of the property to improve my marksmanship.

My friends tell me that my eye tic and eyebrow twitch are less noticeable now. Lately, however, I've been trumped about something (sorry, the ghostwriter says I mean stumped). I'm right-

handed, and my right index finger has developed a jerky quiver whenever I see paunchy, elderly men with light-colored styled and sprayed hair.

Friends say I have the DTs, but I don't drink. Something else must be at work here? I wish I could figure out what it is? If you have any suggestions, reply to #losingit on Twitter. Next week's topic will focus on the benefits of using nuclear weapons.

Yours truly, Your Fellow American,
Billy-Bob Larrabee, gardener and White House beat reporter

Trump Towering

by Craig Faustus Buck

CIA Director Brennan's cap-toed Oxford tapped nervously as he tried to maintain his composure during the morning briefing.

"You think it's a big problem?" said President Trump. "I don't think it's a big problem. It's a business deal. Business deals are never a problem. They're a solution. You just have to make sure you're on the winning side. And I'm always on the winning side. Why? Because I'm a winner, that's why. I always win."

Brennan thought about his predecessor, David Petraeus, who sank his own legacy by failing to keep both his fly and his mouth shut. Since Brennan had been approved to succeed Petraeus by the Senate Intelligence Committee in 2013, he'd done a pretty good job, in his opinion, not counting a few debacles, like the waterboarding thing. But Trump was a vocal fan of waterboarding, so there was no issue there. Still, Brennan felt like his tenure was hanging by a thread. *I was elected to shake things up,* Trump had told him, *so if I discover that you are part of the establishment, you're fired! Get it? 'You're fired.' I trademarked that line.*

"America has a winner for President, now, so we can do whatever we want to make a buck." Trump asked.

"The problem, Mr. President," said Brennan, "is that the President of The Gambia is certifiable. He cuts off the heads of gay people. He murders thousands of Gambian citizens because he thinks they're witches. He withdrew from the Commonwealth of Nations."

"Is The Gambia one of those Pacific Islands? It sounds like one of those blips that are getting drowned off the face of the earth by global warming."

Brennan had to concentrate to keep his eyes from rolling. "It's in West Africa, Mr. President. Here's a map."

He handed Trump a full-color Google map.

"Looks like a skinny dick fucking Senegal," said Trump.

"They prefer to describe it as a banana in Senegal's mouth."

"Looks like a dick to me. Except the balls are square."

"The point, sir, is that selling them B-21s will destabilize the region. The Caliphate is already pressing west. If ISIS takes The Gambia, they'll wind up with state of the art American bombers."

"Don't worry about it. I know what I'm doing, believe me," said Trump. "Watch this."

He picked up a seven iron and smacked a golf ball into the wall. Brennan ducked reflexively.

"Nothing to worry about," said Trump. "Oval walls are a beautiful thing. The ball just bounces around without coming back. It's fantastic."

The golf ball finally shattered a window. Two Secret Service agents barged through the door, guns drawn.

Trump held up a hand, signaling them to relax. "No problem," he said. "Broken windows are a piece of cake. I know because I'm a fantastic builder. People tell me I'm the best builder that ever lived. And a master builder like me knows how to hire people to fix windows. When you fix windows, the crime rate goes down. I taught this to Rudy Giuliani which is why New York is so much safer today than it was before."

With Trump's back turned to him, Brennan allowed himself an eye roll. It felt good.

A woman with a whisk broom and dust pan bustled into the room and did a quick sweep of the visible shards.

"Mr. President," said one of the agents. "There's a lawyer here from DOJ, says you asked her to brief you ASAP on her conversion with a Mr. Cutore?"

Brennan watched Trump's died eyebrows rise. The President turned to him.

"Look Brennan, I've got to take this. Why don't you fold the rest of today's report into tomorrow's? What could be that important, right? And if I miss something, who's going to know? They're state secrets."

"Yes sir, Mr. President," said Brennan, thinking *Thank God he's delaying any bonehead action he might take by at least a day.*

Andrea Martinelli watched Brennan leave the Oval Office. She figured his silk suit cost more than her entire wardrobe, but her outfit was just as immaculate. The difference was, Brennan probably sent his secretary shopping for him in high-end George-town boutiques like Everards or Riccardi, while she subsidized her meager income with the sweat equity of finding treasures buried among bargain sales and second-hand racks.

She was forced to make ends meet on a civil servant's salary, earning a fraction of what she could in the private sector. But if that was the only sacrifice she had to make to do meaningful work, so be it. She ran the ethics branch of DOJ and was proud of it. It wasn't a job, it was a calling.

So this particular favor to the White House did not sit well. In fact, it was a veritable rat's nest of ethical conflicts. First of all, she had been ordered to risk her life by secretly recording a Mafia Don (no "alleged" required) who was brash enough to try to blackmail the President of the United States. And secondly, if Cutore's allegations were true, her boss—the leader of the free world—was guilty of multiple felonies. No, this favor did not sit well. In fact, it sat on a one-legged stool with a white-hot seat of nails.

And to make matters worse, President Trump seemed oblivious to these problems. Of course, during his Presidential campaign, he had advocated issuing illegal orders to solders, including torture and murdering the families of terrorists, whether guilty or innocent of crimes. Legal ethics hid somewhere between dust mites and yesterday's piss on his priority list. If ballyhooing war crimes didn't faze him, Andrea's conscience surely wouldn't.

A Secret Service agent came out of the Oval Office in Brennan's wake and motioned to a secretary, a surprisingly young woman in a tight red spaghetti-strap dress and Grand Canyon cleavage.

"The President will see you now," said the secretary, whose voice implied a confidence and intelligence belied by her appearance. "Would you like some water? Coffee?"

"No thank you," said Andrea.

The girl waved her into the inner sanctum.

When Andrea walked into the Oval Office for the first time, she was overwhelmed by the power and the glory of the room, broken window notwithstanding. She had read up on its history before coming so that she could better appreciate what she saw, as if she were going to a museum.

As was the Presidential custom, Trump had redecorated the Oval Office to his taste, retaining from Obama only the Resolute Desk. Made from the timbers of the HMS.Resolute, Queen Victoria had given the large partners desk to Rutherford B. Hayes in 1880. Since then, every President except Johnson, Nixon, Ford and George H.W. Bush has used it.

In the prominent spot where every other President since the Civil War had displayed a bust of Lincoln, Trump displayed a monolithic model of Trump Tower. The walls were covered by gleaming golden wallpaper, flocked with dollar signs. Gone were the traditional portraits of such Presidents as Washington, Jefferson and FDR. In their places were multiple portraits of Trump.

"Welcome to my man cave," said President Trump, waving his arms about as if he were drunk, though Andrea knew he'd never tasted a drop of alcohol in his life.

This was her first time meeting the man. She felt his eyes appraise her as if he was judging a bikini-clad beauty queen. She disliked him immediately, yet couldn't help but be drawn by his charisma. She couldn't tell whether it was the Presidency, the money, or just some hormonal thing, maybe his pheromones. It certainly wasn't his flying saucer hairdo.

He extended his hand. "President Trump," he said, "but why stand on formality? You can call me Mr. President." He smiled as if he'd made a joke, but she got the sense that he was serious.

"Andrea Martinelli," she said, taking his hand. His handshake was firm but damp.

"I don't usually shake hands," he said. "Germs and some other things. But you are so beautiful, I mean *really* beautiful, that I just wanted to do this, you know?"

"I'm not quite sure what to say."

"Just be honored, Sweetheart. You've touched a great man. A very great man." He plopped himself down on a red silk couch and patted the cushion beside him. "Come on. Have a seat."

Despite his invitation, she sat on the couch opposite. He made a face of mock-disappointment, like a little boy who'd been refused a puppy.

"So I hear we had a visit from my old friend Vinnie Cutore."

"He didn't seem like much of a friend," she said.

"We've had our differences over the years," said Trump. "But nobody stays mad at me very long. It's not in their interest. I always end up making them money. Lots of money. I mean, *lots* of money. Like so much money that you wouldn't believe!"

"He doesn't seem to care about money."

"Please. Everybody cares about money. You think I got elected because of my hair? As perfect as it may be—my wife Melania cuts it for me, very talented woman—but it was my money that turned people on. It's like an aphrodisiac. Believe me."

"Well Mr. Cutore didn't ask for any. He wants an apology."

"A what?"

"It's where you say you're sorry... "

"I know what it means; I looked it up. I just can't accept that he's not after money. The guy's no saint, he's a money grubber like everybody else. Greedy as they come. He told me he's done awful things for money. Horrible things. He's even killed innocent people. He admitted that to me. That's something I would never admit to. Believe me. At least not knowingly."

"Well, all I can tell you is what he said. And he wants it to be public."

"Mr. President," said Trump.

"I'm sorry?"

"'And he wants it to be public, *Mr. President*.' I like how your lips do that cute little curl when you say it."

"I think we're drifting off topic... Mr. President."

"Much better." Trump brushed his hand over his hair as if pushing his bangs out of his eyes, but nothing moved.

"He says you got his niece pregnant and then paid for her abortion."

"Last I heard abortion wasn't a crime," said President Trump. "I'm working on that, but until I can get those jackasses in Congress to approve Alicia Florrick for that vacant Supreme Court seat, it's still legal."

"You do know she's just a character in a TV show, right?"

"Is there anything in the Constitution that says The Supremes have to be lawyers."

"Well... no, actually."

"I rest my case. I think she'd look great in a robe."

"I doubt she'd overturn Roe v. Wade as you promised your supporters."

"I'm already President. I don't need supporters anymore. Besides, my voters are the great uneducated. They'll love me no matter what I do as long as I say it'll make America great again. So Vinnie the Spoon can go pound his flounder in Dupont Circle for all I care."

"Mr. Cutore says he's got evidence that the Mafia has been your main construction subcontractor for years, committing all sorts

of crimes on your behalf. That's not about politics, Mr. President, that's about prison."

"What kind of evidence?"

"Paperwork, cancelled checks, transcripts, probably eyewitnesses. He's threatening to turn it over to the press."

"Those jackals!"

Trump stood abruptly and began to pace.

"I can only imagine what that feminazi Megyn Kelly could do with this," he said. "It would be her wet dream. Why does that bitch have to look so good? Why couldn't she have a dog face, like Carly Fiorina, so I could take her down in public?"

"I think Mr. Cutore is serious about this, Mr. President."

"Look, Andrea. That's your name, right? Andrea?"

She nods.

"Nice name. I like names that end in A. All my wives end in A. Look. What you heard today, you can't tell anyone, you understand? Not a soul. I'm trusting you with these secrets. In fact, I'm classifying them. They are State secrets now, so you can't reveal them to anyone, you understand? As your Commander in Chief I am ordering you."

"All due respect, Mr. President, I'm not in the military. Besides, it's not me who's threatening to reveal all of this, it's Mr. Cutore."

"Are you kidding me? Do you think I'm going to worry about a cheap hood like Vinnie the Spoon? He's an ant, a mite, a flea with a broken leg. He's just jealous, that's all. Him and many, many other people."

"Other people?"

"Everybody. Everybody on the planet wants what I've got. Because I'm a winner. I know how to win. I always win. They don't understand that, so they come after me. But they can't have it because I've already got it all and I'm not letting go no matter what. The looks, the money, the Slovenian model wife, the bankruptcies—which are very profitable by the way—the seven grandkids, the Presidency, the private jet, the yachts, the golf courses, the buildings, the hair… you name it, they want it. Now this putz Cutore thinks he can bring me down? He's got another think

coming. Believe me. Two other thinks. A thousand other thinks. A million other thinks! Let him come after me. Let him try. I'll call out the National Guard. I'll waterboard his entire family. I'll carpet bomb South Philly!"

Andrea wasn't quite sure how to respond. He couldn't be serious, but he didn't seem to be joking. Suddenly he turned to her.

"All classified. Remember that," he said. "Cutore says squat, he's getting a one-way ticket to the Federal pen."

"As a lawyer, I'd advise you to tread pretty softly there, Mr. President."

"Oh yeah?"

He appraised her as he had when they'd first met. Somehow, she felt naked.

"You're no Carly Fiorina either," he said. "I like your looks. You a good lawyer?"

"I like to think so."

He crossed the room and sat down beside her, taking her hand between his two. His touch was both electric and alarming.

"I'm a good judge of people," he said. "An excellent judge. I mean, a stupendous judge like no judge you've ever seen. Nobody judges like I judge. Nobody. I know how to pick 'em. That's why I'm such a great leader. Because I know how to pick the best. The cream of the cream. And I had a feeling the minute I met you that you were the cream I could count on to be my girl."

"Excuse me?"

"Especially since you're more than not bad on the eyes. A lot more, in fact."

Andrea felt her stomach churn.

"I have something very private to ask you," he said. "Something most women would moisten their panties to hear coming from a good looking guy like me. A rich guy like me. A powerful guy like me. I can offer you something no one else in the world can offer. Not one person can make you an offer like I can. When I make it, you're going to float on a cloud, you're going to think you've gone to heaven, you're going to feel like a princess."

He raised her hand to his lips and gave it a princely kiss.

"Mr. President, I apologize if this sounds out of line, but I'm not sure this is a completely appropriate conversation."

"I like that. I like a girl who speaks her mind. But don't get me wrong. I'm a happily married man. In fact I've been happily married many times. Many, many times. But marriage aside, let me ask you something. Something just between you and me. Man to woman. Man to beautiful woman. To a very beautiful woman."

Uh oh, she thought. *Is it a Federal crime to slap the President of the United States?*

"How would you like to sit on the Supreme Court?"

According to Luke

by John M. Floyd

Lucas Pennymore leaned on his hoe and watched his family climb into the old Buick. When Peggy had both kids inside and situated, she got in and started the engine. Her grin through the open window made Luke's heart ache.

He tried to smile in return, but he knew the worried look never left his face. "You're just going to the grocery store, right?"

"Right," she said.

Jennifer called, from the back seat, "You told me I could look for some new shoes, Mom."

"Sorry, honey. Not enough cash for that, today."

"Look at it this way," Luke said. "We'll be paying lower taxes soon."

"And the government's never lied to us yet." Peggy rolled her eyes.

For a second he actually did smile.

"You better get going," he said. "You got your pistol with you?"

"Both of them. One in my purse, one in the glove compartment." She studied him a moment. "You okay, Luke?"

"Sure I am." In his mind he pictured his family's route between here and town. They should be safe enough: there were no lonely stretches of road between here and there. And when they arrived, the Kroger parking lot would be crowded, on a Friday at this time of day. Most of the shoppers would be armed, some carrying several weapons each. Since the last presidential election and the new gun laws, the number of private citizens wearing firearms had skyrocketed. Everybody seemed to own at least one assault rifle. There were more murders, sure, but that was a necessary by-product—Fox News said the relaxed gun-control policies had significantly reduced potential terrorist attacks. Besides, as all the government signs proclaimed, guns don't kill people; people do.

"Just be careful," he said.

"I will. See you in a couple hours."

The Buick rolled to the end of the driveway and headed left on the dirt road toward town; a right turn would take you to the river that formed the county line. The ancient car, pulling a white cloud of dust behind it, was probably low on gas—all the overseas oil-field bombings had sent fuel prices through the roof over the past months—but there should be enough to make the trip. Luke watched it till it rounded the last bend, then he turned to look at the greenish-black forest that bordered the cornfield a hundred yards to the west. Squinting into the distance, he felt a chill shimmy down his spine.

What should he do? Tell someone? Sound an alarm? They'd probably lock him up if he did; they'd certainly brand him a fool. Peggy might never forgive him.

But if it was *true* . . .

If it was true he might have wasted too much time already.

Luke blew out a sigh. Jaw set, he adjusted the heavy revolvers he carried in both pants pockets and marched through the garden gate and up the steps to the house. The phone call took less than a minute.

Afterward, he returned to the front porch, picked up his hoe, and sagged carefully into his old cane rocker. Carefully was always best, now that everyone was carrying around so much firepower; a week ago he'd almost shot himself in the leg.

He looked out over his farmland again and drew in a deep breath. It was a fine day, sunny and cool. Further proof, as the new administration kept insisting, that the whole climate-change thing was a loony left-wing fantasy. The sweet smell of hay and honeysuckle floated in on the afternoon breeze, and puffy clouds scattered pools of shadow across the fields. Luke laid his hoe across his lap like a shotgun and watched the dirt road and waited.

Ten minutes later a tan police cruiser turned off the road and crunched its way up the gravel driveway. Although he hadn't expected cops so soon, it was no great surprise. It made sense that Bobby had contacted the sheriff's office after hearing what Luke had to say.

The car stopped in the yard and two men got out, men Luke Pennymore had known for most of his life. Curtis Denbroeder was the county sheriff and Bobby Vance was the editor of the local paper, the Fordham County Republican. The only sounds were the ticking of the cooling engine and the call of a crow from the fields behind the house. Luke put down his hoe and nodded to his visitors.

Bobby Vance, looking ill at ease, was the first to speak. "Lucas, I took the liberty of calling Denny. Didn't think you'd mind." In response, Sheriff Denbroeder removed his sunglasses, as if to reveal his true identity. At first Luke thought both men had gained weight, then realized they were wearing bulletproof vests under their shirts.

"Don't suppose you got any extra gas you could loan me," Denbroeder said.

"Not a drop, Sheriff. Sorry."

"Just thought I'd ask. The whole department'll be pedaling bikes around, fore long." He paused, frowning at what must've been a sudden thought. "And that's gonna make it even easier to get shot."

Luke waved a hand at the other rocking chairs and forced a smile. "You boys take a seat." Neither of them, he noticed, smiled back. They also didn't take a seat. They just stood there at the foot of the porch steps, looking up at him.

Good grief, Luke thought. If they figured he was crazy *already*, after what little he'd told Bobby on the phone . . .

"Wait'll you hear the rest of the story," he said, under his breath.

"What?" Vance asked.

"Nothing." Again Luke beckoned them onto the porch. Slowly, they mounted the steps and leaned back against the railing, watching him the whole time.

He drew a long breath and asked, "What exactly did Bobby tell you I said, Sheriff?" Denbroeder crossed his arms over his barrel chest and seemed to examine the sleeve of his uniform. "He said you told him we was all in danger." He raised his eyes to meet Luke's. "Is that right?"

"That's right. I think we are."

Bobby Vance's notepad was out now, pencil held ready. "What did you mean, Lucas?" he asked. "What kind of danger? This new healthcare mess we're in, you mean? The national debt? The increase in the crime rate? Chinese computer hackers? The defunding of Social Security?"

"None of that, no." Luke started to say something more, changed his mind, then spoke anyway. "I had a dream last night."

They both stared at him.

"At least I think it was a dream." Luke frowned at his folded hands. "It was so real I started to wonder whether I'd actually gone out there and seen it. But there was no mud on my shoes this morning, no footprints in the yard. And Peg would've known if I'd gotten up during the night—"

"Are you telling me," the sheriff cut in, "that you got us out here cause of a *dream* you had?" He looked back and forth between Luke and Vance as if wondering which one of them to shoot first.

"Actually," Luke said, "it was more of… a vision."

The sheriff's expression didn't change.

"Look," Bobby Vance said. "Why don't you just tell us what it was that you dr—" He cleared his throat. "That you saw."

Luke turned to stare out across the rolling cornfield west of the house. Even now, in the light of day, the wall of trees at the far edge of the farm gave him goosebumps. Sort of like the feeling he sometimes got whenever the new president made a speech.

Don't get sidetracked, he told himself. This was deadly serious. With emphasis on the *deadly*.

"I saw the things nightmares are made of," he said, still looking at the treeline.

Luke could feel his two visitors' gazes on him.

"I was in those woods out there," he went on. "In my dream— my vision—I was in those woods, hunkered down behind a clump of bushes, watching them."

"Watching who?" Vance asked.

"Muslim extremists?" Denbroeder said. "Welfare abusers? Planned Parenthood activists?"

Luke turned to look at him. "The jelly men."

It was suddenly quiet on the porch. Somewhere far away, a crow cawed again.

"Jelly men," the sheriff repeated.

"They were in a clearing, beside a little pond. About a dozen of them. They sat in a circle around a big glowing ball of some kind, like hunters around a campfire. I think the ball was their ship."

Denbroeder and Vance exchanged a look.

"They were maybe three feet tall, and their skin was clear, like gelatin. I remember I could see right through them, could see the trees behind them in the moonlight, like I was looking through water, or glass." Luke paused a moment. "Their eyes were big, like in the movies. A bunch of little transparent jelly men, sitting in a circle and reflected in the water of the pond . . ."

He was struck with a thought. "And they were quick. Lightning quick. Once, as I watched them, a butterfly or moth or something flew right up to the group. When it got close to one of them, the thing's tongue shot out and got it, BAM. Plucked it right out of the air. His tongue must've been two feet long."

Neither of the men said a word. The sheriff's frown had deepened, but he remained silent. Bobby Vance's notepad lay closed in his hands.

"And I could hear them," Luke whispered. "Not words, though. I could hear their thoughts."

He blinked and turned to Vance, pinning him with his gaze. "I could hear their *thoughts*, Bobby."

Vance didn't seem to know how to respond to that. He swallowed and asked, "What were they... thinking?"

"They said—they *thought*—something like: 'Their settlement is near.'"

The sheriff coughed and looked at the porch ceiling.

"Their 'settlement'?" Vance said.

Luke Pennymore drew a shaky breath. He was back in his dream now, hearing once again—receiving—the thoughts of the little men in the fairytale clearing in the woods.

Somewhere to the south, a train whistle blew, long and mournful. Mockingbirds sang in the oaks beside the garden fence. A wasp buzzed past.

"You sure they wasn't them people from ISIS?" Sheriff Denbroeder said. "Or maybe immigrants? I mean, that border wall, construction on that is way behind schedule . . ."

"No. These things weren't human."

"Well, neither are them radical Islamic jihadists—"

"Haven't you been listening to me, Sheriff? They were aliens. Okay?"

"You mean, like, illegals?"

"I mean, like, space aliens. From another world." Luke did a palms-up. "You know what I think? I think with all this hoopla about strengthening our military and sealing our borders and increasing our Homeland Security spending and such, nobody's considered that an attack could come from someplace besides Earth. We've completely ignored that, and now E.T.'s evil aunts and uncles are here, at our doorstep. Ready to do no telling what." He shook his head. "Or, who knows, maybe our government allowed

it. Maybe they *orchestrated* it, to thin the herd. Nothing would surprise me anymore."

Sheriff Denbroeder pushed back his hat and massaged his forehead. A long silence passed.

"You're crazy as a bedbug, Luke. You know that, don't you?"

"I know what I saw, Sheriff."

"What you think you saw."

"Yes," Luke agreed. "And what I heard, and sensed." He sat forward then, his eyes flashing. "But even though I can't explain it, these… things… are real. I think they may even be some kind of advance group."

"Advance group."

"Yes. For an invasion."

"An invasion of what?" Vance asked.

"Of what? What do you think?—our privacy? An invasion of our *planet*."

"Well, even if that was true," the sheriff said, "forgive me for saying so, but I ain't sure I'd be all that scared of a buncha little jelly men. They don't sound overly dangerous, to me."

"Maybe that's not their final form," Luke said, as the thought occurred to him. "Maybe they plan to take over our bodies. Just ease into our civilization, without any big fight at all."

Before anyone could reply, Luke sank back in his chair as if he'd exited his own body. As if someone had jerked his plug out of the wall. "That's it," he added. He felt too tired to argue anymore. "That's my opinion."

Another silence dragged by.

Finally Bobby Vance said, in a hushed voice, "Let me ask you something, Lucas. Have you gone out, in the daylight, to look for this place? This clearing?"

Luke shook his head.

"Why not?"

"I don't know. Guess I'm scared I'd find it. Or maybe I'm scared I wouldn't."

"But you think it's real."

"I told you what I think." Luke felt as if he'd aged ten years.

Sheriff Denbroeder spread his hands. "Well, what would you have us do, Luke? You want me to put out an APB on quick little men with a vision of dominating the world? That's a pretty fair description of most of the folks who're sneaking into our great country right now." He paused, heaved a sigh. "What exactly would you suggest?"

Luke stared down at his lap.

"Everybody just calm down," Bobby Vance said. "Lucas, what does Peggy think about all this?"

"I haven't told her. Haven't told anybody."

Vance looked at the empty garage. "Where is she? Did you send her to her mother's?"

"She's shopping, with the family."

"They're all armed, I hope."

"Peggy has a .38 and a .45. The kids have derringers, and .22s in their backpacks."

"Sure hope they don't plug one of my men by accident," Denbroeder said, looking moody.

Vance let out a sigh of his own. "Tell you what," he said. "Denny and I will stop by all the farms between here and town, and talk to the people there. How does that sound?"

"If we can keep from getting shot," the sheriff said.

"Right. Assuming we can do that . . ."

"They know, from watching TV, to aim above the vest. Damn cop shows."

"Well, assuming they don't," Vance said, "we'll ask if they've seen anything, or anybody, strange."

"You mean stranger than usual?" Luke said.

"Right. Really strange. Would that ease your mind?"

Luke thought that over, then said, "I think so. Yes. That'd be a start."

"You can come too, if you want. See for yourself."

"You got an extra vest?"

"There's one in the back seat," the sheriff said.

Luke nodded. "Then I'll take you up on it."

Vance pushed away from the porch railing and glanced at Sheriff Denbroeder, who just looked weary. The three of them stomped down the steps and across the yard to the cruiser, where Denbroeder opened the driver's door and the newspaperman went around to the other side.

As Luke climbed into the back seat and closed the door, Denbroeder's and Vance's eyes locked for a moment over the top of the car.

"What do you think?" the sheriff asked him, in a quiet voice. "The river bridge?"

Vance nodded. "Guess so." Midway between them on the roof of the cruiser, a fat green grasshopper was sitting motionless in the sun. Both of them saw it at the same time. "Help yourself," Vance said.

Denbroeder shook his head. He put on his sunglasses and got into the car.

Vance stood motionless, his bright eyes narrowed in concentration. Then his tongue—no more than a pink blur in the sunlight—snapped forward and back again. The grasshopper was gone.

Chewing, Bobby Vance slipped into the passenger seat, shut the door, turned so that Luke couldn't see his hands, and eased a pistol out of the glove compartment. Silently he cocked it and held it in his lap. *Aim above the vest*, he reminded himself.

When the car reached the dirt road, it turned east, away from town.

Toward the Green River bridge.

Career Change

by Ross Baxter

Matt Hix shivered and turned his leather collar up against the increasing chill as he trudged despondently down the centre of the deserted street. Years ago he would have crept cat-like from cover to cover, but now he just didn't bother. He had no need to. True, he was now more skilled than he had ever been, but zombies now were not what they used to be. There were less of them for a start; many had been hunted down and more had literally just fallen apart since the outbreak five years previously. The days of the terrifying hordes were long gone; most of the remaining zombies came in ones or two's, or were found in isolated small groups. They were seen more as a dangerous pest now, and that was not good news for a professional zombie hunter.

"You took your time!" a voice shouted accusingly from behind one of the shuttered windows of a house.

Matt turned to view the house, trying to judge which window the voice was behind.

"They're just down the street," came the hidden voice.

Matt nodded and continued walking. The street was in darkness and heavy clouds obscured the moon, but his night vision was keen and he quickly spotted them shambling slowly towards him. There were two, both male, one in a filthy business suit and the other in lurid ripped cycling Lycra. Within a few brief seconds Matt had appraised the situation, devised his attack strategy, and chosen his weapons. He no longer carried guns; ammunition was now hard to come by and expensive, and with a bounty of just ten dollars per zombie the cost of bullets would eat into his meagre profit margin. Instead he hefted twin geological hammers, one in each hand. Light enough to wield easily, but with a carbon-steel rear chisel long enough rend through any skull, they had been his preferred weapon of choice for over two years.

He stopped and let the two zombies come to him. From their gait and appearance he estimated the one in the suit to have been turned in the last eighteen months, whilst the cyclist probably dated from the original apocalypse. They viewed him with the normal look of hungry malice, advancing with dead eyes and gaping maws, their ruined skeletal fingers raised ready to rip and tear. He let them get to within six feet before whirling into action, firstly ducking left and smashing downwards through the skull of the suited zombie with the hammer end of one hammer and then whipping around to ram the chisel end of the other hammer through the cyclist's temple. Both dropped to the ground silently.

Without a second look Matt turned and walked back to retrieve his horse and cart he had left grazing in one of the overgrown gardens.

After delivering the two zombies to the crematorium the next morning, Matt made his way to the Police Station to collect his twenty pounds. The town was quiet and he no problem finding an empty rail to tie the horse and cart to.

"Morning Mister Hix," smiled the desk officer.

"I dispatched the two zombies reported yesterday along Maple Drive, by the old Walmart store," Matt said, tipping his hat.

"The Sergeant wants a quick word if you don't mind," said the constable as she unlocked a steel box and withdrew two ten dollar notes for him. "She's in her office; go straight in."

"Have you any without President Trump on?" sneered Matt before quickly pocketing the money.

The office door was open but Matt tapped on it anyway as he walked in. Sergeant Jones looked up from her paperwork, an uncomfortable look on her lined face.

"Morning Sarah," smiled Matt. "What can I do for you?"

"Take a seat Matt," she replied gravely. "I've got some bad news."

———————

"I can't believe she let me go," Matt grumbled as Steve the barman refilled his glass.

"But you did think it was coming," said Steve with some compassion. "You keep saying that hunting zombies is not the challenge it once was."

"True, but to be replaced by the local Scouts, who will only charge the town five pounds a zombie; that's just adding insult to injury!" complained Matt bitterly.

"The council will do anything to save a few bucks."

"I understand that, but using the Boy Scouts? That's child labour for a start!" cried Matt. "Zombie hunting used to be a profession that people looked up to. It was something people respected; a tough and dangerous job."

"The world changes, and I suppose we have to change with it," mused the barman. "I used to be a top accountant before the apocalypse. I drove a big BMW, holidayed in Australia and had a place in France. Then Trump happened, then the zombie apocalypse, and now I'm a barman. But we're in a time of transition; I think there'll be need for my skills again."

"Yeah, right," muttered Matt.

"You just need a new line of work," said Steve. "What did you do before the zombies put society back two-hundred years? What will this area need in the future?"

"That's just it. I graduated from college with honours in Psychology a year before the apocalypse, but I never got a job as my family were loaded. I've no practical skills, I've never worked, and I never even learned to relate properly to normal working people," said Matt despondently. "Zombie hunting is all I've got."

Steve considered for a few moments, stroking the stubble on his chin. Then his face suddenly brightened. "Matt – you know the council plan to hold elections soon for mayor, and some are looking to re-launch the old political parties?"

"So?"

"Think about our last President, Donald Trump. You've no life skills, no useful work experience and you can't relate to normal people; you'd make the perfect politician!"

Donalds to Donuts

by Brian Asman

Rudy Calles leaned against the glass display case, adding his fingerprints to hundreds of other smudges, and gazed at row upon row of donuts. The pastries were lined up in neat little rows, and completely identical. Gone were the sprinkles, the maple bars, hell, even the crullers. Each donut was glazed, topped with a messy dollop of orange frosting.

"Don't you have anything else?" he asked Karen, who tapped her foot impatiently as she waited for Rudy to make his selection. "Maybe a bear claw or something?"

Karen scowled and shot a look over her shoulder. She leaned forward, voice lowered, and said, "No, we don't have anything else. Ever since the damn inauguration, that's all Barry wants to bake anymore. I tell him, 'Barry, you're the only one thinks these are clever. The customers don't want them.' But does he listen? No, of course not. He's an *artist*."

Rudy sighed. "I guess I'll take three, then. And a coffee."

Karen pecked at her cash register. "Okay, that'll be $8.60."

"$8.60? What the hell?"

Karen shrugged. "Barry raised all the prices. I tell him, 'Barry, customers aren't going to pay a buck ninety-nine for your Thumbnuts. Nobody wants them anyway.' But does he listen? No, of course not."

Rudy ignored the rest of Karen's diatribe and reached for his wallet, rifling through the gaudy faux-gold bills until he found a ten. "Here," he said. "Man, I miss the old ten dollar bills. How do you get rid of Alexander Hamilton?"

Karen snickered. "Don't let old Barry here you say that. You know Mrs. Penzinger? She came in here the other day wearing one of those "Don't Blame Me, I Voted for Hillary" shirts, and you know what Barry did? He kicked her out. I tell him, 'Barry, you can't just kick someone out 'cause you don't like their shirt, this is America, but… "

"Thanks, Karen," Rudy said, taking his bag full of Trumpnuts and cup of coffee. "Keep the change."

"All right, we'll see you next time Rudy."

Rudy stalked out of BK donuts, the bells on the door jingling behind him. He used to grab a booth in front by the window and stare at the car wash across the street, just for something to look at. If he was in a chatty mood, he might grab a stool at the breakfast bar and shoot the breeze with Karen for a while. She was all right, even though a conversation with her was like a conversation with Barry, since pretty much all she talked about was what Barry said and what she said back.

When Trump ran for office though, Barry went crazy, and Rudy tried to avoid him as much as possible. Barry spent most of his time in the back, making donuts and taking smoking breaks, but even a quick run-in was more than Rudy could handle. He hadn't even been to BK in months, instead settling for those little chocolate donuts at the gas station. But this morning he'd had a hankering for a real donut, fresh out the fryer. For real, honest-to-goodness donuts, BK was the only game in town.

He passed Barry's truck, a Ford F-150 liberally plastered with right-wing rhetoric. *ISIS Hunting Permit. Welcome to America, Now*

Learn English. Hillary For Prison. He thought about keying it, but someone had beaten him to it. Three deep gouges ran from the rear bumper to the driver's side door.

Opening the door to his own sedan, he fished a donut out of the bag. The thick dollop of orange frosting swayed for a moment, then fell over into his lap.

"Shit!" Rudy said, searching the bag for a napkin. Of course Karen hadn't given him any. He stared at the orange blob on his jeans for a moment, until he remembered he had an old CVS receipt in the center console. He carefully wrapped the blob and tossed it out the window, before rubbing the remains of the icing into his jeans. A faint discoloration glared at him from the left side of his zipper, but he figured it'd come out in the wash.

Rudy took a bite of the donut. It was on the dry side, somewhat tasteless despite the glaze. Clearly Barry was phoning it in these days. He took a sip of coffee to wash it away. At least that still tasted good.

"Surprised to see you here," someone said from the window, their breath bringing the rank smell of cigarettes and coffee.

Rudy looked up and saw Barry's craggy face leaning into the car. He looked more like a drill sergeant than a donut maker, with his high and tight haircut and slim build. His reddish-tinged nose was like a flashing billboard for Dewar's.

"What do you mean?" Rudy asked.

"I figured they would have rounded you up by now, shipped you back to Me-He-Co."

"Dude, I'm from Riverside."

Barry shrugged. "Whatever you say, Pancho."

"You know what?" Rudy said, crumpling up the BK bag. "These donuts suck." He threw the bag at Barry, but it bounced off the donut maker's chest and fell back into the car. He thought about tossing the coffee in Barry's face, but he needed the pick-me-up.

"Don't come back here again!" Barry shouted, bits of spittle showering the inside of Rudy's car.

Unable to think of a clever response, Rudy dropped the transmission into drive and pulled away, kicking up gravel behind him. He glanced in the rearview and saw Barry, red-faced and flipping him the bird with both hands. Rudy stuck a finger out the window and returned the gesture.

As he drove, Rudy glanced down at the crumpled paper bag of crappy donuts that had now rolled onto the floor beneath the passenger's seat. His stomach grumbled, upset at having been denied the donuts it craved. He thought about driving up to Brawley, hitting Donuts Plus, but then saw Neighbour Ned's coming up on the right. The "u" had burned out, ending the Anglicization the former owner mistakenly thought added a touch of class.

Neighbour Ned's, or Neighbor Ned's now, was not a classy joint. Not many desert bars were, or at least the ones that opened at six a.m. A single low story of mismatched brick and frosted glass, there was something almost brave about the way that Ned's unapologetically presented itself as a blight on the community. Rudy was finally coming off a three-month ban for getting in one too many fistfights. Since he had nowhere in particular to be, as he made his living from a patchwork of odd jobs and disability checks, Rudy parked next to a pair of motorcycles and took his coffee into the bar with him.

Ned's was, if nothing else, the kind of place that believed in meeting expectations. The dingy interior was barely lit by a few neon signs, and featured a collection of rickety bar furniture and a pool table with a massive brown stain spreading across the felt. The juke box hadn't worked in years, but was still plugged in, sucking down energy.

Rudy nodded to the leather-vested bikers at the bar, guys he didn't know by name but had seen around town enough. The bartender eyed the cup in his hand for a minute before deciding if he was going to start giving a shit about something, Rudy's coffee wasn't it. His nametag said "Ned," even though his name was Chuck. The old owner wasn't even named Ned, he just like alliteration even if he didn't know what it was.

"Hey Chuck," Rudy said. "Usual?"

Chuck grunted and turned to pour a Jack and coke. "Little early for you, isn't it Rudy? Don't usually see you till happy hour."

"It's been a shit morning," Rudy said. "You know what, forget the coke. Can you just pour a shot in my coffee?"

Chuck shrugged. "Saves me a glass. I'd ask you why it's been a shit morning but we both know I don't care."

"Thanks Chuck, that means a lot."

"You got a little something right there, by the way," Chuck said, pointing at the stain at Rudy's crotch.

"Yeah, yeah. Less talking, more pouring, garcon."

Rudy sipped his Irished coffee and glanced up at the TV, which was the only way the inhabitants of Ned's could tell what time it was. Mornings were news, afternoons the Home Shopping Network, and evenings police procedurals with both the sound and closed-captioning turned off. Chuck sometimes put a game on if enough people complained.

"Hillary Clinton Receives Death Penalty," the crawler at the bottom announced. The screen cut to President Trump in the White House press room, pretending to choke to death on poison gas. Bulging out his eyes and grabbing his throat, before finally collapsing over the podium with his tongue sticking out. The room erupted in a flurry of activity as reporters jockeyed for attention. Trump stood back up and pantomimed being strapped into an electric chair, his jowls shaking with the imagined current.

"Huh," Chuck said, looking up at the screen. "Now I've seen everything." The two bikers laughed heartily, slapping the bar. Rudy picked up his coffee and moved to a booth on the far side of the room.

Around either his fifth drink or his sixth, Rudy started thinking he should drive back to BK Donuts and give Barry a piece of his mind. The coffee long gone, he'd switched to Jack, neat, until he felt his wallet getting thin and switched to well bourbon. He tried not to look at the label while Chuck over-poured.

The bikers were gone, having been replaced by a few construction workers on their lunch break. They were quiet enough, content to sip their drinks and blend into the bar furniture until

they had to return to the job site. Rudy figured they were probably with the crew putting up the new border wall. There wasn't a lot of construction going on in the county otherwise.

And all the while, as he watched the bikers become construction workers and video of the Toronto attacks give way to the Home Shopping Network, the little orange icing-stain at his crotch taunted him.

In fact, it didn't seem so little any more. Magnified by cheap whiskey and rage, the stain looked positively huge. Stupid Barry and his stupid donuts.

Barry used to make a pretty good donut. Not great, certainly nothing on the level of a Krispy Kreme, but passably good, considering how few options there were out in the desert. No longer. His adoration of the orange-haired asshole who'd ridden a last-minute scandal all the way to the Oval Office had seriously affected Barry's donut-making. Not that Rudy would have given him another Trump dollar anyway, even if they were the best donuts on the planet.

Rudy had actually voted for Trump. At first, he liked the way the billionaire told it like it was. He didn't say one thing when he really meant another. Even after the terrorist attacks, people like Clinton and Obama still tip-toed around the real problem. Wouldn't call a spade a spade. Rudy couldn't respect people like that. Trump didn't always know what he was talking about, but at least he wouldn't let the terrorists walk all over us like we were France or something, or so Rudy thought.

He hadn't figured on people like Barry, though. Once Trump won they came out of the woodwork. Rudy had never thought of himself as Mexican, but guys like Barry seemed to think that his great-grandparents being from Sonora mattered more than him growing up here, even joining the Army. He wasn't Rudy to them, not anymore.

He finished the last of the well bourbon, debated having another. One or two more and he'd get sleepy. Chuck might even try to take his keys. The bartender wanted to make sure his

patrons made it home alive, so they could fork over their cash another day. Not that there was much to run into out in the desert.

No, he'd had enough. The orange stain screamed at him, all manner of epithets. *Wetback. Murderer. Rapist.* He could go change his jeans, go to the laundromat and scrub that stain into nothingness. Or he could go back to the donut shop. He checked his watch. Barry and Karen would be closing up soon.

Rising from the table, he steeled himself to get past Chuck and out the door. Every step was taken with deliberate care, to avoid an inadvertent wobble that might give him away. But as he neared the bar, Chuck was busy with a crossword puzzle. Rudy waved, just in case he was half-watching, headed out to the parking lot.

After walking a few steps he realized he wasn't as drunk as he feared. No, in fact he felt pretty good. He had a healthy buzz, but his brain wasn't the least bit foggy.

He opened the trunk and pulled out a tire iron, taking it with him into the car. Just in case things with Barry went bad, which he kind of hoped they would. He missed having a gun, but he'd gotten rid of it after a particularly bad night at Ned's. After a fist fight with another drunk hadn't gone his way, he'd stumbled out to his car to grab his 9mm and show the guy he wasn't someone to fuck with. Thankfully, he'd passed out before he'd been able to get it out of the glove box.

Driving back to BK, the stain continued to taunt him, and the booze had kindled a fire behind his eyeballs. Fuck Barry. Fuck Karen, even, for putting up with Barry. And most of all, fuck Trump. Barry wouldn't have had the balls to say anything if Trump hadn't gotten elected. He would have run his mouth in private, sure, made a few beaner jokes when Rudy wasn't listening. But he wouldn't have gotten in Rudy's face like that. Wouldn't have dared to tell him to go back to some place he wasn't even from.

Rudy pulled into the parking lot, kicking up gravel. Barry's truck was the only one in the lot. He could see Karen through the window, standing behind the register and snapping her gum. The display cases looked just as full of Trumpnuts as they'd been

a few hours before. Apparently Rudy wasn't the only one who didn't care for them.

Grabbing the tire iron, Rudy exited his car and made for the entrance. As he passed Barry's truck, he said what the hell and took a swing at the rearview mirror. The glass cracked, and a large piece tumbled to the ground. Rudy caught a glimpse of his reflection in the remains of the mirror. He didn't look too drunk.

Karen looked up as the doorbell jingled. "Oh hey, Rudy, didn't expect you to be back. Listen, Barry said… "

Without a word, Rudy walked over to the display case and gave it a bash with his tire iron. Made of stern stuff than a side-view mirror, the tire iron glanced off without inflicting any damage. The stain at his crotch cackled at his impotence.

"Hey, what the hell!" Karen cried. "Barry, you better get out here!"

Rudy wound up and took another swing at the display case. This time a huge crack began to appear. He hammered away at the case, and the orange frosted donuts within, while Karen screamed for Barry.

"Fuck your donuts! Fuck your donuts! Fuck your donuts!" Rudy yelled.

Barry came out of the back, wiping his hands on his heavily stained apron. "What the hell are you doing, boy? I told you not to come back here."

Rudy took one final swing, smashing the case wide open and showering the rows and rows of orange-frosted Trumpnuts with broken glass. "Fuck your donuts!"

"Alright, that's it. Call the cops, Karen, I'll deal with this." Barry cracked his knuckles and walked around the corner, while Karen picked up the phone and dialed.

Rudy looked up from the destroyed display case. Barry advanced, cautious despite his bluster. After all, Rudy had a tire iron.

"You're next, you sonuvabitch," Rudy said, raising the tire iron. "All I wanted was a goddamn donut."

With one fluid motion, Barry snatched a pot of coffee off the burner and tossed it at Rudy. Without thinking, Rudy swung the tire iron, smashing the pot of coffee in mid-air like Mark McGwire. The pot shattered, sending hot coffee splashing straight onto Rudy's face.

Or lukewarm coffee, really. Rudy blinked for a moment, wiped his face off with the sleeve of his shirt. A few bits of glass had scratched his cheeks, but otherwise he was fine.

"God damn it Karen, when was the last time you made coffee?" Barry shouted.

Covering the mouthpiece of the phone with a palm, Karen replied, "Nobody's been in all day, what am I gonna waste perfectly good coffee beans for?" Returning to her conversation, she said, "I tell him, 'Barry, every time I brew coffee after noon hardly anybody wants it,' but does he listen? No, of course not. Anyway, where was I? Oh yes, send the police on over if you could. There's a young man busting up the place with a tire iron."

Rudy turned his attention back to Barry, who began to back-pedal, both hands held in front of him. "Now listen, Rudy, I don't want any trouble. You have to understand. You come in here trashing a man's place of business, how do you expect him to react? Besides, I got my wife to think of."

"Your wife, huh?" Rudy said. "Because we're all rapists and murderers, right?"

Sirens wailed in the distance as Rudy pulled the gas can out of the trunk of his car. He'd never burned down a building before, but he figured with all the cooking oil a gallon would do. The stain on his pants certainly seemed to think it was a good idea. He could still see Karen, running down the road towards the sirens. Rudy hadn't done anything but yell at her. He'd done a bit more to Barry, though. He still couldn't believe he'd been able to shove twelve donuts down Barry's gullet before the baker choked to death.

He dumped gas all over the kitchen and tipped over the grease traps, the liquids pooling in the grouting between the black and

white tiles. Stepping over to the back door, he set a matchbook from Neighbour Ned's on fire and tossed it into the soup. As the first flames erupted, he pushed through the door, into the afternoon sunlight. The sirens sounded closer than ever. He probably wouldn't get far, not without his car, and without any place in particular to go. But he figured he might as well try.

Great Again

by Zev Lawson Edwards

The knock shook the door so hard it rattled and threatened to come unhinged. "Hey, Petey, ya in there?" The knock again, harder this time. "Come on, man. Open up. It's Rog." The door handle shook. "If you're hungover, a little hair of the dog will do ya some good."

Pete awoke with a gasp, as if from a dream, remembering everything and nothing. The line between reality and the imaginary blurred into an indeterminate remnant. One that couldn't quite come into focus no matter how hard he tried.

"Just a minute," Pete called, rising from a couch. He took in his surroundings. It was unfamiliar. Whose office was this? The décor somewhat simple, elegant, and a little behind the times. There wasn't even a computer. Just a plain desk. Clean, meticulous, devoid of clutter, as if no one ever used it. A lone pen and... a half-full ashtray?

Mechanically, he patted his jacket pocket. Something squished at his touch. He pulled free a pack of cigarettes. Lucky Strikes. Since when did he smoke?

"Petey, open the goddamned door," the voice called. "I ain't kidding man. It's an emergency."

Without much thought or inclination, Pete opened the door. Much to his surprise his name was stenciled on the front. Pete Cosgrove, Account Executive.

He was greeted by two people, not one. A beautiful brunette looked at him apologetic. "I'm so sorry Mr. Cosgrove. I told Roger you didn't wish to be disturbed, but he wouldn't listen and just barged past me."

"Oh come on, doll. Barge in! Ya make me sound like a tyrant. I did no such thing. I told ya it was an emergency. I need ice."

Rog, a middle-aged man, dressed in a suit with red tie, and hair so pure white it appeared like snow after a recent storm, held up an empty glass. His expression comically helpless. "What do you say, be a pal?"

"Uh… sure," Pete said.

Rog smiled and gave the secretary a reproachful stare before patting her on the behind. "Careful, doll. Next time you might get spanked."

Her face flushed red as she returned to her desk. Rog watched her go the way a person eyed their dinner.

"Women," Rog said with a smirk. "Ya got ice in your mini bar, right?"

Mini bar? If Coop—his boss—knew Pete had liquor in his office, he'd be fired on the spot, without explanation. Pete ushered Rog in and quickly closed the door behind him. On second thought, he locked it.

"What's up with that tie?" Rog asked. "That the same one from yesterday? Another rough night on the town, huh? I want to hear all about it."

"Um . . ." Pete looked down, surprised at his clothes. Since when did he wear a suit? Where were his usual khakis and polo? The workplace was always casual.

"Hey, it's okay. Ya don't have to spill the beans if ya don't want to. I get it, being married and all. If my old lady knew half the s—"

Pete's mind drifted. Married? He looked down at his hand. Sure enough, there was a gold wedding band on his left ring finger. Also on his left hand was a gold watch. Pete hadn't owned a watch since high school, let alone a fancy, expensive one.

Rog scooped two ice cubes from a metal cooler and deposited them into a glass. Clink. Clink. Next came the distinctive sound of a bottle top being loosened, followed by a slow pour, and then the snap and pop of ice cracking.

"Out of ice," Rog said. "Ya believe that? I told that birdbrain of a secretary of mine to make sure it's stocked up every night before she goes home, but does she listen? Nope, no sir. She's more concerned about the makeup on her face or the latest gossip in one of her girly mags. I tell ya, these broads we hire nowadays are good for the eye, but lacking in the brain department. Ya know what she asked me the other day? She wanted to know if it was true that you got an eggplant by planting an egg. I about died. And the sad thing, she was serious. Ya believe that? Hey, Petey, ya listening to a word I'm saying?"

"Uh… yeah," Pete said, momentarily taken aback by a framed picture on the wall. In it was a bubbly blonde dressed in a bright yellow summer dress, smiling like the future was one big happy ending. Pete had his arm draped around her, with the same care-free smile stamped on his face like it didn't belong there. Cradled between them was a baby. Its face comical, as if knowing that it was the center of attention, of so much amusement and joy.

"Ya seriously need to get yourself something other than rye," Rog said, bringing over two glasses. "Shit gives me gas. Here, take this."

Rog handed Pete a glass, filled to the brim with golden brown.

"Bottoms up, Petey."

Rog clanked glasses with Pete's, spilling a little in the process. The rest was downed in two quick gulps, leaving less than half. Pete stood motionless. His eyes kept returning to the photo on the wall.

"Hey, earth to Petey. Ya gonna drink that or just hold it all day like a limp dick?"

Pete took a quick, conservative sip. The whiskey burned his lips.

"Don't be a such a Sally, Petey. Come on, drink up. We got a meeting in about thirty and trust me, ya don't want to be sober for this one. That HR manager of ours could bore a Chinaman to death, slant eyes and all."

Pete winced and tried not to show his contempt.

"Hey, what gives?" Rog asked, reducing his drink to just quarter full.

"Isn't that a little politically incorrect?"

"What? Slant eyes! Politically incorrect! Now there's a term I haven't heard in a while. Not since that singer from *The Voice* became governor. What's his name—Adam something? I hope you're not getting all sentimental on me, Petey. I remember those days when we had to constantly watch what we say. But those days are over. Now we can say whatever we want. Thank Gawd they rewrote the First Amendment. It was long overdue. I'm telling ya, ya can't have a democracy with thin skin."

Pete had no idea what he was talking about.

"All the pussies, faggots, towelheads, and naysayers can stay in Canada where they belong," Rog continued. "Best thing this country ever did was deport those socialist pansies. 'Merica, right buddy?"

Rog extended his fist and, so not to insult him, Pete bumped it.

"That's the spirit, buddy. Say, can ya bum me a smoke? I'm fresh out. Another thing Miss Shit-for-Brains was supposed to take care of today."

Pete reached into his pocket and handed Rog the pack of smokes. Rog shook one loose and put it in his mouth. Then to Pete's amazement, he struck a Zippo and lit it right there in the office.

"What are you doing?" Pete said, eyes wide. "You can't smoke in here."

"What do you mean I can't smoke in here?"

"You can't smoke in public buildings. Besides, you're gonna set off the fire alarm."

"Since when?" Rog chuckled. "And what fire alarm? Did ya hit your head or something? Of course I can smoke in here. Where ya been the last twenty years?"

"*Twenty years?*"

"Yeah, The Right to Smoke Bill, ring a bell?"

"Jeez, you're making it sound like we're living in the 1950's."

"What ya talking about? We are living in the 50's. Just different century."

Pete took a big swallow of his whiskey. His whole throat burning this time. He tried to collect his thoughts, but Rog was making less and less sense.

"That a boy," Rog said. "I'm gonna make another and then I want to show ya this new secretary they got up front in reception. She's the bell of the ball, this one. Tits right out to here."

Rog held out his hands a considerable length. "And an ass that'll make ya wish you were a chair. I'm telling ya, you're gonna need more than a drink and a cold shower after seeing this one, Petey."

Rog patted him hard on the shoulder and then made for the mini bar.

"Better make me another while you're there."

Pete finished what was left in his glass with one quick motion. It did little to calm his nerves. It felt like the world was spinning out of control and he was still trying to catch up.

"That's the spirit," Rog said. "Say, we still going out for drinks after work tonight? There's this new place on the east side I really want to check out. Been getting rave reviews. They even had an article in *The Patriot* about it and I guess The Man himself was even there on opening night. Lots of girls too. The take-your-wedding-ring-off types. My favorite kind."

"Uh... sure," Pete said. "Wait... maybe not. I just remembered there's something I may have to do tonight."

"What? Betty riding your ass again? I got the cure for ya. I did the same thing for my Joan. Here's what ya do. Get yourself

one of those colored maids. They don't work nearly as hard as the Mexican ones used to—one of the downsides of that wall—but they're affordable. Anyway, have them take care of all the housework and chores that way the missus can sit back and relax and watch her programs or read her little magazines or do whatever it is that broads to do kill time until we come home. Make her feel happy and supported, like your hard earned money's going to all the right places. And if that don't do the trick, just buy her some fancy, new jewelry. Works every time. I know a guy who can set you up with a good deal. Just tell him Roger sent you. Here, take this."

It was a business card.

"And this."

Another drink. Only one ice cube this time.

"Come on, let's go. I'm telling ya, this girl is gonna give ya a boner just by looking at her. I'm hard just thinking about her!"

Pete followed Rog out the office. The trail of smoke from the cigarette made his eyes water. He held up a hand to stifle a cough. Straight ahead a row of desks, all occupied by girls in their early to mid-twenties, talking into headsets attached to their ears. All young and all pretty, with red lipstick, long, wavy hair, and big, bright, perfectly white smiles. Their dresses shown too much leg and their tops shown too much skin.

"Hey, Rog," one said with summertime delight in her eyes.

"Hey, doll. That a new dress?"

"Sure is."

"Looks good on you, but I bet it looks better off. How about you and me meet for drinks sometime this week?"

Her lips, bright with lipstick, broke into motion, mouthing the words "call me."

"That one there," Rog whispered to Pete, "Now, that's a wild one. I got some stories ya wouldn't believe."

Rog winked and took another long swallow. "Drink up, sport. It's almost time for round three . . .or is it four? Oh well, don't remember and don't care."

"Hiya fellas, what's the ruckus?" A tall, athletic man, with blue bulbs for eyes and a blonde crewcut for hair, patted them on the backs.

"Harry, my man. Not much. Just showing Petey here the new secretary."

"Uh-uh, hands off, Rog. I already called dibs on her."

"Get out of here, you damn socialist! You can't call dibs on the office pussy. This is a free market. Open competition. May the best man win."

Harry gave him the finger.

"Hey, man, don't be sore. You know what your problem is, Harry? Ya got a secretary that's older than you. Ya need to cash her in for something younger. Maybe twenty-three. Now that's a good, ripe age."

"Sorry, but I had my fill of youth with your sister. How old's she again?"

"Ha-ha-ha, very funny, faggot. Say hello to your mom for me. She looks just as good naked at forty as she did the first time I had her at eighteen. Wait... could it be? Ya never met your father did you, Harry?"

Harry reiterated his middle finger and walked away.

"I don't even know why he tries," Rog said with a grin. "Youth. His secretary used to be mine. She's pretty good in the sack too. Something about those redheads. I would've kept her longer, but then this cute twenty-year-old started at reception and I just had to snag her away. That's what I like about secretaries. I get older and they stay the same age."

A secretary walked past them and Rog slapped her behind and not gentle either. Pete couldn't help but wince. He expected her to scream or at the least, slap Rog, but instead she just gave him a playful look and kept walking, her movements a well-orchestrated sway. Pete looked on in disbelief.

"What?" Rog said. "Girls like an aggressive man. They already have a pussy; they don't need another one. That doll we just passed. I did her in the copy room the other day. She kept wanting me to smack her ass and I mean *smack*. Full on flogging. It hurt my hand."

To emphasize, Rog waved his hand in the air.

They stopped in another office—some newbie named Herald—to restock at his mini bar. The office heavy with smoke. By the time they reemerged, Pete felt somewhat drunk. His head flighty, up in the clouds.

"There she is," Rog said with a sly grin. "Get a load of that stack of tits. Have you ever seen hair that dark and pure? And skin that smooth? Must be Mediterranean or something. I tell ya, if she was a Jew, she'd convert Hitler."

"Really?" Pete said incredulously. "You had to bring Hitler into this."

"What? I thought you loved my Fuhrer jokes. But back to the girl. Fine, right? I bet ya wherever she goes, it's boner-central. Pop-pop-pop-pop-pop."

To emphasize, Rog popped up his finger repeatedly in an area near his groin that was too close for comfort. Pete felt embarrassed just being around him.

"Come on, let's go talk to her."

Before Pete could protest, Rog had a hold of his arm and was dragging him to the desk, where the girl sat reading through a stack of papers.

"Hey, you must be new here. I don't think we met. I'm Roger, but you can call me Rog, and this is Petey, but you can call him Pete or Peter or whatever you want. What's your name, doll?"

The girl raised an eyebrow. Her face impassive.

"Peg, not doll, and no, it's not short for Peggy. Just Peg."

"Okay, Peg. Thanks for clarifying. Say, me and a few of the guys are getting some drinks after work tonight if you're free. Could be fun."

Rog winked.

"I've got plans." Peg resumed looking down at her papers.

"In case ya change your mind." Rog placed his business card on the paper she was reading. Peg picked it up with the tip of her fingers and without so much as a glance, let it fall into a drawer in her desk. Pete couldn't help but smile.

"Call me some time, doll," Rog said encouragingly.

Peg raised her eyes. They were sharp as knives, ready to draw blood. "Do you need something? Some of us actually have work to do around here."

She eyed his half-empty glass of whiskey and resumed sorting through the stack of papers. Rog's smile faltered for a second, but then he patted Pete on the shoulder and whisked him away.

"What's her deal? Must have a stick the size of New Jersey up her ass. That or it's the time of the month. Women. I tell ya, thank Gawd they can't run for President. They're lucky we still allow 'em to vote. They only got two places in the modern world. Behind a desk or at home. Am I right or what, Petey?"

Pete took another drink, wondering when this all would end. What kind of sick, mad world had he stumbled into? Perhaps this was all just dream, a terribly bad dream. If so, he wished he'd wake up already.

They turned a corner and Pete accidently ran into a janitor, knocking cleaning supplies all over the place and spilling part of his drink down the front of his pants.

"I real sorry, mister," the older black man said, running a worn, leather hand through his thinning white hair. "Getting clumsy in my ole age."

"Jesus, watch where ya going there," Rog said. "What are ya doing up here anyway? I thought you colored folks was supposed to stay downstairs."

"Sorry, mister," the janitor said. "Boss man had us clean out the office again. Special meeting or sumthing. I awfully sorry."

"It's okay," Pete said. "Don't worry about it. I ran into you. Here, let me help you clean up this mess."

Pete bent down to help the man, but Rog grabbed him by the arm. The look on his face incredulous. "Are you crazy or sumthing? Somebody may see you." Rog led him away. "Man, you must've really hit your head this morning. Don't you know it's unethical to mingle with the coloreds?"

Pete couldn't believe what he was hearing. "What do you mean?"

"Jesus, Pete! Seriously? Don't you remember the race wars of the late teens? Nearly tore this country apart. But then we reintroduced segregation, but fairer this time, and things are a million times better."

Pete was just beginning to think that this day couldn't get any more ridiculous. Was he part of a new run of *The Twilight Zone* or something? Perhaps Netflix picked up the rights and gave it a revamp, making it more documentary than fiction.

"Come on," Rog said. "We better head to the meeting. New clients coming in and we need to prep before we wine and dine 'em. And get this, I guess they're Chinamen. You believe that? We haven't had any foreign clients since the wall went up, but I guess they're pretty desperate, ever since their economy went belly up. But that's just the way it's been ever since President Bieber took over."

"*Wait*, did you say President Bieber, as in *Justin*, the pop star?"

"Yeah, what rock you been hiding under?"

"But he's Canadian."

"Do I have to explain everything to ya? They changed that natural born citizen hoopla years ago, to get Schwarzenegger in office. I kind of hope they repeal that act after this Democratic debacle. I was all for the Bieb when he talked about making Cuba the sixtieth state, but talking with China, no way Jose. Those bastards don't play fair."

They stopped and refilled their drinks in Pete's office before the meeting started. Pete was feeling both heavy and light. His mind and world, for that matter, turned upside down. He sat through the meeting, thinking the last half hour of his life must be some kind of sick joke.

Pete eyed the ceilings, looking for the hidden cameras. They had to be somewhere. Any moment now, a group of smiling, laughing people would come bursting through the door and let Pete in on the joke.

You've been Punk'd! Haha. This is Candid Camera. Haha. Bloopers. Haha

Pete waited the entire meeting for someone to lift the curtain, expose the ruse, point out the obvious, but the minutes dragged on,

becoming hours. Eventually, the meeting ended and the morning became the afternoon. Still no big reveal.

Pete went back to his office and collapsed on the couch. His mind spinning from the alcohol. Sleep beckoned. He wanted to will it all away, return to normalcy. If this was a practical joke, he wished someone would let him in on it.

Then he could laugh at the ridiculousness of it all.

That Hope-y, Change-y Thing

by Caroline Taylor

THAT HOPE-Y, CHANGE-Y THING

"Did he call?"

"Nope."

"But it's been two months! He promised . . ."

"Yeah."

"Well, maybe tomorrow. Do cheer up, darling. We've done everything we can to show our love and admiration for the man. You *have* tweeted your support for the Mexico boycott, haven't you?"

"Yep."

"Why did I think it would all be so— so *easy?*"

"Because."

"Well, yes. Because he said it would be. Imagine those horrible Mexicans, refusing to pay for the wall. How dare they!"

"No money?"

"Well, neither do we. But, wait. Didn't he say, early on, that he would pay if they refused?"

"Yep."

"Oh, right. That's before he discovered it would be more than even he can afford. I guess maybe his business isn't doing too well, either, since he had to put the kids in charge?"

"Beats me."

"You posted your daily "like" on Facebook, didn't you, sweetie? They do have ways of finding out who the slackers are."

"First thing this morning."

"Good. I did, too. Although… Have you ever wondered what we should do if—"

"Every fucking minute."

"Really?"

"He ain't gonna call."

"But he said he would personally respond to every veteran's complaint."

"He *said* he was going to do a lot of things."

"Well, yes."

"What's he done so far?"

"Oh, come on, darling. The gilt pillars on the White House portico? The colored searchlights on the lawn? The fabulous redecoration inside?"

"You *would* think of that."

"Hey. What's that supposed to mean?"

"Forget it."

"You have been in such a *mood*, lately. So the job's harder than even he imagined it would be. I think that's been true for most presidents in the past, hasn't it?"

"Sure."

"Look, I'm sure he'll call soon. This'll all be straightened out, and you can go to the head of the line at the VA hospital."

"Right."

"Well, he did promise."

"Yep."

"Now, don't lose faith, darling. Hope springs eternal, you know. I'm sure he'll call tomorrow."

"And if he doesn't?"

"Then… Look, sweetheart, let's not worry ourselves sick. The tumor's likely to be one of those slow-growing—"

"The Ashtons tried to emigrate."

"What's that got to do with us—with you?"

"Got turned away at the Canadian border."

"*What?!?*"

"You heard me. Bob was told they weren't letting in any more Americans, so they had to turn around and drive all the way back here."

"You're kidding. Although… Who would want to live in the Frozen North anyway? Not to mention having to learn French."

"I might."

"Oh come *on*, darling. You're just feeling sorry for yourself. Or perhaps pulling my leg?"

"Nope."

"What you need is a cup of Trump tea, along with some of those divine chocolates."

"What I need is my problem with the VA solved!"

"I understand, dear."

"No, you don't. You're not the one rotting away while the VA twiddles its bureaucratic thumbs."

———————

"Did he call?"

"Nope."

"Well, that's just not right."

"You got it."

"You're not losing faith, are you, dear? You've still been Face-booking and tweeting your support, I hope."

"Yeah."

"Well, then, it will pay off eventually. Let's just be patient. He is, after all, a busy, busy man. All those talk show appearances and the guest shot on Jimmy Kimmel—plus the movie. Maybe you should try the VA again."

"I did."

"And… ?"

"The same recorded message telling me to call the White House or visit whitehouse.gov."

"Well, maybe you ought to call him again—just in case your complaint might have been mislaid."

"Waste of time."

"Now, sweetheart, don't be so pessimistic. He's doing the best he can, isn't he? It's just a really tough job. What does the White House website say?"

"Beats me."

"You haven't tried?"

"*You* try it. All I get is a blank screen. The papers are saying the site's overwhelmed and constantly crashes. Big fucking waste of time."

"Maybe it's time to write your congressman."

"Like that would help."

"It might."

"How? She'll haul the man in for hearings? Hah! You don't do that to the president of the United States."

"Wasn't she the one he called a fat dumb blonde?"

"Uh-huh."

"The one who, every time she says something critical, he claims it must be her time of the month?"

"At least he's still telling it like it is."

"Darling! Really!"

"Just saying."

"Then maybe she'd love to get back at him. What if there's some kind of special channel from Congress to the White House?"

"Don't bet on it. If there was, it's now been completely cut off. You think he wants to hear from those bozos who didn't jump on the Trump bandwagon during the campaign?"

"They have to work together, honey, or… or nothing is ever going to get done."

"I wonder if Mexico would let us in."

"I don't want to learn Spanish."

"I just want my fucking problem dealt with!"

"Did he call?"

"Not exactly."

"What does that mean?"

"Some assistant deputy to the deputy chief of staff called."

"Okay… What did *he* say?"

"He said the Crimean golf course and casino deal with Putin is taking up most of the president's time."

"Well, yes. I suppose that's probably more important than—"

"And then he asked me for money."

"Money! We're dirt poor!"

"Told him that, but he kept asking anyway, saying Trump needs everybody's help to make America great again—"

"But we can't even pay our utility bill."

"—And how fantastic it's going to be when the new presidential yacht is finally delivered, not to mention the supersonic Air Force One, how that will make those cheap-ass Euros stand up and notice, how—"

"—Okay. I understand. But what did he say about your problem with the VA?"

" 'Get in line.' "

In the Service of the People

RJ Meldrum

After the shock of the election result in November, I kept a close eye on our new President. I imagine quite a lot of people did, especially those of us who didn't vote for him. We wanted to know just exactly how many of his election promises he would keep. We watched to see what insanity he would unleash upon the world. The wall was his first big initiative; despite advice from various people that it just wasn't feasible to build it, he actually decided to break ground on the project. The man himself was there in Arizona to watch as the diggers started construction. He also tried his best to move on the immigration issue, but that wasn't quite as easy as signing contracts with construction firms, eager to make millions from his folly. Even though the press reports were heavily sanitized it was clear he wasn't getting far with his proposals to remove all Muslims from U.S. soil.

But in the end it didn't matter. I, like many others, were waiting to see if his characteristic volatility would show itself. And of course it did; the only thing that surprised me was how quickly he

lost his temper. It was over nothing, as these things usually are. The problems in the Middle East had flared up in late 2016.Syria was still in chaos and the unrest in Turkey was getting worse. He waded into the issue with some fairly undiplomatic statements. I think he was trying to be statesman-like but it didn't work. He lost his temper during an interview with CNN and called the Turkish people "uneducated fools". Naturally this caused a huge online backlash from Turks all over the globe. And that was the catalyst for the end of the world. As you all know, less than two months in office and the brand new POTUS, Donald J. Trump, in a fit of infantile rage caused by a tweet from Turkey stating that despite all his so-called education it was likely he probably didn't know where Istanbul was, pressed the button.

And how was this momentous first use of nuclear weapons in over seventy years announced to the world? Twitter. I was casually checking his tweets for his latest gaffe when he announced, actually announced, he'd just sent a dozen nuclear missiles to Istanbul to prove he knew where it was located. That was followed closely by another tweet, reassuring his people he was safe in the presidential bunker. He was smart enough to know there would be a backlash.

During that morning I watched in growing horror as the news outlets reported death and destruction in Turkey's main city. The place was devastated, thousands killed or maimed. The radioactive fallout spread across Europe, causing outrage amongst our European partners as they watched the skies grow dark. Trump spent hours on Twitter justifying his decision in peace-keeping terms. He had wiped out the terrorist threat from Istanbul, a statement that was technically true, since he had wiped out pretty much everyone in Istanbul. I was waiting for him to be sectioned on the grounds on diminished responsibility, but it was quickly apparent that a lot of my fellow citizens, at least those online, actually agreed with his actions.

The world went very quiet for a couple of days, almost as if the world governments were wondering what to do. And then all hell broke loose. Everyone with nuclear capability got in on the game. Kaboom! Russia, China, North Korea. The US must have

been hit hundreds of times by all the countries we'd pissed off at one time or another. It was a free for all. Trump had unleashed the nuclear genie and everyone else gleefully joined in.

I was at home the morning it happened. When the sirens went off I guessed what was happening. I grabbed Linda and headed to the basement. As we cowered under a table we heard huge, vast explosions. The house rocked on its foundations and we were covered with dust and rubble from above. The walls of the basement cracked and groaned, but thankfully didn't collapse. We were safe for the time being.

Luckily I had taken some precautions after the Istanbul incident and we had some food stored down in the basement. The laundry room had a sink, so we had access to water. We stayed there for a few weeks until the food ran out. We had no option, so we left the basement, emerging into a world of grey dust, dark clouds and eerie silence. Our leafy suburb of identical homes had been flattened. Too close to Washington I guess. Leaving Linda to survey the wreck that had been our home and perhaps find some family treasures in the rubble, I headed out to survey the neighborhood. I wandered around for a while, not finding anyone. It was a depressing morning, but things soon started to look up. A few doors down from our house I smelt an exquisite scent. Following it, I found my friend and neighbor John in his back yard, cooking a solitary sausage on the barbeque. He looked up and smiled.

"Bill, you survived. Good news. Linda?"

"Yes, she's trying to find her grandmother's ashes."

He gave me a look, but didn't comment on the irony of what I'd just said. The smell from the grill was intoxicating. He caught me staring at the sausage.

"Want half?"

"Wouldn't mind."

He cut it in two with the spatula and passed half to me. I relished the feeling of the greasy meat in my hand, staring at it for a few moments before gobbling it down. John ate his, then shut the grill off.

"That's the last of it. No more food. How are you set?"

"Nothing."

"Well, now we've got each other, I suggest we raid the nearest supermarket."

"What about fallout and the radiation?"

John was a physics professor.

"Too late now. We've already had a lot of exposure, so a bit more won't make any difference."

I went back to Linda and told her the good news. She was happy too, she had found the ashes, which she carefully placed on the remnants on our mantelpiece. We held a planning session. Food and water were our priorities. Shelter we had. We opted for the nearest supermarket, about three blocks away.

The raid on the supermarket was successful. The building hadn't been too badly damaged and a lot of the stock was intact. Each of us filled a shopping trolley and headed back home. After a quick discussion it was decided the three of us would settle in our basement. John's had been damaged worse than ours, with the back of house collapsing and filling most of his basement with rubble. Days, then weeks passed. We kept ourselves amused with stories and songs. The food, despite careful rationing, didn't last long. A second raid was soon required.

John and I decided to leave Linda in the basement. The radiation had affected her badly and she was pretty weak. This time our luck changed. The local supermarket was bare. Clearly there were other survivors in the area, even though we hadn't seen anyone. John and I moved onto another store and then another, but they had both been stripped of all food and water. We returned empty handed to a distraught Linda. We had nothing. Over the next few days we started to starve. As we lay in the darkness of the basement, John spoke.

"I knew that prick would do something dumb."

I grinned through cracked lips.

"Yeah, but not this dumb!"

"The wall was bad enough. Do you know how much that would have cost?"

"I thought Mexico was paying for it?"

We laughed.

"Imagine, some-one was crazy enough to give him the access codes."

"You would have thought they'd give some fake ones. Just in case."

"Yeah, that would have been my choice."

"Shame we're paying the price."

"We are. Starvation and radiation sickness."

"He's probably holed up somewhere warm and safe, with plenty to eat and drink."

"Well, he's been in his bunker since the day he pressed the button. I'm sure he's just peachy."

"I imagine so. And the mention of peaches brings us back to our current predicament. I guess we have to head out and try to find something to eat. Otherwise we'll die here, something I personally object to."

"Yup, I guess so."

We left Linda in the basement, she was still too weak. She was also thoroughly demoralized.

John and I, despite our weakness, walked miles, searching every store and house still standing. There was nothing. We found ourselves heading into the city, the ruins of the White House and the Capitol Building visible in the distance across the Potomac. They had been hit and were mere piles of rubble. John sighed.

"He wasted the whole place, didn't he? Not even the British back in 1814 did such a thorough job. I wonder what the rest of the world looks like."

"The same I imagine. Quite the mess."

We continued to wander, every corner turned bringing new horror.

"The whole of the U.S. must be like this."

"Yes, the cities certainly. I imagine the rural areas are worse. Factions, armed to the teeth, fighting for food, for water and for gas."

We checked out a small convenience store, but the story here was the same as all the other places. As we emerged, there was a

sound from behind us, a sound that had been missing from our lives for weeks. It was the sound of a car engine. I thought I was finally hallucinating.

"Huh?" said John, just as a black Escalade swept past us on the debris strewn road. It stopped. It had a seal on the front door and small flags fluttered on the hood.

"Interesting," said John. "The EMP pulse from the airburst missile attacks should have destroyed the electrics in that vehicle. The only way it could have survived was if it was stored in a shielded garage. Underground."

I noticed the front doors were opening. Out stepped two tall, muscle bound men, with clear bulges under their suit jackets. They opened the rear door of the vehicle. A figure stepped out.

"It can't be," whispered John, but it was. There was the man himself, resplendent in a neat suit, complete with a well-groomed toupee and fresh spray tan. There he was, the orange psychopath who had caused all this destruction. He smiled at the sight of two of his disheveled citizens and opened his arms.

"I have returned to you, my loyal citizens. I'm smart, I know words, but my emotions… tears… choke me up. I have won the war for you, no need to thank me. Look, the streets are free of immigrants. No more terrorists. I had nuclear and I used it. Nuclear is powerful, my uncle told me that. The Arabs in… that place I bombed… they know it now. I learnt them a lesson. I am smart, went to Wharton, very smart. The Arabs are good negotiators, but I am better. I used my Second Amendment rights. America is powerful. America is great again. I earned my Purple Heart."

And then he smiled, that smug smile I had seen so many times on television. Seeing it in person for the first time was just too much. Perhaps it wasn't just the smile. Perhaps it was also the rambling, incoherent speech, perhaps it was the vision of his slick, smug oiliness in front of us or perhaps it was because he'd been getting three square meals a day in his underground bunker while the rest of us starved. I snapped. Without realizing what I was doing, I launched myself towards him, half expecting to be gunned down by his Secret Service protectors. It came as a surprise

to find myself punching him, watching him drop to the ground. John stepped forward and stopped me from doing more. Panting, I looked up at the Secret Service agents, expecting to be arrested or shot. Instead they both smiled.

"Man, thank you! That's exactly what we hoped would happen. We've been stuck in the bunker with him. Just him and all his family. It's been the absolute worst. He's been driving us crazy for weeks now, so finally today we suggested a nice drive out. We thought the sight of Washington in ruins would make him realize what he's done, but it just made him worse. He thinks he won the war. Not sure what war he's talking about, but he seems confident. We can't stand him anymore. He's all yours, do what you want. We're heading south. I hope the Mexicans can forgive us."

They climbed back into the Escalade and drove off. John stared at the figure sprawled on the tarmac. His suit was dusty and his toupee had slipped. He stared up at us, unsure now that he was outside his gilded cage. I wondered if he cared that all his Trump Towers were dust. Probably not.

"What shall we do with him?"

I wasn't interested in babysitting an idiot. I had Linda to worry about. We still had no food.

"We should just leave him. There's a few wild dogs around here."

Trump whimpered at the suggestion. John shook his head. He clearly had an idea.

"Hang him?" I suggested as an alternative.

More whimpering from the POTUS. John shook his head again.

"Tut, tut. Such poor imagination. I have a different idea. A mutually beneficial notion."

He laid out his plan. I watched as Trump's eyes widened.

In hindsight it was the perfect idea. We dumped him into a wheelbarrow we salvaged from some-one's back garden. Linda was shocked to meet our latest house guest, but quickly warmed up when we told her our plan. We tied him up in the basement until we were ready. He tried to persuade us to release him, but we

knew that we were about to do ourselves and the world a favor. We decided to make it a big event. John and I went around to each of our neighbors' houses, surprised to find that a lot of them were still alive. No wonder the supermarket shelves had been stripped bare. We outlined our plan and set a date. Everyone agreed to come.

It was the social event of the year. Mrs. Jones from number three even brought some of her carefully hidden rye whiskey to celebrate. When we brought our honored guest up from the basement it elicited a cheer and a round of applause. Poor Donald, I think he thought he was being released. That we had been teasing him about our plans. But it wasn't to be. John had scrounged up some propane for his grill and everyone was full of anticipation of the feast to come. I did have some initial misgivings, but our beloved ex-POTUS made the most perfect entrée for our barbeque. His plumpness and rich diet made him extremely succulent. After the meal was over, John, his stomach distended and full for the first time in weeks, sighed, burped then spoke.

"In the end he wasn't all bad .In the end he served us very well."

Down Mexico Way

by Ring Bunsen

It was a hot July day in Arizona. Two horses cropped lazily at the thin grass, resting while their sometime riders stretched a new length of barbed wire along a fence that happened to coincide with the Mexican border. The humans were dressed identically in jeans and denim shirts, except that one wore a Stetson, and the other a faded bandanna headscarf.

Hank Campbell put down the wire-stretcher, took a carefully-gauged swig from his canteen, and turned to his daughter-in-law. "There we go. Reckon we won't have any more of our cattle emigrating without export permits for a while."

The woman shrugged. "*Insha'Allah*, Hank." She grinned. "And Ramón will be glad to know we've found the gap."

"I'll call him this evening and let him know." He went to mount his horse, and stopped. What was that sound? "Wait." He held up his hand for silence. There it was that again – a low murmur that seemed to come from everywhere and nowhere. Should he put his ear to the ground like they did in the old movies? But there was

123

no need; the rumble grew clearer with every minute. The building crew were arriving.

"You get back to the house. Sounds like we've got strangers coming by, and an almighty shitload of them, too. I'll radio you if they're friendly."

"Hank..."

"It pisses me off too, honey, but these aren't normal times. Not since the Houston lynchings. You get into the safe room with the kids. Natalie can handle anybody who comes to the door. And John, too, when he gets back from town."

Aliah looked heavenward, muttered something in Arabic that Hank didn't recognize, mounted her horse, and galloped off, head-scarf fluttering. Hank rode more sedately up the spur, and turned onto the dirt track that ran uphill to the southwestern corner of his ranch. As he rode, the noise grew louder; he could make out the sound of engines, and what sounded like gunshots. He reached the boundary fence, crossed the cattle grid to the government land outside, rode a hundred feet more to the top of the ridge, and shook his head slowly. The building crew were here.

A ragtag army of cranes, excavators, water tankers, cement mixers and flatbed trucks straggled across the grassland towards him, five miles long and a quarter mile wide. Behind them all, a superhighway of churned earth stretched to the horizon. Though they were still half a mile away, the sound was like a city construction site.

On the south flank, dozens of crews worked side by side, building a wall out of huge prefabricated panels three times as tall as a man. Hank could see every stage in the process at once, as if he were reading assembly instructions for a propane grill. The nearest crews were digging ditches; further back, cranes lifted the panels into place and held them while workers joined them together with tools that sounded like high-caliber rifles. Further back yet, cement mixers fed gangling long-armed machines that pumped concrete into the excavation. Every five minutes or so, a crew finished one panel, fetched a new one from a flatbed, leapfrogged laboriously to the front of the pack, and began again. The wall was within half

a mile, and inching closer with every minute. It was like watching army ants on the move.

A light armored vehicle detached itself from the madness and drove up towards him. Its machine gun was not directed at him, but the gunner sat ready. Hank waited, trying to keep his breathing even, as it approached. It stopped ten meters away, and the man sitting beside the driver got out and tramped toward him.

The man was scrawny. He wore a set of beige fatigues that suggested the surplus store more than military service. Dirty-blond hair straggled out from a ball cap saying TRUMP CONSTRUC-TION. There was something familiar about his face...

"Jefferson Scott?" Jeff had been a troublemaker and a small-time drug pusher in high school, like his brother before him. He'd dropped out in Grade Eleven, and Hank had hardly seen him since.

"Hank! Good to see you, buddy! How's the family?"

"What the hell are you doing here?"

Scott grinned. "Well, you know how it is. The packing plant closed once we got into that trade war with Europe, and the Border Construction Corps were the only guys hiring. It's easy work. And promotion was fast." His hand made a desultory motion towards a silver T on his shoulder. "Same pay grade as a fucking colonel." He spat tobacco juice into the dust. "Of course, with the Emergency, most of it comes as Patriot Bonds. Only twenty cents real cash in the fucking dollar, just like all the other government workers, but you can just about live on it."

"I don't mean you, Jeff. What's your whole damned circus doing here?"

"Nothing personal, Hank. But the law says it has to go through. Course, it also says the Mexicans are going to pay for it"—he looked southward—"and I don't see our amigos standing there with their checkbooks. But I'm not the fucking collection agency. I'm just the construction boss."

"Jeff, I don't want that wall on my property."

"It's not going to go on your property, it's going along the boundary. You don't own the fucking boundary, now do you? Be reasonable." He spat again. "Besides, it'll save you a shitload of

maintenance. And I purely hate to put it like this, Hank, but I've got ten of these LAVs down there. All armed like this one. Don't make me do it the hard way." Scott looked genuinely pained.

"I'm not seeing any surveyors out ahead of the crews."

"All those bastards quit three weeks ago. But nobody gives a shit. So long as it goes from one side to the other, Washington's happy. They've got bigger problems. We're just winging the fucker, following the fences." He spat again.

Hank was silent. Finally he pointed over his right shoulder. "Well, there's where she goes. Up over the flat land there."

"You sure? Thought it was that line down to the south."

"No siree. *That* fence runs down into Mexico, down to the canyon."

"Canyon?" Scott scratched his head. "I don't remember any fucking canyon on the map."

"It's thirty, forty feet deep. Narrow cliffs, straight up and down. Not quite big enough to show on a map, but you'd never drive that herd of yours across it." He wondered whether he should add some rattlesnakes.

"Just as well I don't have to, then. Well, enjoy your new wall, Hank. "He spat once more, plodded back to the LAV and left in a cloud of dust.

"Thanks, Jeff." Hank wheeled his horse and rode away. Fifteen minutes later, he paused and looked back. Crews were already putting the first panels along his northern boundary. He grinned and headed back towards the farm, whistling "South Of The Border." Life would be better with a nice high wall between him and President Trump.

Arlene's Visitors

by Andrew Garvey

It was, or it should have been, an ordinary Saturday morning for Arlene Clay. After waking, clambering into a neat, fresh-smelling housecoat and heading downstairs, she made some coffee and waited for a knock at the door. It came at 8:47am – twelve minutes to spare in the delivery window she'd been promised via a cheerful email. Distractedly opening the door, her smile faltered when she saw the deliveryman was one of them. With the tiniest of sighs, she corrected her smile – for the sake of politeness and appearances and instructed him to leave the bags on the front porch. She tipped him more generously than she really wanted to with a couple of notes dropped into his outstretched hand. She watched him all the way back to his van and off her property, muttering a little and wondering how things had gone so wrong in America. She scanned the trees that bordered her neat property and, seeing nothing unusual, headed back inside.

Thirty minutes later, breathing a little heavier after a rigorous session of Chairobics interrupted only when she paused to listen for any unusual sounds, she made some more coffee but then left it, remembering she might need to restrict her fluid intake for at least a few hours yet. She busied herself, straightening things that were already straight and dusting things whose coating of dust was light enough that only a forensic examination would reveal the difference. Then Arlene headed upstairs, washed and dressed and, after gently creeping across the hall and listening for a brief moment, went back downstairs and waited for her friends to arrive.

They were due in twenty minutes or so and, to pass the time, she flipped through a few TV channels before settling on an Australian soap opera. She'd previously been a big fan of trashy, subtitled Mexican *telenovelas* but it had been a few years since, despite an Executive Order banning their import had been struck down by a succession of courts, every leading TV station had decided they were no longer something their audience needed to see and pulled them from the schedules anyway. Arlene knew she could still easily catch them online but that just felt wrong and besides, she'd started to quite enjoy these bright, sunshine-y folks from Down Under with their almost-American teeth, their blonde hair and their sentences that lilted upwards at the end, making everything seem like a question. True, their lives weren't as dramatic as those of the ever-passionate, two-seconds-from-a-furious-argument characters she'd seen so much of in *telenovela-land* but their cosy suburban lives and Christmas dinners on the beach had a very different charm to them.

The first knock at the door would be Derek. It always was. Today, in that sense at least, was no different. They exchanged hellos and hugs on the doorstep and she ushered him in. He took off his hat, a Fedora he'd taken to wearing a year or so earlier, and then took up his usual place in her second favourite armchair. As she rushed off to the kitchen, he noticed she seemed brighter this morning than she had at the exact same time a week ago, springier of step, more twinkly of eye. "Coffee, Derek?" she called to him.

"Sure, Arlene. Best get one in now, it'll be hot later. Gonna be a fine day today."

"Oh it most certainly is" she yelled back from the kitchen. He heard her clanking cups and spoons and whatever else in there and felt pleased to be here with her again. She called out again, "you hear from Derek Jr. or Derek-John this week?"

"Sure did. Got a Skype from both of 'em. They're doin' great up there."

Arlene returned to the living room, carrying Derek's coffee and placing the mug on the table in front of him. "They stayin' outta these damn riots and things?"

"They're not really riots, y' know. Protests, I guess is a better word."

"Hmmm, not that I've seen, honey. Anyways, glad they're doin' OK." Just then, another knock at the door distracted her. "Ah, that'll be Sally and Faith. Together as usual, huh?" They shared a smile and she hurried away to answer the door.

Thirty minutes later, after listening to Sally and Faith's weekly update on their slowly failing flower business (Arlene wondered, somewhat unkindly, whether they'd be doing a little better financially if they didn't choose to employ staff on a Saturday and come a-visiting her) and nodding in all the right places to their tales of incompetent suppliers, inconsiderate customers and staff whose work ethic fell well below real American standards, Arlene decided it was time to make her announcement. She took a long, deep breath and asked her three closest friends "can you guys keep a secret? I mean a real big secret?" She knew they could, of course. This little group had shared so many over the years they'd been meeting here at her house every Saturday morning and, before that when Derek's wife was alive at his and Penny's.

Sally was particularly intrigued and, as she often did, spoke for both herself and her (as Arlene liked to think of them) close, personal friend, Faith. "Go ahead," said Sally eagerly.

After one more huge, preparatory breath, Arlene blurted out her story.

"Well, it was last night and I was about to get ready for bed when I hear a knock at the door. A great, loud knockin' like something awful's happened and some folks are in desperate need of help. But y' know, I've seen those movies so I get my Taurus 38 ready and when I open up, there's this enormous linebacker of a man stood there dressed ever so smart in his suit and tie and he says to me, 'Ma'am are you by any chance Miss Arlene Clay', just as polite as I've ever been spoken to by a stranger. And when I says 'yes' he says to me, 'you have a very important visitor, Miss Clay' and I say 'oh, yeah, who's that?' and he steps aside and there *he* is..." Arlene stopped there, unable to get any more words past her massive grin. Sally and Faith exchanged glances full of piqued interest and, given Arlene's past history, some concern.

Derek spoke first. "Who was it, Arlene?"

"Well, I'm so pleased someone finally asked, Derek dear. It was the President of the United States. Mr POTUS himself, Mr Donald Trump. Can you believe that?"

They couldn't. And they didn't. But as her closest friends and decent, Christian men and women who'd supported each other through difficult times, they all wordlessly agreed to tread carefully in this particular minefield of Arlene's wish-fulfilment.

Again, Derek, who'd been so grateful for Arlene's friendship when his wife had died, broke the awkward silence. "The, uh, the President? I, erm, I thought he was up in Washington, stuck in bed with the 'flu."

"Oh well, that's a cover story. He's keepin' a low profile right now, what with all this, y' know, this impeachment nonsense and..." she trailed off, finding herself unable to speak of it, so terrible and unjust a situation it was.

Sally, the only one of the group to have challenged Arlene's Trump fandom in the last year or so, and even then with intensely practiced tact and subtlety that was rewarded with an order to 'get outta my Goddamn house if you wanna talk that kinda thing about *Him!*' asked Arlene for more details. "What happened then? Don't leave anything out, Arlene. You tell us all about it."

"Well, I will, least, as much as I can because I did say I wouldn't speak of this but you three bein' so close and all, I couldn't keep it from you, especially with him still bein' here..."

"Wait," Faith interrupted. "He's here now? Uh, where is he, then?"

Arlene looked flustered, reddening with embarrassment that to her, was because she'd foolishly said too much. To her friends she looked like a small child, their face be-crimsoned because they were about to be caught out in the process of a lie. "I wasn't supposed to say nothin' about that." She sighed deeply, muttered 'stupid Arlene' to herself and continued with her story. "Yeah, well, he's still here right now but anyway, last night, as I was saying, he steps out from behind that big, polite linebacker and he says to me, 'Miss Clay, it's a pleasure to meet you.' And then he shook me by the hand, a lovely, warm, firm handshake he has, let me tell you. I just, I think I babbled something about admirin' him so much and it must've been something like that because he says 'I know, Miss Clay, I know. In fact, that's why I'm here. You might be the last admirer I have left in America and I need to spend a little time with you. If you don't mind.' He was so, so polite and sweet and y' know, he looked just so sad that I wanted to give him a great, big hug but I didn't think that linebacker'd be too happy so I guess I just invited him in instead. So in he came and we talked a while and then when he said he was tired I made up the spare bedroom for him and he slept in there."

Another silence of a few too many heartbeats filled the room until, again, Sally spoke. "And he's here, up there now, in your spare room?"

"Oh no, he's in the bathroom now."

Derek almost snorted back, "the bathroom?"

Ignoring his tone, since she was sure Derek was simply surprised by such an amazing event on a Saturday morning, Arlene replied "yes, he's been in there most of the morning."

"Right, uh, is he having a bath or something?

"I'm not sure, Derek, but I haven't heard no running water so I guess he's sittin' there. He did tell me last night he does a lot

of his thinkin' in the bathroom these days. It's a habit he got into, what with it bein' one place he can get some peace and quiet from all that White House mess they got up there."

"Yeah," Derek agreed, "I guess it would be."

Arlene beamed back at him, pleased that he was beginning to understand and accept the situation. "He told me that's where he came up with the Wall. And the Asian embargo. The Newspapers and News Bill. And the Mid-Terms campaign."

'And that's where the Mid-Term campagin shoulda stayed' Faith thought, 'right in the toilet.' Instead, she gently asked Arlene "is that what he's doing in there now, thinking a way out of this whole mess?"

Arlene nodded, a halting bob of the head full of pride that the President had come to visit her but also of sorrow that he'd felt the need to.

"So, uh, if he, I mean, when he, uh, when he came and spoke to you, did he say why you? How were you...?" Derek began to ask.

"How was I chosen? Well, I asked him that. It was the second or third thing I said to him, in fact. 'Why me?' I said. 'And how?' And he said, 'Miss Clay' and I said, 'please, do call me Arlene' and he said he would – isn't that something, the President and me chattin' like old friends? - and he said 'I've got some very smart people who look at the social media and they tell me that no matter how tough things have gotten at times, or how many lies the media tell about me, there's one name that always comes up, one voice that always backs me up no matter what and that's Arlene Clay.' So from there, he got his Secret Service people to find out where I lived and he came by for a visit and to get the Hell outta Washington for a while." She slapped her armchair in triumph, so pleased to have been both chosen and found.

Faith frowned and, without thinking asked "isn't that a little creepy? Tailing you on social media and showing up at your house?"

Arlene stared coldly back at her, straightened herself in her chair and with quiet resolution answered "no, no it is not."

"OK," Faith said. "It's just, a little, I don't know. I'd be a little uncomfortable about it."

"Yeah, me too."

Arlene wasn't surprised that Sally would share the same thoughts as Faith since, she uncharitably thought, they sometimes seemed to share a brain as well as a bed. She chose not to answer and instead turned to Derek. "And do you have anything to say?"

"Uh, no. I guess, I'm a little in shock, really. This is quite the story. Uh, quite the thing to have, to happen to you. To someone you know."

"'A story, huh?'" Arlene stood up and announced primly, decisively "I'm going to get some snacks. If you'd all like some." All three of them nodded eagerly and with a variety of extravagant gestures reinforcing the point that they would, very much so.

Left in her neat, cosy living room, the three of them shared glances, raised eyebrows, mouthed 'what!!?' or 'I don't know!' at each other until Arlene returned with a plate stacked high with a selection of biscuits, cookies and miniature cakes. They all took one each and ate silently, taking great care not to drop any crumbs. Always the fastest eater, Derek destroyed his oat and cherry cookie and asked "so, what happens now? With the President, I mean."

"I'm not sure I follow…"

"How, uh, how long is he staying here?"

"He didn't really say and I'm not about to throw the President of the United States out of my house, now am I? Well, maybe I would've that Kenyan…" She laughed, a little nervously but beginning to relax in the knowledge none of her friends had outright called her 'crazy' or a 'liar', or suggested her old 'problems' might have returned. "So, I can't rightly say. His Secret Service guys, they're out there, watching the house by the way. I had to give them your licence plates and descriptions so they'd know to let you by. Oh and the grocery boy, he came by too, but I showed 'em the email confirmation. But I wouldn't like to be an unannounced guest while *He*'s here. Those young men mean business!" She laughed again, relaxing even more now that her secret was one she shared with her closest and dearest friends.

Sally demurely finished her cake and, as she dabbed at the imaginary remains around her mouth with a napkin, asked "can we meet him?"

Arlene gave a 'who knows?' gesture with both hands and stood up. "I'll go ask him." With that, she crossed the room and, closing the door carefully behind her, headed upstairs. All three of them listened to her heavy footfall on the wooden stairs and, when they felt she was far enough away, broke out into a babble of whispers, questions, hisses and wild speculations.

"Oh my God! What are we going to do?"

"I don't know!"

"What can we do? She's totally convinced."

"Yeah, she's really gone this time."

"I mean, that quilt she made with the Wall and all, that seemed a little, y' know, I don't want to be unkind but that was a little kooky. But I don't know what the Hell this is!"

"I guess she's had a rough time, defending him all the time with all this going on."

"Yeah, she's ALWAYS defending everything he does. He could come in here and shoot one of us and she'd find a way to blame us."

"It's been gettin' worse, I know, but, but this??!"

"Do we call someone? Y' know, like Dr, what was that guy? The one she saw last time?"

"Oh, I don't know, anyway. He left."

"What, he left town?"

"No, no, no. The country. Went back to, uh, Pakistan or wherever, y' know the Re-Registering of Foreign Professionals thing. He was caught up in that."

"God, what are we gonna do?"

"Stop asking us that and think of something, will you?"

"Hey, I'm not good with things like this, Derek."

"What things?"

"Y' know, crazy things! Crazy people."

"She's not crazy. She's confused. She's stressed and she's, I guess, fantasising about this, this whole thing."

"A cry for help?"

"Yeah, maybe, unconsciously, or something."

"I think you mean subconsciously."

"Subconsciously, unconsciously, whatever it is, Donald Trump is NOT sitting upstairs in her bathroom but she's tellin' us he is. That's a problem!"

"Yeah, and we should be helping her."

"Sshhh, she's coming back."

As Arlene re-entered the room, they quietened down, like guilty, hormonal adolescents almost caught fumbling with each other.

"So, uh, what did he say?" Sally asked.

Arlene sat down, steadying herself to deliver the bad news. "He said no. He's not really ready to face anyone. It's been a tough few weeks and he feels, he feels like he needs some alone time."

"Ah, I see." Sally tried to sound both disappointed and supportive at the same time.

Faith stepped in. "Have you been feeling OK lately, Arlene?"

In a movie, the camera would have rushed towards Arlene at this point, just as the actor playing her, and the comfortable chair she was sitting in, were thrust, on wheels, towards the camera. But this wasn't a movie. This was Arlene's home and the three people she trusted most in the whole world were refusing to believe in her, perhaps even mocking her. She felt the pressure rise in her head. Felt her heart beat faster. "I'm going to say this once, Faith. Sally. Derek. The President is upstairs in my bathroom. You can believe me, or you can not believe me but it does not change the fact of the matter that he's there. You know why he doesn't want to see you? D' you, huh?"

Derek tried to soothe her, remembering how kind and understanding she'd been to him when Penny passed away. "Tell us, Arlene. Go on."

Arlene hitched a little, taking in a heaving breath while at the same time trying to breathe outwards and speak – the action of a woman who was deeply upset. "It's his, uh, his appearance, you see. It's important to him that he looks good and his hair, it, uh, it's gone."

Derek's mouth, despite his brain not believing any of this was really happening, gaped at the thought of a hairless Trump. "It's... gone? What d'you mean? He was on TV last week, his speech against the impeachment, it was there, all, there..."

Arlene nodded, small, repetitive nods that said 'I know, I know, it was a shock to me too'. "It all fell out. Overnight. Before the Mid-Terms. He has all kinds of stylists and wig-makers and make-up people now. He can't be bald and he can't look gray, or get all saggy and old like that dirty Bill Clinton got. But those people, they're not with him right now and he looks so, so kinda old and just not Presidential anymore. It's just so sad to see him that way. He just can't see you like that and I think he'd be really, really upset if he even knew that you knew that but I want to be honest with my friends, y' know."

No one spoke for a while.

Eventually, Derek announced that "Derek-John said he might be Skyping today, before the football game. He's covering it for the college paper and he knows I like to hear the pre-game, er, the preview. I think I better go soon."

Exchanging rapid-fire glances, Sally and Faith both managed to settle on an excuse about checking on the flower shop, dropping in unannounced to see how things were going. Arlene listened to their gentle lies, feeling saddened at their reactions. But she accepted their words without argument.

She hugged Derek as he left. He lingered longer than usual, and grasped her hand before he went, squeezed it, hard, a gesture of reassurance and love. Sally hugged her first, then Faith, who also whispered "Arlene, honey, if you need anything, just call us." Arlene brushed her off with a cursory nod, a plastic smile and a robotic 'yes, I will.'

With a chorus of waves and 'take cares' they headed to their cars, scanning her property and the surrounding trees for the Secret Servicemen she'd claimed were hiding there, each of them feeling at least a little foolish for doing so. Seeing nothing, they got in their vehicles and drove carefully away, full of concern for their friend.

Arlene had barely watched them go before closing the door and then, breathing deeply, went to sit in her favourite armchair where, for a moment or two, she doubted her sanity.

Upstairs, in her bathroom, an elderly man sat on the toilet, where he'd been for several hours now. His pants around his ankles, his sock suspenders keeping his shins neatly covered in the finest of immediate footwear, he sat in wonder and despair and regret. He thought of his recent, secret divorce, of the children who'd finally had enough. Of the things he'd said and done and what he'd learned since taking the Presidential Oath. He felt like he was sagging almost to the point of collapse, like an old tarpaulin, dragged down by heavy rain and storms. And he wished he could re-do these past few years. His elbows on his knees, his bald, shiny head held in his little, manicured hands, Donald Trump gently wept.

Looking Good, America

by Katherine Tomlinson

Marissa groaned as the President's voice reverberated through the barracks as his daily wake-up message to the troops was broadcast through the loudspeaker built into the barracks wall. It wasn't that she minded the sound of his voice, but she'd been out drinking with friends the night before and she was feeling like a really low-energy person this morning, which meant she was letting the president down. She didn't want to let the president down. He had enough problems dealing with those sore losers in the other party who kept ranting about recounts and impeachment proceedings and generally keeping him from getting anything done. He'd won fair and square despite their best efforts to rig the system against him and everybody knew it, but that didn't stop the losers from being all pissy-pants about it. And they were constantly making him look bad by not being bi-partisan about anything. Marissa's mother didn't seem to think that was the problem. Marissa had had to explain it to her. "It's not his fault he's not getting anything

done, okay? The press hates him big league and it's just a disgrace." Her mother had not been convinced.

Marissa felt like she was wearing a big sign that said "loser" on it but no one seemed to notice she was being unusually quiet because everyone else was excited about the delivery of the new uniforms the First Lady had designed. They'd been shipped in from the president's own factory in China and the first batch would be phased in to replace the "Operational Camouflage Pattern" that had made its debut in January 2016.

The President's people had kept the design under wraps, but he had repeatedly assured the troops that they were going to love the improvements that had been made to the clothes they wore on a daily basis. "Believe me," he had said, "these are the best uniforms you've ever seen. People from other countries are going to be enlisting in the U.S. military so they can wear our uniforms. They're going to be so jealous."

He'd made the new uniforms sound like the coolest thing since M&M tested out their chili nut flavor and Marissa would totally have been excited if she hadn't felt like crap.

"I heard they're going to be the most beautiful uniforms ever," Stacy said as she stowed her gear, tossing back her glossy hair. "So beautiful you won't even believe it." She flashed her dimples as she added, "So beautiful" and poked Marissa in the ribs to get her to smile too.

But Marissa did not return the smile. She was in a grumpy mood because in addition to her hangover, there was blood flowing out of her wherever and she'd forgotten to buy Tylenol the last time she was at the PX. So she was bloated, and that meant her usually trim size 8 tummy was bulging and that meant she would have to squeeze herself into her uniform, which meant she'd have to skip breakfast because if she put so much as a boiled egg in her stomach, she'd have to pull out the size 10 skirt she kept for "those" times of the month.

She did not want to be trying on new clothes when she was having a "fat" day, especially since the new presidential guidelines for female troop fitness decreed that uniforms for women soldiers

could not be made in any size larger than a ten. She couldn't afford to push her luck by getting fat, especially since she'd barely qualified for service under the president's new 10-point scale for physical attractiveness. Coming in at a 7.5, she'd been on the bubble until she'd applied for and received a special waiver after promising to declare an MOS that would keep her out of the public eye and swearing she would not allow herself to be photographed in uniform.

The U.S. Army had a reputation to maintain after all. The President himself had declared that "the American military is the elite of the elite, with more good-looking people in it than a California casting call for a remake of *Twilight*."

Marissa did not want to let the President down. Because he knew what was important. Because he knew that there was something going on. He never really said *what* was going on, but that was okay with Marissa because she liked that he didn't want to bother everybody with details. He was a big-picture kind of guy and when he said, "There's something going on, believe me," she believed him.

There were red, white, and blue striped shopping bags on everyone's beds when they came back from chow. The bags bore the personal crest of the president, an ornate gold initial surrounded with an imperial laurel leaf wreath embossed in gold.

Classy, Marissa thought.

Inside the bag, the new uniforms were wrapped in red tissue paper and there was a note from the President himself printed on special stationery that had a portrait of his face in the place where the Presidential Seal usually went.

Marissa knew she would keep the note for the rest of her life in the box where she kept her special things. She loved the way he expressed himself. He used the word "I" a lot. She appreciated that. A lot of those elitist politicians only said, "we" when they were talking to other people about important American stuff. "Saying "we" instead of "I" when you were talking about fixing all the problems in the country just made it sound like they were talking about themselves and their imaginary playmates.

It always made Marissa giggle when people who thought they were important said, "We." As if they thought anyone but the president could get things done.

Marissa eagerly unfolded the note and read the president's personal message to her. *Dear American Soldier—I don't know you but I know you're probably a very nice person. Because I know, from personal experience, how tough it is to serve in the military, I wanted to do something that would raise your morale.*

For a minute Marissa was confused by the president's reference to his military service, but then she remembered that he had a Purple Heart. And people just didn't give you a Purple Heart because they liked you. *I know your commanding officers have ideas about what's needed to make the American military great again, but in consulting with myself—my primary consultant is myself because I know more than the generals do—I realized that morale is low because your uniforms are a disgrace. I mean seriously folks, what is going on with that olive drab? Nobody looks good in that color, not even the First Lady and she looks good in anything. And tuck your shirts in, for God's sake. You're a soldier. Dress like it.*

Marissa absently tucked in her shirt as she kept reading. *If you like the new uniforms, Tweet me @Potus and let me know. And let the First Lady know too (@Flotus) because I asked her for some input on the uniforms you girls are trying on right now. The cheetah print on the t-shirts? That's all her, and a tribute to my oldest son's many adventures in places where the liberals have not taken guns out of the hands of sportsmen. You like cheetahs right? I've heard that, that girls like animal prints. We're probably going to license the design worldwide.*

Marissa noted a small white tag on the clothes that said, "Made in China," and smiled to herself. It was just like their president to make the Chinese manufacture uniforms for the American Army. *I bet they actually paid him for the privilege*, she thought, smiling wider. *He's the best deal maker. A really excellent deal maker. Because he's so smart. He knows how to make the big deal.*

Marissa read the rest of the note which concluded with, *So, you're welcome* and the president's signature, which was a couple of up and down squiqqles and triangles. Marissa had always heard that the worse your handwriting was, the smarter you were.

Marissa had never had an IQ test but she bet if she had, the President would have had a better score than she did. Because she knew he had the best brain. He'd told everyone how smart he was during the election campaign and she had believed him. Her mother had not voted for him and had tried to talk Marissa out of doing it. "He's not that smart," her mother had insisted, "just rich and lucky."

When that argument had failed to land with Marissa—because who didn't want to hang with people who were rich and lucky?—her mother had tried another tack. "Don't you want to vote for the candidate who's going to do the most for women?" she'd asked.

Marissa had just smirked at that. Her mother and grandmother were always going on about equal pay for equal work and glass ceilings and a bunch of stuff that was so irrelevant to her and her generation. Before she'd enlisted, Marissa had worked at a McDonald's and there'd been way more girls than boys manning the fry-basket.

In Marissa's opinion, the reason that there'd never been a woman president wasn't because people didn't want a woman to be president—that was just silly. Look at all the countries that had had women presidents—England and Israel and Germany and Bangladesh and India and even Liberia, wherever that was. No, the reason that there'd never been a woman president in the United States was that there had never been a woman as qualified as a man to be president. And the candidate her mother and grandmother had voted for? Well, she belonged in prison, didn't she? The President had said so and he wouldn't have lied about something that important.

He knew something was going on and he wasn't afraid to say so. "I know it's not politically correct," he always said, "but I'm not saying anything that everybody isn't thinking."

That other candidate hadn't fooled her. There just something untrustworthy about her. Marissa had not been born yesterday; she'd been born in 1995, which made her a millennial and if there's one thing a millennial knew, it was how to spot a phony. She'd pointed that out to her mother one time, adding

that, "Mom, you just don't want to vote for him because he's been married three times and you've been bitter since dad took off with his secretary." That had made her mother cry, and Marissa felt a little bad about that for a while.

In the end, her mom hadn't voted for the president but for his opponent, but when the new anti-sedition laws had been put into place right after the Inauguration, she'd stopping talking about who she'd voted for altogether. I

In fact, Marissa thought with some satisfaction, her mom didn't talk about much of anything these days. And that was okay with Marissa because her mother was kind of a nag. She had really wanted Marissa to go to college, but even four years at a state college was out of their reach financially, so Marissa had joined the army after her first choice, the Marines, had turned her down because her breasts weren't big enough to qualify under the new presidential requirements.

"Marines lead the way honey," the recruiter had told her, patting her on the chest. "And with those little pimples, you're going to be at the back of the line," Marissa's mother had been outraged by the recruiter's behavior and had tried to get Marissa to file a sexual harassment complaint, but she'd ignored her mom's old school overreaction and simply gone looking for another place to enlist. That's what the president would have told her to do if she'd been his own daughter.

The new uniforms were a lovely sky blue, the best blue ever. Marissa approved. She thought olive drab was, well, drab. She thought it was dumb that uniforms had always come in such boring colors. Even nurses got to wear cool print scrubs now instead of the starchy white dresses they used to have to wear back in her grandma's day. She liked that the President had gone with such a bold color choice. One of his campaign promises had been to make the American military great again and he knew that the way to do that was to start by making them look great. And really, he was right, nobody really looked good in olive drab. Except maybe redheads. They could wear that color but pretty much everyone else ended up looking like a dead artichoke.

She pulled off her green t-shirt and picked up the new t-shirt, which had a cheetah print overlaid against the blue background. *I like this*, Marissa thought. *I could wear this to a club.*

"We're going to stand out like a sore thumb if we wear these on duty in Wall guard duty," Leila said, looking at the sky blue clothes dubiously, not making a move to change.

"I know," Stacy said. "It'll be really easy to tell that we're not Mexicans." She looked at Leila's dark hair and olive skin and added, "Well, most of us anyway." Leila gave her the finger and tugged the t-shirt over her head.

"Runs small," she said to no one in particular.

The new uniform jackets had stylish zippers instead of buttons running up the front.

That is so cool, Marissa thought. The new uniform tops kind of reminded her of the Starfleet uniforms from the first *Star Trek* show with the short skirts and all, but Starfleet uniforms hadn't had any zippers.

"Damn," Leila said, "My zipper just broke." She ripped the jacket off, "Made in China piece of crap."

Everyone glanced toward the loudspeaker in the wall. Everyone knew that it broadcast two ways.

Marissa looked at Leila. "Um, Leila… ."

"I'm just saying, this is a cheap-ass plastic zipper and it's broken. What's wrong with buttons? Buttons work."

"Who said that?" the President's voice suddenly boomed from the loudspeaker. "Who said that?"

The women all looked at each other and then everyone looked at Leila, activating the tiny cameras that were now standard issue and embedded in their dogtags. Their commanding officer had told them all the footage was routed to a room in the Pentagon, but Marissa had seen a video that showed it all was fed into the Oval Office.

He's looking at us right now! she thought, giddy at the idea. She had to throttle the impulse to wave.

"You, you with the big tits," the President said. "What's your name?"

"Leila," Leila said, and Marissa almost swooned. She'd do anything to have the President ask her what her name was.

"Layla? Like the Eric Clapton song?" the President asked. "I love that song. It's a beautiful song. I know Eric Clapton. He's a friend of mine. I know lots and lots of musicians. Beautiful people, musicians.

"I asked Clapton to play at the Inaugural Ball but he said he had a prior engagement doing a benefit for typhoon victims or something. Personally, I think anyone who can't get out of the way of a typhoon is a loser and needs to clean up his own mess, but you tell me."

Marissa smiled to herself. "You tell me," was one of the President's favorite things to say. She liked a leader who was open to learning new things from the people around him.

"You tell me Layla," the president repeated. "You know, you're a beautiful girl, you know that?"

Leila, who had definitely not voted for the president, smiled, relieved that he didn't seem to be mad at her. But her relief was short-lived.

"It's not Layla like the song," Marissa suddenly burst in, her jealousy getting the better of her. "It's pronounced the same but it's spelled L.E.I.L.A. It's an Arabic name."

All eyes in the barracks suddenly darted away from Leila as the president's voice exploded from the speaker. "Is that true Layla? Is that why you're bad-mouthing my border plans? Trying to undermine my authority at the wall? Is one of your terrorist family members planning to enter the country that way?"

Leila looked like a deer in the headlights. "No, I…"

"Get her out of here," the president snarled. "Get her out of here."

Marissa, who'd never really liked Leila very much, was the first to grab her and drag her toward the barracks door. Stacy was already on her phone, calling the MPs, who showed up in less than a minute and bundled the traitor into a truck.

As the truck drove away, the President said, "I have to go now girls, but keep up the good work." Marissa was bummed that he

hadn't asked her name, especially after she'd exposed Leila, but she smiled bravely, just in case someone's dogtag camera was on her.

"Keep up the good work," the president repeated, "especially you with the rack," he said, and everyone looked at Stacy, who had put on the new uniform jacket but only zipped it up midway so that her breasts bulged out of the V-neck.

Stacy had been born with nice breasts and female soldiers were encouraged to augment them with military medical benefits, so she had.

Not sure if the President could still see her or not, Stacy swept back her glossy hair and tossed it over her shoulder. Her hair was colored the same shade as the First Lady's, a delectable caramel brown. The move made her breasts bounce. The other women had to admit the uniform looked good on her. but then, Stacy was a U.S. Army soldier and that was her job, looking good for America.

Hoo-rah!

A Phone Call to the White House

by Pat Anne Sirs

"Hello. This the White House? Donald Trump's White House?

"Yeah. I know he doesn't live there. Not glamorous enough, I guess, after his spread in Trump Tower. Not to mention Mar-a-Lago, that place in Florida. Besides, who'd want to live in DC?

"But I don't need to reach The Donald, really. Can you connect me to the Trump Defense Fund?

"No, not the fund that's raising money to pay his legal expenses for the impeachment. Seems like they've talked about impeaching every president in the last few decades. Clinton actually was impeached, wasn't he? I forget what happened there. Why not Obama? For that matter, why not one of the Bushes? Or both of them? They've all done pretty questionable things. Who'd have thought they'd really go ahead and impeach Mr. Trump?

"What I'm looking for is the fund where he pays the legal fees for people who got arrested punching somebody out at one of his

rallies. He said he'd help the people who took care of protestors at his rallies.

"Yeah, the rallies before he was elected. Or even before the Republican convention. What a fiasco that almost was! But in the end, they did nominate him. They had to, really. He's what the people wanted.

"Back to the rallies, though. Mr. Trump said some people needed to be roughed up. I guess he didn't think his security guards should do that. He might be liable if they were his employees. Or maybe by their contract they couldn't do that. Who knows. But he did say he wanted protestors roughed up. And that he'd pay for the legal defense of anybody who did it for him. You can look it up on the internet.

"No, he *definitely* says the part about paying for the legal defense.

"Well, yes, it did happen a while ago. And I haven't heard much about it lately, either. Not since he got in office. He doesn't need that kind of support any more, does he?

"But, see, the guy I roughed up just died. The coroner says it was from a traumatic brain injury, from when I punched him. I think the coroner must be wrong—I just gave him a little tap, really. There must have been something else wrong with the guy. Weak heart, maybe. But he's been in the hospital since then, and he just died. So when he died, they changed the charges from assault to murder. And I got picked up again. They came right to my job and hauled me away. Right in front of my foreman and everybody. Not that I'm ashamed of what I did. But still, they could have waited until I got out of work.

"Then they raised my bail. To a couple million dollars. No way can I come up with the ten percent I'd need for a bail bondsman.

"So does the defense fund cover bail? 'Cause I could really use some help here. If I'm locked up much longer, I'm gonna lose my job. And if I lose my job, I can't keep up with my payments. And if I'm not making payments, I'll lose my house and my truck.

"Yes, of course I got arrested. Isn't that what I just told you? I'm calling from the county lockup. It's a madhouse in here. Can't you hear all the noise in the background? There's six guys waiting

to use the phone. This is the only chance I'm gonna get to use it for a while. And do you have any idea how much it costs to make these calls? It's not like your phone out on the street. You got to have money in your phone account—lots of money. These calls can cost fifty dollars, easy. Especially long distance to DC. And you can't just call any old number, you got to get your list approved before you got can call. Takes a while. Days, sometimes.

"Why'd they approve this number? I told them it was a call to get legal counsel. They have to let you make those calls. At first they said maybe it wouldn't count as a legal call, but then I explained to the lieutenant on duty and he just shrugged. He said, 'What the hell,' and signed off on the sheet.

"After all, it *is* a legal call, isn't it? Soon as I got arrested on the assault charge, I sent a letter to the Trump Defense Fund. Of course, it wasn't at the White House then—I sent it to some address in New York. That's where Trump's from, right? Trump Tower, I think I sent it.

"No, I haven't heard back yet, but a lot has happened since then. Mr. Trump's been elected president. He's had a lot of push-back. And he's got that impeachment thing going. He's been busy. I figure he probably has other people taking care of things like this, but he'd want to see the details before he approved sending out any money. He *is* careful with his money, right? Got to be, or he wouldn't have so much.

"It wasn't real urgent before this. I came up with the ten per-cent the bail bondsman needed for the assault charge, and told the public defender to just keep getting continuances until I heard from the defense fund.

"But the guy dying changed all that. Even if he did die from being punched, which I don't think for a minute is what happened, shouldn't it be manslaughter, not murder? I don't think they would have asked for as much bail on a manslaughter charge. I'm not likely to go around punching people anyplace else. Or up and take off and not appear in court when I'm supposed to. Not with my job and house and all that here. But the public defender doesn't think

it'd be worthwhile to ask for a bail reduction. He just says we'll have to wait until the next hearing or whatever.

"Meanwhile, I'm stuck in here. This is gonna set me way back. Maybe ruin my life. When do you think the Defense Fund is gonna get in touch? Do you know if they got lawyers who handle this kind of stuff, or do I have to find one myself and have them pay for it? Since all the states have different laws, I can see where they might want people to hire local lawyers. But a good criminal defense lawyer is expensive. And they all want to be paid up front.

"Well, if you've got no idea, could you transfer my call to somebody else? Maybe somebody in the defense fund office? I got to talk to somebody soon. See if they can arrange something about this bail.

"Hey, no. Don't hang up. Like I told you, I'm not gonna get another chance to call. Maybe you can have somebody else look up where to switch the call to while you talk to me a little. These guys, they all want to make their phone calls. They're not exactly the patient kind, if you know what I mean.

"There's got to be *some* kind of fund or account to cover this. Maybe they don't call it a fund. Maybe it's called a grant or something. They got a grants office? When I tried to get in touch with them, I just sent a regular letter. If there's some kind of special application to send in, I haven't done that yet. If you find one, could you mail it to me?

"No, there's no way I could get an e-mail. Or a fax. It'd have to be by regular mail. And could you have them write 'Legal Mail' on the outside? That way it'll have a much better chance of getting to me. Mail gets inspected here before it comes through. And sometimes it doesn't make it through to the person who's supposed to get it.

"Look, I know the 'incident,' as you call it, was a while ago. Before the election. But Mr. Trump made it clear that he wanted us guys in the trenches, so to speak, to deal with protestors for him. Rough people up, if necessary. Just go look at the videos of him at rallies. Listen to what he says.

"And the guy I hit. Well, nobody's gonna miss him. Nobody came forward to say they were his family. Or his friends. Or even his employer. I bet he didn't have any health insurance. So the hospital or the government or whoever had to pick up the tab. At least the only thing he's gonna cost them now is a burial. Or a cremation. That'd be better. And cheaper.

"Thing about that guy—I got to talk low here, you know. I got all these jailbirds behind me, and they take offense easy. A lot of them are the types of guy Mr. Trump was always talking about. Y'know, criminals.

"That guy I hit, I don't know what background he was, but he was one of those dark people. Certainly not a righteous Aryan type. Probably an illegal alien from Mexico or somewhere. And maybe not even Christian. Could have been from Iran. Even a terrorist. Them's the folks that're pulling America down all over the place. Like Mr. Trump says, we're better off without his kind. That's one of 'em they won't have to send back to where he came from!

"If we're gonna make America great again, we got to give the power back to the people who made American great in the first place. Look at the mish-mash we got in some of our elected offices! We need right-thinking men, men with experience, men who can work hard and make sacrifices to do what's right for this country.

"I'm not gonna play 'politically correct' here. I'm gonna tell it like it is. We need white men. For the first few hundred years in this country, white men were in control, and look where it got us. It's only been since these so-called minorities and women have been elected to office that things have fallen apart. They don't know how to run things. They shouldn't be put in positions where they can make important decisions. They just mess things up.

"As a country, we had the right idea just after World War II. Men out working in jobs made for men, and women taking care of the home and family. It worked fine. Everybody was happy. Whatever happened to that ideal?

"You haven't found any defense fund yet? They must have called it something different. Mr. Trump *promised*. I know quite a few people got involved in fights or whatever on his say-so. Do

153

you have any idea how many of them got lawyers and had Mr. Trump pay for them?

"No, that would have been lying if he didn't cough up the money. And Mr. Trump wouldn't have lied, would he? Not over something important like that. Not to his people. We're his people. We elected him.

"I mean, I know sometimes he exaggerates, and sometimes he makes stuff up, but when it comes to taking care of his people, I think he means what he says. He's a true American. Not like some of those politicians, who are so corrupt they probably don't even remember which side they're on today, and they'll be on the other side tomorrow.

"I have to admit that unless Mr. Trump gets involved, or send somebody, I really don't have a good feeling about this murder charge. I'm looking at a lot of time, you know?

"My public defender says I should look to cop a plea. Maybe get a reduced sentence or something. But that isn't what Mr. Trump wants, is it? That we should plead guilty.

"Or maybe it's all part of the process? I wish I could talk to someone who knows. Mr. Trump's the president. He can issue pardons, can't he? After a conviction?

"Is that the way it's supposed to work? Technically, I'm guilty, so I agree to a plea bargain? Maybe something like an Alford plea, where I don't admit guilt but say there's enough evidence to convict me. And then Mr. Trump moves in and issues a pardon? I hadn't heard about that happening, but they'd try to keep it kind of hush-hush, wouldn't they? That'll be okay, I guess.

"Or he might at least commute sentences. Didn't that crook Obama do that for a whole bunch of drug dealers? People who'd gone to prison for years, or even for life, because they sold drugs. Probably most of the people who he let go were blacks and other minorities, weren't they?

"Well, I'm a good old boy, a true-blooded American. Don't I deserve the same kind of consideration?

"'Course, it'd be better if I didn't get convicted in the first place. I mean, having that felony conviction puts a lot of restrictions on you. Harder to get a job. Can't buy a gun. Things like that.

"Look, I have to let the next person use the phone, or these guys are gonna start beating on me soon. Could you make sure those forms or applications or whatever get sent to me? No way can I use a typewriter or computer or anything to fill it out, but I'll write real clear on them. Or if you don't find the forms, at least have somebody write and tell me what's up. My ability to communicate is pretty limited here, you know.

"I'm sure it's just an oversight that I haven't heard from Mr. Trump or his staff yet. Folks like me, we're behind him one hundred per cent. He's just got to make sure we're in a position to support him.

"After all, how are we gonna make America great again if we're locked up?"

Lunch Special at the Trump National Golf Club

by Rachel Cassidy

Chef really makes *the* most delicious sandwiches, though I must say the meat is taking on a distinctly green aspect now.

I shouldn't complain—it was such a stroke of luck (pun intended!) to have been here at the clubhouse with a Cordon Bleu chef when the bombs dropped. That silly bitch Madison squealing about mushrooms and I'm thinking *oooh! velouté aux champignons!* and it turns out they were more of the cloud variety than a base for lightly herbed duxelles.

But even these poor souls with the horrid radiation burns need to eat, and now there's just the one hip roast left to be gobbled up before it completely turns. The meat is fall-apart tender, which does make one thankful for Chef's aversion to physical exertion.

It will be a hardship to have him completely gone, of course—but Madison is quite frankly pissing me off and these lovely Shun knives are simply the sharpest I've ever used, and so nicely balanced in the hand.

Pulling Strings in DC

by TL Snow

FADE IN:

EXT. A WASHINGTON DC FINE DINING RESTAU-
RANT - PRESENT DAY

Two middle-aged men sit opposite each other at an outside table on a terrace lined with cherry trees in full bloom. ROQUEFORT is dressed in a gray business suit right off the rack. MCKEAN wears a dark tailor-made suit of Italian wool, a conservative $200 silk tie and an American flag pin on his lapel. The White House dome appears in the distant background.

A WAITER, fit-looking, on the wrong side of thirty, pulls their chairs for them, hands out menus and disappears into the kitchen while tying the back of his apron around his white shirt and black pants.

ROQUEFORT

Where is everyone? It's so quiet in this joint I can hear my pacemaker misfiring. They say you can tell how good a restaurant is by the number of its customers. Why do you like it here, anyway?

MCKEAN

Don't worry. This place is usually full of household names. But we're not here to hobnob with the politicos. That's more your thing than mine.

McKean studies his menu.

MCKEAN (CONT'D)

Chef Bernard runs the kitchen. I recommend his squab.

ROQUEFORT

Pigeons and I have an understanding: they don't crap on my head and I don't eat them. And why are we here so early? Meeting at 11:30 in the morning is downright uncivilized.

MCKEAN

So, someone's finally teaching you civility, are they?

Roquefort acknowledges the barb with a sneer.

MCKEAN (CON'T)

My people are asking me to finalize our, er, arrangement, and I wanted privacy.

ROQUEFORT

Fine. Let's finish this meeting and shake hands over a couple of dirty martinis. Besides, what's there to discuss? I got Donald the nomination, didn't I?

MCKEAN

Yes, indeed you did. Congratulations; you managed to keep him on a leash long enough to eliminate the competition. Frankly, after he began that witch-hunt five years ago about Obama not being born in the U.S., I thought Donald's political career would go the way of the pharaohs.

ROQUEFORT

(sarcastically)

Hmm. Funny how we forgot to bring that up during our campaign.

MCKEAN

We can see how you've earned your reputation as a tier one campaign manager.

ROQUEFORT

What I do for a living is simple, McKean. All you need to do is understand your constituents. We live in an anxious era. The people are disenchanted with the establishment. They're sick of one-sided international trade agreements, terrorists taking over the world and our national debt growing out of control. As a friend once said to me, "A trillion here, a trillion there; after a while it starts adding up."

MCKEAN chuckles.

The waiter returns and snaps McKean's napkin in the air, laying it across his lap, then does the same for Roquefort.

MCKEAN

George, I'll have a half dozen oysters and the Salade Niçoise, please.

The waiter nods and jots down the order.

ROQUEFORT

A hamburger'll do me. And ketchup for the French fries.

The waiter again scribbles and leaves.

ROQUEFORT (CON'T)

As I was saying, when you have so many disenchanted people in the country, you need a leader who preaches massive reform.

MCKEAN

You mean anarchy, don't you?

ROQUEFORT

You say potatoes … . Gotta give it to Donald, though. He *is* an expert at the old scaremongering. If I hear him say one more time how the U.S. is going to hell, I swear even I'll start believing it.

MCKEAN

It amazes me what he gets away with. When he claimed that thousands of Muslims in New Jersey were filmed celebrating the 9/11 attacks, people just assumed it was true.

ROQUEFORT

Even Ben Carson announced he'd seen the video, but he had the good sense to withdraw his statement after he discovered the news clip was of Palestinians in Gaza, not Jersey.

MCKEAN

I'm just beginning to understand the credibility and cachet a TV celebrity can garner.

ROQUEFORT

Especially when he holds his index finger in the air that way and repeats his expressions over and over again. I taught Donald those annoying gestures, but the repetition is all his—just him being nervous. Still, somehow it seems to hypnotize his audiences.

MCKEAN

Like a cobra hypnotizes a mongoose. I must admit, when this whole thing started, I thought Cruz would be your biggest hurdle. I once heard him referred to as the next JFK.

ROQUEFORT

Humph! The kid couldn't take a punch. All Donald had to do to him was claim that the National Enquirer story stating Cruz's father worked with Lee Harvey Oswald had never been denied.

MCKEAN

And then after Bush and Rubio fell on their swords, Kasich rose to the surface.

ROQUEFORT

Like curds in sour milk. It only took a couple of smear ads to send him packing too. Donald claimed Kasich helped bring on the global financial crisis when he was a managing director of Lehman Brothers. The funny thing is Kasich's former boss later equated Donald's attack on Kasich to blaming a pilot for the failure of Trump Airlines.

MCKEAN

Well, it certainly sounds like everything in the first half of our agreement fell right into place for you. Well done, Mr. Roquefort.

ROQUEFORT

Thanks. The hardest part was convincing Donald to become a Republican. He's been a Democrat since 2001.

MCKEAN

But there's still the matter of fulfilling your contract. You've successfully eliminated his Republican competition, but you were also tasked with making sure Hillary wins the election. Given your resignation yesterday over this ugly Ukraine business, my associates

have certain concerns about you not being around to keep the brakes on Donald's momentum.

ROQUEFORT

You're not trying to diddle me outta my ten million bucks, are you? Her victory's practically a done deal. Haven't you been following the latest polls? Hillary's leading them all.

The waiter returns and whispers into McKean's ear. McKean nods and waves him away.

ROQUEFORT (CON'T)

You know, Corey tried to pressure me into making Donald seem more presidential, but I went through Donald's kids and took care of his butt. Then I convinced our camp to just let Donald be Donald. He's already shot himself in the foot more times than a liquored up cowboy with a hair trigger six-shooter. Why, he's alienated practically every demographic sector from the middle class to the blacks. How popular do you think he is in the mosques, after announcing he wants to stop all Muslim immigration?

MCKEAN

And I'm guessing he won't be very popular with the Hispanics either, after he asserted that Mexico sends all their murderers and rapists north of the border.

ROQUEFORT

Yeah, then he announces that he wants to have a wall built across our 2,000 mile southern perimeter—and get Mexico to pay for it, for Chrissake! I can't see them forking out $12 billion for no reason. Do you have any idea how large the Hispanic electorate is in this country?

MCKEAN

Over 25 million eligible voters, but only 32% of them make it to the polls.

ROQUEFORT

I see you know your stats, McKean. Even so, that's still a lot of votes to be throwing away.

MCKEAN

I almost choked when Donald claimed Judge Gonzalo Curiel ruled against him on two cases involving his defunct real estate university; said Curiel was biased because of his Hispanic heritage.

ROQUEFORT

And did you catch Donald's tweet last month after the terrorist attack on the Orlando nightclub?

McKean shakes his head.

ROQUEFORT (CONT'D)

How did it go? 'Appreciate the congrats for being right on radical Islamic terrorism."

MCKEAN

Yeah, Donald always did sound like a schoolyard bully saying, "I told you so." Sometimes I think he wields his prominence like he's afraid of losing it.

ROQUEFORT

Not to mention displaying a clear lack of sympathy for the victims and their families. And of course, there's also the perception of Donald being a misogynist. Did you know that more women will vote this November than men? Their votes have decided the last four presidential elections. Donald first started to come unstuck when he confronted that debate mediator, Megyn Kelly.

MCKEAN

And don't forget how he referred to Senator Warren as 'Pocahontas," because of her self-proclaimed, and unproven, Native American heritage.

ROQUEFORT

He's stopped doing that now. Said it was unfair to the memory of the real Pocahontas. Now he calls her 'Goofy.'

MCKEAN

That's almost as bad as 'Crooked Hillary.'

The two men share an uncomfortable laugh.

ROQUEFORT

So it's clear that Donald's quickly eroding his credibility with the entire public, quoting facts and figures that just aren't true, like how Obama plans to accept 200,000 Syrian refugees over the next two years; that he can shave $19 trillion off the national debt in 8

years; and that the country's real unemployment rate is 42%. His bullcrap will soon overshadow Hillary's Benghazi shortcoming and her potential email indictment.

MCKEAN

Just leave the email situation to us.

Roquefort nods.

ROQUEFORT

'The Donald' miscues every time he speaks in public these days. Cripes, his platform is anti-gun control and anti-abortion; not exactly the fashion of the day. And don't forget his camp's failure to distribute pledged funds to veteran charities. Who do you think delayed those checks? And what about me also convincing him not to submit his tax returns?

MCKEAN

Oh, I think you're right about your former candidate self-destructing, Mr. Roquefort. Even most Republicans consider Donald toxic and have been quietly trying to distance themselves from him. I can see the election headlines now, 'Hillary Trumps Donald.'

ROQUEFORT

Then how can you people possibly think I haven't finished the job? I put Donald's campaign in a complete nosedive. His recent gaffes are preventing a much-needed cash infusion. All the Daddy Warbucks out there are afraid to be discovered contributing to his campaign. He's become a real pariah.

A man's voice can be heard. (OS)

Sorry ladies. We're closed for a private function.

Roquefort twists around to peer down over the railing.

ROQUEFORT (CONT'D)

Hey, McKean, you've booked the whole joint for us, have you?

MCKEAN

As I said before, our meeting is way too important to be interrupted.

Roquefort acknowledges him with a nod.

ROQUEFORT

Hillary's team has already begun general election TV ads in eight swing states—versus precious few from the GOP. And his

camp's way behind in hiring field staff in the battleground states. And do you also realize that Donald's communications director role has only just been filled?

MCKEAN

It's my job to know. But I'm afraid you've now proven yourself to be a political liability to us. If you'd jump into bed with Ukraine's former regime, I'm pretty sure you wouldn't think twice about selling us out.

McKean snaps his fingers and the waiter comes out onto the terrace, handing him a small electronic instrument.

MCKEAN (CONT'D)

Mr. Roquefort, the scanner built into your chair has picked up something metallic. Hold him down, George.

The waiter walks behind Roquefort, yanking him backward by his tie and twisting his arm behind his back. He pulls Roquefort's other arm around and secures them both tightly with a pair of handcuffs.

McKean turns on the device and scans Roquefort'S body. He rips Roquefort's shirt open to reveal wires leading from a receiver to a miniature recorder clipped to his belt.

MCKEAN

Who was this meant for, the GOP? The CIA? The FBI?

ROQUEFORT

(nervously)

I just wanted some leverage, in case you tried to screw me out of my money. Seems my instincts were correct.

MCKEAN

My associates were right about you. You're nothing but an empty shell of a man with no scruples, no loyalties.

ROQUEFORT

When I'm working for a Democrat, I'm a loyal Democrat, and likewise for Republicans. Er, usually, that is.

MCKEAN

(louder)

I'm not talking about your damn job. And I sure as hell don't mean which party you sign up for.

ROQUEFORT

That's funny, coming from you, about as staunch a Democrat who ever lived.

MCKEAN

The Democrats? Is that who you think I work for?

ROQUEFORT

Either the Party or the government. I Googled you, but couldn't find a thing. And nobody's heard of you.

MCKEAN

How naïve, especially for a person who knows his way around the political arena. I thought you understood how this nation of ours works. My organization and I bear no allegiance to any party. When Americans are unhappy, we, shall we say, 'assist' the Democrats. After they blow out the budget, we get the Republicans elected to balance it again.

ROQUEFORT

So with Obamacare and our burgeoning national deficit, isn't it time for a Republican leader then?

MCKEAN

Usually, but who knows what hit our coffers would take if Donald were to cancel all our trade agreements, bolster our military presence and initiate ludicrous projects like building that border wall.

ROQUEFORT

Well, at least if the U.S. declares bankruptcy, Donald has plenty of experience in that area. So what is this secret society that likes to rig elections?

MCKEAN

Rig elections? You, of all people, shouldn't be throwing stones in that direction. My association's been working quietly in the background since we gave the British the boot.

ROQUEFORT

You don't look that old.

McKean smirks.

MCKEAN

We like to consider ourselves the true protectors of the constitution, anonymous but effective. Who do you think arranged Lincoln's assassination?

ROQUEFORT

Why would anyone kill off the greatest president who ever lived?

MCKEAN

From what I gathered, it had to be done. The South needed some revenge and closure. Believe me, if we hadn't let Johnny Reb save face, our country would never have healed.

ROQUEFORT

The only two words that pop into my mind right now are 'sick' and 'misguided.'

MCKEAN

It may seem that way to the uninformed, but if we'd given the Iraqis a couple of minor victories in Desert Storm, there probably wouldn't be an ISIS today.

ROQUEFORT

Okay, I'm going to add 'deranged' to my list of adjectives.

MCKEAN

And there've been numerous other times when we've changed the course of American history. Remember the Mormon leader, Joseph Smith? Well, we agitated the mob that murdered him.

ROQUEFORT

You guys sound to me like just a bunch of cutthroats.

MCKEAN

Sometimes drastic times call for drastic measures. Think about John Brown's anti-slavery movement, or pulling strings to get Lee Harvey Oswald back from Russia. I could go on and on.

ROQUEFORT

Look, these cuffs are cutting into my wrists. Can you just let me go? I've done right by you.

MCKEAN

This mission isn't just about rigging some damn presidential election; it's about saving the United States of America. The groundwork you've already laid will also translate into more Dem-

ocrats in Congress, restoring its balance. Hell, we might even be able to approve a budget on time, and get a law or two passed along the way.

ROQUEFORT

(sarcastically)

Glad I could help. But things aren't resolved between us yet. Even though Donald gave me the axe, I want my compensation, or I *will* go to the press.

McKean stands and sets his napkin on the table.

A red crosshair pattern appears on Roquefort's chest.

Roquefort looks down at it with a panicked face.

ROQUEFORT

You can't just shoot me.

MCKEAN

Maybe Hillary was right after all, about the need for better gun control in this country.

FADE OUT:

Success Story
by Robert S. Levinson

There was a line that stretched from the front door down the block and around the corner when Ernie opened for business that morning. He knew it would be that way all day, as usual, so there was no time to lose.

He'd handle the walk-ins, limit each customer to no more than fifteen minutes, while his wife, Gloria, dealt with all the calls that routinely flooded their phone line, always with the same question she'd answer the same way, explaining the waiting list was the best she could offer and warning all that did was secure a place in line for a face-to-face with her husband.

Ernie's first customer was a portly, white-haired gent in a silk suit and tie who paused to review the shop before plopping down in the chair across the desk from him, popping a fat cigar between his thick lips, and frisking himself for a pocket lighter. He lit up, sent a shaft of smoke into the air, and surveyed the office.

"Not much of a shop you have here," he said. "You want to know the truth, I expected something larger. Fancier. Decorated

in a manner that reflected the success you've been having, not to mention what it must have done for your bank balance."

"The missus and me, not the ones to take anything for granted. It's only by accident what happened for us, and—" He snapped his fingers—"our good fortune could all end tomorrow, the good Lord forbid." He crossed himself. "So, did you have something special in mind, sir?"

Ernie heard him out. "Nothing we can't handle, but I need to look at the property before I submit our bid."

"Not necessary," the gent said. "You say you can, that's good enough for me. And price is no object. Invoice me whatever you decide is a fair price once the job is done and you'll get paid promptly."

"I will need a down payment," Ernie said.

The gent pulled out his checkbook from inside his jacket. "Give me a number," he said.

———

The next several customers weren't in the market for anything Ernie hadn't done before, except for a blue haired old maid hugging a handsome little Corgi protectively, like a mother might hold onto a young child skirting the edge of a swimming pool. "You promise my precious Elizabeth will be safe and secure ever after?" she said.

"Every job, no matter how big or how small, comes with our exclusive guarantee of a hundred percent satisfaction or double your money returned, missus," he said, and leaned over the desk to gently stroke the Corgi, who responded with a soft, contented sound and a wagging tail that washed away the woman's concern.

"My Elizabeth likes you, so I like you, too," she said.

"And I like Elizabeth and you, but can it be I notice something that tells me Elizabeth is a male?"

The woman's seaweed green eyes ballooned and her voice dropped below sea level. "Please don't ever say that again in front of Elizabeth," she said. "She doesn't have to know."

———

Unhappy customers come with just about every retail outlet.

This one bucked the line and stormed into Ernie's place mid-afternoon, demanding satisfaction. It was not his money he wanted returned, he wanted the problem inspected and corrected, or else.

"Or else what? Tell me," Ernie said.

"You really don't want to know," the customer said, his complexion Technicolor red with anger.

"I really do, sir. Try me," he said.

Ernie slipped a hand off his lap into a desk drawer and extracted his .38 caliber revolver. He was leaving nothing to chance. This was one hulk of a guy in black leather pants, motorcycle boots, a bandana, and a t-shirt drenched in sweat that pictured the Grateful Dead and showed off mountains of muscles.

"I'll put it to you this way—get it done or you're a goner."

"Is that a threat, sir?"

"It ain't exactly a bedtime story."

Ernie glanced over to Gloria, who clearly was frightened by what she'd overheard. He was more concerned for her safety than his own. "Let's us make arrangements to meet at your place and start the ball rolling again," he said.

They settled on this time tomorrow.

———————

The day ended on a more satisfying note.

His final customer was a little boy who couldn't have been more than six or seven. He approached Ernie's desk hesitantly, clutching a mason jar filled almost to the brim with pennies and dimes, and stood staring at him, tongue-tied, struggling to get past silence, then a mumble, in an effort to explain what had brought him to the shop.

Ernie exhibited patience coaxing the words out of him.

He had come to buy an anniversary gift for his mother and father, he said, and proffered the mason jar as a show of sincerity. "I heard them talking about what they wanted and they even said your name," he said, "so I started saving up to surprise them. If it's not enough, I'll get you more in a few months, promise." He gave the Boy Scout salute. "Scout's honor."

"Aren't you too young to be a Boy Scout?"

"My brother is, and he showed me how. He's waiting outside. He took me here because I'm still too young for the subway and busses by myself, although I don't think so… So what do you say, Mr. Ernie? Can you?"

Ernie handed back the mason jar.

The boy took it reluctantly and seemed on the verge of tears, but only until Ernie broke out a smile and told him, "Congratulations. This your lucky day, young man."

"Huh?"

"My wife and me, we keep good track of things. You being our customer Number Five Hundred, that means you win the prize— all the work we doing for you is free for nothing." He called over to his wife, "Gloria, this fine young man, he the newest winner of our free prize that goes to Customer Number Five Hundred, so take down from him all the information we need to get the job going."

Gloria looked at him like he was nuts, although this wasn't the first time she'd seen him invent a good deed and put it in front of anything less. She waved the boy over.

Next morning, Ernie woke earlier than usual, showered, shaved twice (to do his best to diminish his five o'clock shadow), and dressed in the suit Gloria had set out for him, the one he saved for Sunday church services.

He arrived at the studios of World News Network an hour before he was scheduled to be interviewed by that pretty-looking Sally O'Malley at 7:30 on "Success Story." Better early than late was something he had trained himself to do over the years. It always impressed clients, most of whom were used to their hired labor showing up late and blaming it on traffic.

He didn't want to be late for Sally O'Malley.

After all, she's the one who had called inviting him to be on her show, to talk about his career. *Career*, she had called it. He'd always thought about it as work, his job, no more, no less. Calling it a *career* was like a promotion, It made him feel important for one of the only times in his life. He practiced on the drive over, inventing

questions he expected Sally O'Malley to ask and answering them as completely and honestly as possible.

―――――――

"You're early," said the production person who came out to greet him in the reception room. She was also blonde, but not as attractive as Sally O'Malley; with goose egg eyes that fluttered a mile a minute. Her identification badge was turned over, so he couldn't see her name, which she never mentioned.

"Makeup first," she said and led him off, assuring him on the way to the makeup room that Sally O'Malley wasn't being rude. "She never sees a guest before he's settled across from her on the set, right before she introduces him. She feels it lends itself to greater spontaneity and a superior interview, you know?"

"Of course, yes," Ernie said, hoping he sounded like he'd done these interviews hundreds of times before.

―――――――

Waiting to go on, they settled him in the green room and pointed him to the coffee and tea dispensers and a variety of breakfast goodies. He helped himself to a coffee and a sweet roll stuffed with strawberry jam and topped with vanilla icing. He was supposed to be dieting to lose twenty pounds, but allowed himself the sweet roll, then a chocolate covered doughnut, because he had rushed off without the usual breakfast of orange juice, oatmeal, and a handful of vitamin pills Gloria put together. He never asked what they were. They could have been poison pills for all he knew. Not really. That was a joke he and Gloria shared on a daily basis.

There was a couple settled across from him. He didn't know their names and speculated he had seen them before on Sally O'Malley's program, why they looked so familiar. They were making a meal of yogurt and fresh fruits when he wandered over, excused himself and asked if they knew why it was called a "green" room, given there was nothing green in the room.

"Good one," the man said and went back to his yogurt. "Very good, you a funny fellow," the woman said, also turning away from Ernie. Both spoke with the same thick accent he always attributed

to people from somewhere overseas in Europe. Maybe they also didn't know why it was a "green" room, but didn't want to let on. Sure, he decided, that was it.

The couple was escorted from the green room and interviewed first by Sally O'Malley, talked for what seemed forever about politics and some crisis or other of no interest to him. He was not politically minded, so he stepped away from the monitor and attacked the snack table a time or two before they came for him and sat him across from Sally O'Malley seconds before she welcomed her viewers back to "Success Story" and introduced Ernie, mispronouncing his name.

"So, Arnie," she said, "tell me and all my many viewers around the globe exactly how your well-deserved success came about."

"By accident, Miss O'Malley," he said, and launched a story he shared proudly, about how jobs were almost impossible to come by when he went searching for some kind of work, any kind that paid enough to keep a roof over his and Gloria's head and food on their dinner table. He was a jack of all trades, good with his hands, and didn't mind getting them dirty and calloused.

A week rolled into a second, then one more without success.

Not even close until—

Late one day, nightfall starting to invade the sky—

Waiting at a bus stop after another round of rejection—

He saw a Help Wanted sign posted in a storefront window across the boulevard.

The painted sign above the window advertised: WALLS. He had no idea what the store was about. He didn't care. He was ready to say whatever he had to, no matter how large the lie, to get hired. He ignored the stoplight and dodged traffic racing across the boulevard.

The shopkeeper was in the process of closing, drawing the iron security gate across the door. Ernie approached him on the run yelling:

I am good with these two hands, mister. Whatever is the job needs doing, I can get it done. Give me the chance, mister. If I don't work out to your

satisfaction after a week goes by, you don't have to pay me nothing and no hard feelings.

The man was somewhere in his late fifties, solidly built, and wearing proof of years at hard labor on a richly tanned and wrinkled face. He studied Ernie cautiously through clear blue eyes magnified by Coke bottle lenses and said: *What's your specialty, fella?*

Whatever you got need for, mister, but especially—pointing up to the storefront sign—*I do walls, like I see you do. I do them really fine.*

The man cracked a smile. *I'll tell you a secret, fella, only you gotta keep it to yourself.*

Sure, mister, that what you want, you got. I'm the best worker taking orders, you'll see.

The smile became a horse laugh. *Walls is my name, that's why it's up there. Jack Walls. I'm a general contractor, so I do more than walls, lots more.*

Ernie wasn't about to give up. *Me, too. You'll see. You take this chance with me, you won't ever be disappointed or sorry. I learn fast, faster than anybody else you ever hired.*

It took almost a minute for Ernie to pull back from the memory.

"I don't know exactly what Jack Walls saw in me, Miss O'Malley, but he hired me on the spot, told me to be back and ready to work first thing in the morning. You can only imagine how that night my Gloria and me, we celebrated our good fortune, for that is what it was. I did not disappoint Jack Walls in the sixteen years I worked for him. I learned from him to do everything he did, some things even better than him, he often said, like a proud poppa. No one was sadder than me when the cancer took his life. No one was more surprised or grateful to learn he had left the business to me. That was seven years ago and Gloria and me, we struggled to begin with, but business today is better than ever before."

"I understand customers are lined up around the block on an almost daily basis. What caused this astounding success, Arnie?"

"It was only last year. A limousine double-parks in front of our shop and a man gets out and comes inside, trailed by three other men I take for his assistants. He says: *I was attracted by your sign. You're a wall maker, you make walls, is that correct?*

"I explain how it's the name of the founder of the business, Jack Walls, and I keep it up in his memory, but, yes, walls are something we do, along with other kinds of work you would expect from a general contractor. We talk some more, maybe fifteen minutes, before he hires me to supervise construction for him of the great wall he has been of a mind to build for some time, the greatest wall ever built since the Great Wall of China.

"The very next day, the news is full of stories about how I'm the man in charge of getting the wall built for—well, I don't have to tell you who. That's what attracted business to our shop. The lines grew longer the closer we got to finishing the wall to great fanfare and acclaim, and it shows no sign of letting up, thank the good Lord and the man who made it all possible."

"You should-a been there and seen for yourself, Gloria."

Ernie was reliving the experience at the dinner table when the doorbell sounded, followed by heavy, unrelenting knocking. *Bang. Bang. Bang. Bang.* They weren't expecting company, so it had to be another one of those sales people constantly invading the neighborhood. He removed his napkin from his shirtfront, dropped it next to his salad plate, and headed off to send the sales person on his way.

He flipped on the porch light and opened the door the length of the chain lock, revealing four men similarly dressed in dark suits and highly polished Oxfords. The man in front, a six-footer with neatly trimmed hair, a thin mustache and a poker face, spoke before Ernie had a chance to shoo him and his friends off.

"Ernesto Rodriguez?" he said.

"Yeah, that's me, but I already got whatever you're selling, boys, so thank you anyways."

The man held up an identity card and badge, as did the three others. "Federal agents, Mr. Rodriguez. Please unchain the door and allow us in."

"Sure, no problem," Ernie said, undoing the chain and stepping back. "But tell me what this is all about. Maybe you got the wrong Ernesto Rodriguez and I'm not the one you look for?"

"Walls, that your business? You the Ernesto Rodriguez who had a hand in building the government's wall? Gave an interview on television this morning?"

"That's me, 'Success Story' with Sally O'Malley. So what's this all about anyway?"

"It's been determined that you're an illegal alien, Mr. Rodriguez. Undocumented, and we have the documents to prove it. We're here tonight to escort you out of our country."

"That's not right. You know how long I been here?"

"To the month."

"Nobody, not anybody, love this country more than me. I'm a patriot. I always pay my taxes."

"You'll need a jacket, Mr. Rodriguez."

"This can't be happening. You know who I built the wall for? Does he know what you're doing?"

"It's his executive order we're acting under, Mr. Rodriguez."

"What about Gloria, my wife?"

"Her, too... If there's anything special you want to pack, this would be a good time."

Ernie knew there was no use arguing. "I'm a good citizen, a patriot, and I do whatever it is my country needs me to do," he said, and called, "Gloria, can you please come on here now? There's something I got to tell you."

The Wall

by Warren Bull

"Do any of you pups feel lucky?" asked Secretary of Defense and Personal Fitness, Josey Callahan. He surveyed the room full of reporters with a look on his face that quieted the room. "Pussies," he mumbled under his breath. "Well do ya'?" The reporters said up straight in their chairs and put their hands in their laps.

A reporter in the back raised his hand.

"Well, Glenn Beck. I'm glad to see that someone besides Rosy O'Donnell still has some cojones. Welcome back. How was obscurity?"

"It was peaceful, Mr. Secretary." He stood.

"Didn't you say in an interview that you expected to end up in jail whichever of the candidates got elected?"

"I did, sir."

"You said something about the current administration and Fascism if I remember correctly."

Beck swallowed. "Yes sir."

"But you haven't landed there yet. So what do you want ask in the short time you have left as a free man?" Callahan picked up the podium in front of him, turned it sideways and raised it over his head. He lowered it to his chest and did a series of fifteen presses.

"It's about the wall, sir."

The secretary lifted the podium again and brought it down behind the back of his neck for the first of fifteen repetitions.

"You mean the construction process that Mexico started on its own the minute the election results were announced? The one that hasn't cost American taxpayers one red cent? Or were you talking about the well-behaved citizens of Mexico who lined up without squawking and crossed the border to the south by the thousands?" I mean the self-deportation that continues even as we speak."

"I suppose my question applies to both, Mr. Secretary."

"Secretary is such a wimpy term," said Callahan. "It sounds like I could be bleeding somewhere. I'm open to suggestions for a different word that isn't so girly. But nobody better suggest the word 'Fuehrer.'"

He lowered the podium to the floor.

"I wouldn't dream of it, sir. I have just one quick question. Now that Canada is also erecting barricades at it border, I have to wonder. Is the wall supposed to keep them out? Or is it supposed to keep us in?"

Callahan made a circle in the air with his finger. He pointed at Beck. Men wearing black body armor labored "Security" and carrying automatic weapons headed rapidly toward the standing man.

"Congratulations, Mr. Beck, on the accuracy of your prediction."

The Census Master

by Manuel Alex Moya

Life in the land of the free was great for everyone. We were always happy, well-fed and full of sunlight for all of our days. All our days except one of course. The day of the census!

The day of the census was a sheer reckoning. It was not a day, but a night. A night where we had to turn in all our papers to the Censusmaster who oversaw all on a hill. And one had to have all their papers in order, or else. Or else he'd have to deal with the Censusmaster himself and that was no piece of pie. Not even a mudpie.

You see there was this one fella who didn't get his papers in order. He was a real fool. He didn't understand the world yet. There he was enjoying the sunlight and the freedom, then all of a sudden, he took off his sunglasses, got up and rushed back to the room in his house, a room in every house where one must have enough space for storing all their life's census papers, and the man scrambled all the files around to grab all the papers he could, ran out and shoved the taped scramble in the hands of the collectors

who were walking out at night holding torches on one hand and a fist in the other. We never let our kids play out on that night.

So the man breathes a sigh of relief and goes back home to watch some TV. Survivor was on and he didn't want to miss that episode where that guy was voted off by some his crew, but some voted for him to stay only for political reasons. Well, I guess that's like every other episode.

Anyway, he sits down with his remote and a good beer. But when he lifts his right leg over his knee, what does he see? A paper. A paper is stuck to the sole of his shoe. Was it a *Paper* paper? He peeled it off and examined the words. Ohh my. Yes. Yes indeed. It most certainly was a paper. How could he have missed it, in fact? It was right there, and should have been in that jumble he just handed over some minutes ago. Well, he jumped up and raced out to reach the collectors, but they were already gone. Too late. It was too late for him.

Everyone knows, once they're gone, they're gone. They don't come back. Unless of course, one files an extension. But the deadline for that was long overdue. Now all he could do was wait. He turned off Survivor, but still drank his beer. After sitting in the dark drinking and thinking, drinking and blinking, he went out of his room and started to pack his suitcase. Threw in a few whites, and some tank tops. And then he just sat there on his bed with the suitcase next to him until he dozed off.

"Sebastian!"

"Sebastian!" the voice reached the ears of all, including Sebastian who had just now awoken. The Censusmaster didn't have to send down anyone to collect him, since the Censusmaster would simply keep on calling the name until the accused appeared before him. Nobody wanted to hear the constant name-calling interfering with their days of plush freedom, so either the accused went on his own or he would be forced to go by those who knew and loved him, which would be unbearable to endure. So Sebastian stood upright with his packed suitcase and embarked on the path toward the Censusmaster.

In the middle of the night, he hiked up the tallest hill in the land, while hearing his name shouted out from a distance, "Se-bas-ti-an! Se-bast-i-an!" over and over. In fact, the man had never been to the Censusmaster and wasn't entirely sure of the way. All he could do was follow the sound of his name being called out and the sight of the tower on the hill from afar. Finally, he fell to the entrance of the Censusmaster's chambers panting and out of breath.

"Sebastian?" he echoed from under a shadowy silhouette that darkened his long robes.

"Yes, it is I my Lord."

"Sebastian, there's something missing here," he shook the pile of crumpled papers. "You're missing a paper."

"Ah, yes my Lord. I believe so. I have the paper you need right here my Lord," he lifted it.

But just as he was about to set foot inside the palatial hall, the Censusmaster shouted, "Nah-ah-ah!"

You see, the Censusmaster valued punctuality. It was not the missing paper that was important, but the principle of turning it in on time. Everyone knew that, even Sebastian, but he thought he'd give it a try anyways.

He had me shipped off to an island with all the others that couldn't meet their deadlines and keep their papers in order. We couldn't mix with the rest of the orderly world. It was paradise.

The Emperor's New Wall

by Tamar Auber

"It was the best of times, it was the best of times..." That was how Sarah started each and every day in front of her mirror. Every day ended like this: "Let's keep America Great!"

Sarah was the chief editor of superlatives and censorship at the Bannon Times. It was an important post and she enjoyed it bigly. It also took a lot of her time, which is why she was buying her second cup of coffee at 4 am from a coffee truck guy named Jerry.

Jerry had once worked in the very same office as Sarah did now, the one on the fifth floor of the towering office building that had an unobstructed view of the ledge where the disgruntled line-up to sit, scream and plunge themselves into the sidewalk below.

When Jerry was the junior editor at a disgustingly fraudulent and now defunct New York newspaper, he bought his early morning coffee from a guy named Carlos. But after the Greatening, Carlos had suddenly and graciously accepted an invitation from the Relocation Office to go visit his grandmother in Juárez, a place he had never visited since he had arrived in America when he was just

three. Jerry, who by that time had been told his services were no longer needed spreading media lies, took Carlos' job and his truck.

Sarah envied Carlos. She had heard that down in Mexico they were lazy and probably still asleep right now. Jerry envied the disgruntled who at least had the courage and the $5 line fee to end their own lives.

"And what a great day it is!" Sarah said as Jerry handed her her extra large brew in a styrofoam cup with three sweeteners.

"Uh, huh, lovely day," Jerry mumbled back, making it clear he had no future in the superlative biz.

By the time Sarah had gone up the shiny new escalator and reached her desk at 4:11 am with her coffee in tow, there was already a stack of misinformation so high that she could barely see the giant 6-foot poster of President Trump on her wall behind her workspace. Still, she took time to read the message of the day. It was, as usual, a tweet from President Trump, a real man of the people, always up to help greet America's workers and remind them of their mission to work harder and make work more pleasurable seven days a week. Auber "Emperor's New Wall"

"Mexico will pay for the wall! #AmericasGR8." The tweet linked to an announcement.

"Holy YYYYYUUUUGGGE" Sarah exclaimed as she clicked it open.

For three years, Sarah had toiled behind the same editor's desk, righteously stopping those who did not believe in the Great Wall from confusing the public with their uninformed views and claims of implausibility. Now, today, it was happening. The first giant block of the wall was ready.

But it was even better than that. The very first piece of the wall would be displayed in Times Square just blocks away from her office. Already in the propaganda and censorship division, the chanting was beginning.

"Build the wall, build the wall!"

Sarah knew that the chant would soon be ringing, not only in her entire building or block, but the entire country made great by President Trump. She also knew she had to hurry. Beginning

before sunrise the speakers would start and then, just as the sun came up over Manhattan the marvelous wall, the huge feat of engineering that it was would appear before their very eyes. There was no time to waste.

"Jerry," Sarah shouted as she walked past his coffee truck. "It is happening, the Great Wall is happening."

Jerry merely nodded and handed a cup of coffee to the next man in his longer than usual line.

Sarah thought for sure Jerry must not have heard her, there was no way any real American like Jerry could not be excited about such a great thing, but she rushed on anyway, eager for the awesomeness she was about to behold.

It was just a short walk on the trash-strewn sidewalks and a few minutes later she found herself outside of Trump Studios, the former home of the very dishonest network morning show that was shuttered for telling lies. The sounds of electric guitars pounded from giant speakers and screamed through the plaza. At a distance she spied a huge platform covered in a big red, white and blue cloth and tried to imagine what mysterious showstopper was about to be revealed.

A small crowd had gathered, but Sarah knew there were more to come. This was huge. No one would want to miss this moment of triumph.

Then suddenly, the music stopped and the screens above the studio flickered. President Trump, back when he was still winning America's hearts, minds and votes, loomed large above them all.

"I will build a great wall — and nobody builds walls better than me, believe me —and I'll build them very inexpensively," he said. "I will build a great, great wall on our southern border, and I will make Mexico pay for that wall. Mark my words."

"Build the wall! Build the WALL!" Sarah screamed with the crowds and the screens flashed a montage of the most glorious moments of Trump's America so far.

Then the promised speakers took to the podium one by one, each telling them how they had seen the piece of the wall and it was magnificent.

"The most High ruleth in the kingdom of men, and giveth it to whomsoever he will, and setteth up over it the basest of men," one of President Trump's righteous band of campaign preachers shouted into a microphone, quoting his favorite bible verse. "We have been blessed, my friends. So many people have tried to tear us down, tell us it would never happen, but let me tell you brothers and sisters this is a special wall. In fact, it is so special, let me tell you, only the righteous among us can see this wall.... are you ready?"

"Show the wall, Show the WALL, SHOW THE WALL," the crowd chanted as a fervor worked its way through the crowd.

"Do you want to see the wall?" the preacher man called back.

"SHOW THE WALL!" the crowd roared.

The first glimmers of sunlight were bouncing off of the shiny fabric covering as it was slowly and theatrically hoisted into the air. Sarah strained to see the marvel of modern Trump engineering through the crowds. She could not make it out.

"I see it, I see it, It is amazing," a woman's voice rang out breaking the hush of the crowds.

"I see it too!" a man chimed in.

Sarah looked harder. She worried that perhaps she was not worthy to see the greatness of such a spectacular sight. Then, as frustrated welled in her eyes, a patch of silver slowly appeared, her first glimpse at the wall's glory.

"Make America Great, I see it too!" she screamed above the ecstatic jubilance that was overtaking the plaza. Unable to contain themselves, some were falling to the ground in fits of joys. Others danced and cheered. The chants of "That's the wall" were deafening.

The sun was coming up.

Then out of nowhere, a disgruntled ran in front of the crowd clutching a $5 bill. "It is all a lie! It is all a lie," he screamed. "There is nothing here!"

"Trump, Trump, Trump," the crowd replied, drowning the ne'er do well. Security quickly appeared and drug him out before anyone got a good look.

But the moment was lost. By the time Sarah turned back to the platform, the cover had been lowered. The wall was hidden once again.

On the way back to the office, Sarah looked for Jerry to tell him about the glorious moment she just witnessed and the ruiner who tried to take it all way.

Surprisingly, there was no line at his coffee truck. Then, she realized Jerry was not at his post at all.

"Closed.. Have a Great Day," someone had scrawled on a piece of cardboard that was stuck in the spot where he usually hung out to say hello.

She went back up the elevator thinking about how she would just have to drink the now cold cup of coffee she had left on her desk. She also wondered where Jerry, always reliable Jerry, might be.

Then, just as she was about to sit down at her desk to tackle the day's misinformation, she spotted her coffee guy outside her window in the long line of disgruntleds patiently waiting their turn on the ledge. She waved.

"I finally got $5," Jerry called out to her, waving back at her with the money clutched in his hand.

"What a great day it is!" she called back with a smile, "Let's keep America great!"

Trumped

by Ronald P. Wolff

"Welcome to Rudy Giuliana Middle School," Mrs. Roberts said. "Please stand and recite the Pledge of Allegiance." With a sigh of relief, she observed all forty of her eighth grade students slide out of the right side of their desks and put their hands over their hearts.

I pledge allegiance to the flag of the United States of America, the greatest country in the world, and to the republic for which it stands, one nation under God, indivisible, with liberty and justice for all.

She had sighed prematurely. Mario Hernandez, a thin child with black hair she had deliberately seated in the front row, had not spoken several key phrases. Should she pretend not to notice? No, that would probably not be wise. His transfer file had identified him as a troublemaker, and the sooner she confronted him the better. She would keep him after school and set him straight.

"We are going to have a great school year, believe me," Mrs. Roberts announced. "Some of you may know that we got a new

principal last year, and he has fixed everything. Trust me, everything has been fixed. Everything."

Mario's hand shot into the air. "What was it exactly that was broken?"

"I didn't call on you, Mario. I don't know how your school operated last year, but in this class you need to wait for permission to speak." Mrs. Roberts watched him lower his hand but saw the jet-black pupils in the center of his wide white eyes announce that the battle had just begun. She took two short breaths instead of the one deep one that would have been far more satisfying. "I've uploaded today's schedule to the school's website," she continued. "This morning we will focus on English. We will cover a lot of useful information. Believe me. A lot. No class in the United States of America has ever covered more information in a single morning. After lunch, we will study real estate."

Mario's hand went up again.

"Yes, Mario, what is it?"

"When are we going to study science?"

Jimmy glared at him. "Get this guy out of here, will you?" He was one year older than the others, held back the previous year on account of being one inch too short for the advanced class. Puberty had started to impact the size of his biceps, and his balls, but for reasons unknown he wasn't yet getting taller.

"What's 'science'?" Debbie whispered to Sally.

"I think we had it two years ago." Sally whispered back. "If I remember right, it was hard."

"Now, class, we need to be respectful." She winked at Jimmy. Then directing a sincere gaze at Mario, she answered his question. "We don't need to study science anymore. It's confusing. Scientists themselves couldn't always agree on what to believe. They are all being retrained as contractors, specializing in the design and construction of vertical barriers. Fortunately, our principal is an expert on everything. Everything. If we have a question, all we need to do is ask him. Believe me, he'll have the answer. The right answer. Every time. Without fail. Trust me."

"Damn straight," Jimmy said. "My dad says he's the greatest principal this school has ever had. And he got Mexico to pay the electric bill."

Mrs. Roberts glanced at the clock. "We need to focus. Our history lesson today covers the Bill of Rights, adopted on December 15, 1791. We'll start from the beginning. Debbie, will you please read the text of the Second Amendment?"

"I thought we were going to do English," Mario muttered, loud enough to cause a small commotion in the circle of students surrounding him.

"What's the disturbance there?" Mrs. Roberts asked, and all the other students starting chanting "USA! USA!"

"Nothing," Mario replied. "I just thought you said we were going to do English this morning."

"No, I never said that. I said we were going to learn a lot. And we are. A lot. Trust me." She turned her attention back to Debbie. "Now, sweetheart, do you have the text on your monitor?"

"Yes I do, Mrs. Roberts. Would you like me to read it?"

"Please, in a nice strong voice."

"The right of the people to bear arms shall not be infringed."

"Very good, Debbie. And would you tell the class what it means?"

"I'll tell you what it means," Jimmy interrupted, pulling a small, concealed handgun out of his boot. "It means I can carry this anywhere I want, and I can beat the crap out of anybody who says I can't." He fist-bumped the guy sitting next to him, a blonde with hair just beginning to grow on his forearms.

"That's a great segue to one of last year's most important Supreme Court decisions," Mrs. Roberts said. "In a five-to-four decision written by Justice Hannity, all restrictions on gun ownership for people over the age of ten were declared unconstitutional. 'Hunting is a great American tradition,' the Justice declared, 'and no red-blooded, flag-waving patriot should be denied the privilege of participating in that sport at an early age.' And he's right by the way. The principal said so. Those of you who were here last

year will remember the scholarly essay he distributed, attributing common sense, finally, to our unelected judges."

Mario raised his hand. Mrs. Roberts attempted to ignore it, but Mario stood up and waved it vigorously. "Mrs. Roberts, you said we were starting from the beginning. Then you asked Debbie to read the Second Amendment. Isn't there a First Amendment?"

"I wish you would stop quoting me out of context. But I'll answer your question anyway. There used to be a First Amendment. It was repealed last year."

"May I ask why?"

Jimmy threw a spit wad at Mario and mouthed "I'm gonna get you at lunch, you son of a bitch."

Mrs. Roberts took a step toward Jimmy and reproached him with a crooked grin on her face. "Now pay attention. Pay attention. We have to learn to tolerate people who are different than we are. They are all tremendous people. Just tremendous. I am proud to call some of them friends."

Jimmy winked at Mrs. Roberts and fist-bumped his friend again.

Mrs. Roberts returned her attention to Mario. "The First Amendment served its purpose for more than two centuries. People in those days didn't always respect everyone else. They didn't understand that it's okay for people to believe things that aren't true, to worship different Gods than genuine Americans do, to protest laws and social practices they mistakenly felt discriminated against them. Now all of our problems have been solved. There is no discrimination. Everyone has jobs. There is no crime. There are no drugs. Everybody can walk the streets without fear of being attacked. Why would we want our Constitution cluttered up with stuff that isn't needed anymore?"

Mario sat down. He started to say something, glanced at Jimmy, and decided to hold his tongue.

The four loudspeakers, one on each wall, emitted a short, obnoxious squeak. Then the principal's voice filled the classroom. "Good morning, fellow Americans, and welcome to another year of fantastic education at Giuliana Middle School. This will be the

best year you have ever had. I guarantee it. Believe me. The best. Ever. When you are ready to graduate and move on to Chris Christie High School, you will be very happy you attended this school. Bigly happy. By the way, they have great lunches there. Trust me.

"Now that we no longer have to meet those ridiculous national common core standards—just ridiculous, countries all over the world were laughing at us—I'm introducing a new feature into our curriculum. Every day I will focus an announcement on some aspect of your intellectual development. I'm calling it 'The Truth.' Today, foreign policy. 'Foreign,' by the way, just in case you haven't had that word in vocabulary yet, means 'un-American.' Forget that crap you hear about the Scandinavian countries being the happiest places on earth. Lies. Crooked lies. We all know that Disneyland is the happiest place on earth. So let's put that one to rest, okay?

"Now, some of you who still get news from any source other than Fox News—in violation of the President's new Executive Order, by the way, but that will be the subject of tomorrow's 'Truth'—may have heard that Canada wants the United States to pay for the wall they're building on their southern border. That is total crap. There's no way the United States is going to pay for that wall. Believe me. Not one red cent. Not going to happen. If any of you ever happen to meet a Canadian, you have my permission to beat the crap out of them. Okay? And the school district will pay your legal bills.

"I'm so happy about this next announcement. Since Russia liberated Estonia, Latvia, and Lithuania last year, more and more Americans are learning Russian. It is rapidly becoming the second most important language in the world. Beginning next semester, we are dropping Spanish from our curriculum and adding Russian. Every student will be required to study it. Unless you're a moron or something.

"That concludes today's 'Truth.' I know the rest of your day will be just as educational. Bigly educational. Trust me."

Mrs. Roberts looked at the clock. "Wasn't that inspirational, class? I know by comparison this will be boring, but we have time for one more lesson before lunch. We're going to study the

strategies and tactics of persuasive speech. This material will serve you well when you start looking for jobs after you graduate from high school.

"Since this is our first day together, I know you haven't had time to prepare in advance. So I have put together two arguments on climate change. One student will present each argument. Then members of the class will vote on which presentation was more persuasive and present reasons for their choices. Okay, who wants to participate?" Sally and Mario raised their hands. Mrs. Roberts sighed.

"Mario, why don't you go first? Just read the paper I give you, and I'll show the slides that illustrate the points you make."

Mario walked to the front of the room, stepping over the leg of the blonde guy who tried to trip him. "It's clear from incontrovertible scientific evidence that the activities of human beings are contributing to significant global warming," he read. "As evidence, I present the following: 1) the rate of increase in the level of the oceans is twice as great in the last century as it was in the previous century; 2) most of the increase in the Earth's surface temperature since 1880 has occurred since 1970, and ten of the warmest years since 1880 have occurred in the last 12 years; and 3) the acidity of surface ocean water has increased about 30 percent since the beginning of the Industrial Revolution. Since we all know that burning fossil fuels adds to the concentration of carbon dioxide in the atmosphere, resulting in greater absorption of the sun's energy and acidification of the oceans, human kind's activities in the past 150 years have clearly impacted our climate and are in danger of creating a world very different from the one our grandparents inhabited." He looked up from the paper. "Thank you for the photos and the graphs, Mrs. Roberts."

Scattered applause greeted Mario's retreat from the front of the class, and Sally walked to the front. Mrs. Roberts handed Sally her script.

"Climate change is a bunch of hooey," she read. "It's a figment of the imagination of liberals who want to destroy our way of life.

Don't believe it for a minute. Not for a minute." Raucous applause and whistles followed.

"Now, class, as I stated, this exercise was not really about climate change. It was a sample debate to illustrate a point. Which of these two presentations was more persuasive?"

The blonde jumped to his feet. "Mario's so-called scientific evidence is easily contradicted. But Sally presented no evidence, so she can't be contradicted. Therefore, Sally was more effective."

"Very good. Does anyone else want to express an opinion?

Jimmy raised his hand. "Sally was better."

"Would you like to say why you believe that?"

"No. And by your reasoning, my opinion will persuade more people if just stop right there. Sally was just better. Period. No defense or rationale is necessary or desirable."

"How many in the class agree?" Mrs. Roberts asked. Every hand went up except Mario's.

Mrs. Roberts took a large gold star from her desk drawer and handed it to Jimmy. "That was the perfect response, young man. Congratulations. And the rest of you, remember this the next time you try to win an argument. People don't like being confused by things they don't understand. Just tell them what to believe, and if you do it persistently enough, eventually they'll believe it, too." Mrs. Roberts looked at the clock. "Oh, where did the morning go? You may turn off your monitors and get ready for lunch."

When the bell signaled the end of lunch, the students of Giuliana Middle School lined up to return to the building. All those under five feet tall stood in front of door A. From five feet to five feet two inches, door B. And so on. Mrs. Roberts' class grouped in front of door E.

When they returned to the room, the students sat quietly. Even Jimmy and his blonde buddy kept their hands folded on top of their desks and their gazes toward the front of the room. Astounded by the speed with which the class came to order, Mrs. Roberts, with nine years of teaching experience, knew something was wrong. She glanced around and quickly discovered Mario with

his head down on his desk, turned to the side, his cheek covered by his right hand. She approached. "Mario, is everything all right?"

No answer.

Then she saw blood trickling onto the desk.

"Mario, you're hurt. What happened?"

No answer.

Mrs. Roberts lifted Mario's hand away from his cheek and laid it gently into his lap. His right eye was swollen. His lip was cut and bleeding. "What happened? Did you fall?"

"May I go to the office?"

"Yes, of course." She glanced around the room. "Jimmy, will you help Mario get to the office?"

"I'll be happy to help, Mrs. Roberts." Another fist bump.

"Hurry back, both of you. You don't want to miss out on how to become wealthy."

The school nurse put on rubber gloves and applied direct pressure to Mario's lip with a thick white bandage. She soothed an anesthetic ointment around his eyes and cheeks. "I should call your parents."

"No, please don't. May I just stay here the rest of the afternoon?"

"What happened?"

"I fell off the wall."

"Why were you on top of the wall?"

"You wouldn't understand."

The nurse inspected Mario's face more closely. "It seems like if you fell off the wall, you would probably turn your head one way or the other, and only one side of your face would have been bruised. If you landed straight on, then your nose would be cut, but it isn't. Since both of your eyes and cheeks are purple, I'm confused. What really happened, Mario?"

"You wouldn't understand."

The nurse removed the rubber gloves carefully and paged through Mario's file. "This is your first day here?"

"Yes, ma'am."

"And you attended school last year in Arizona?"

"Yes. I was born in Tucson. Third generation. My grandfather immigrated from Mexico."

"I see. Well, your lip might need a stitch or two, and I can't do that here. We need to get you to a doctor."

Mario's mother answered on the second ring, and the nurse explained that Mario had fallen off the wall and landed on his face. "What doctor do you go to?"

"Uh, well, we don't really have a doctor, not anymore." The nurse thought she heard sadness in a distant, resigned voice. "They repealed the Affordable Care Act last year, and it hasn't been replaced yet. Maybe you heard."

"Ah, yes, I'm aware. I really didn't think that would affect any real people."

"Yeah, unfortunately it does."

"Well, can you pick your son up? I'm doing the best I can, but his lip won't stop bleeding."

"I can't. I have to be at work in half an hour."

"If you don't mind my asking, where do you work?"

"A little café. I'm a server. Can't afford not to get my tips for the day. Besides, if I don't show up, I'll be fired."

"Well, what do you want me to do? Can his dad come get him?"

"He's doing construction, a hundred miles away."

Mario grabbed the phone, and the blood flowed more rapidly. "Mama, just tell her to send me home. I have an idea."

"Are you sure, Mijo?"

"Yes, I'm sure. I learned so much in school today."

"All right. I'll see you tonight."

The nurse put on another set of gloves and held a thick bandage against Mario's lip until it stopped bleeding. She tossed the red-stained cloth and the gloves into the hazardous materials waste container. She gave him another bandage and instructed him to walk home quietly, not to run, and to hold it up to his lip even though the bleeding might appear to stop.

Mario stopped at the door before he left. "This school is nothing like my last one," he said. The words were almost inaudible and muffled by the bandage.

"Everything is changing," the nurse replied. "All the schools in America are pretty much like this now."

"Thanks for your help. I appreciate it."

Mario's mother gasped when she saw his injuries later that night. "Mijo, what happened?"

"I don't want to talk about it."

"Well, tomorrow's my day off. I will go to the school with you and find out."

"I'm not going back."

She sat down on the edge of his bed. "But why, Mijo? If there's trouble, we can fix it. Please tell me what's going on."

"I'm not going back."

"But why? I can't help if you won't talk to me."

"I'm not going back. I don't need to give a reason. And I'm not transferring, either. I'm done here. Period. End of story. Never going back. Trust me."

Mario wasn't in class the next morning. During lunch, Mrs. Roberts asked the principal whether he knew anything about it. Oh yes, he replied, he had received a phone call from the mother earlier in the morning. The family had decided to move to Mexico. "Mario won't be coming back to school," he said. "Too bad. This is the greatest school in the history of this country. The greatest. Believe me."

As American as....

by Khomans Ens

After the door banged behind Sophie, Olivia split some kin-
dling and then swept the floors. By early afternoon, she grew
tired of the usual chores and pulled out her recipe book. Sophie
had it tougher than her—a long wintery drive to Minneapolis
then endless hours mopping hospital floors. Maybe Olivia could
make the day a bit easier for her...wife—yes, *wife*, dammit, no
matter what the Supreme Court said—by baking Sophie's favorite
dessert, an apple pie.

She sucked on her lip as she flipped pages. Gathering ingre-
dients, preparing them, baking—none of it was easy during this
fourth year of the Trump regime. Living here at their lakeside
cottage only made things harder, but the rioting in the city after
the Destabilization took hold had left her and Sophie no other
option.

One step at a time. She'd start with the crust. At least there
was plenty of flour. You couldn't give it away, not after Trump

had banned wheat exports to China, Japan, Africa, Philippines, Mexico, and South Korea. The price had dropped like a stone despite his claim that a free market would settle on the appropriate price per ton.

There was no butter or shortening, not after four years of climate-change caused drought. In his first year, Trump had given the finger to Trudeau seven times during water negotiations with Canada and that—as Sophie had exclaimed—had been that. There probably wasn't a dairy cow or soybean left in the sun-scorched Midwest. However, the semi-tame deer that Olivia had shot by the lake a week ago had rendered plenty of fat. She cut some into a mound of flour, then rolled out the crust.

Next up was apples. Damn! The fridge held only one wizened Granny Smith. "Dopey dum-dum," Olivia said, mocking her forgetfulness by using the latest Trumpism. Without migrant fruit pickers, all fruit had gotten too expensive to buy. She'd been lucky to get some windfalls from the neighbors before the snow came but they hadn't lasted as long as she'd hoped.

She closed the fridge door. Why was she even bothering? One pie wouldn't fix their problems. The rest of her and Sophie's lives were going to be spent at this subsistence level bullshit. And how about when Sophie couldn't find any more maintenance jobs? Cleaning floors didn't pay as much as when she'd been a university professor, but it was getting them by.

Olivia sighed. A cup of raspberry leaf tea might help her mood and the kettle was already warm. She'd have given several Trump Dollars, or even an old-fashioned single, for a cup of coffee, of course, but she hadn't tasted any since the Mexican Wall went up and, in solidarity, all of Latin America had imposed embargos on the U.S.

The empty pie shell continued to mock her as she drained her mug. All right, then! If her grandmother had gotten through the Depression, she could get through this. There must be something she could substitute for apples. Or, maybe she could use the crust for dinner and make a meat pie instead. Most of the deer meat had been salted and canned but some of the uglier bits of the

carcass were left—one testicle, part of the liver, a kidney, and the tongue. Not as good as the chitlins had been, and they were getting pretty gamey, but they would have to do.

She washed the offal carefully and placed it all on the chopping block, reflecting on what her life had become. No career once the kindergartens had been closed; unable to hold Sophie's hand in public without risking arrest; it was almost medieval. She took her frustrations out on the grisly bits, swinging the cleaver wildly, and then extended the filling with oatmeal and the last of the raisins.

Spices were another problem. The stores hadn't stocked cinnamon, mace, and cloves in months. Not since Trump had bombed Indonesia to pieces, thinking it was Indochina.

Oregano from the garden and some wild mint would have to do. She placed the top crust and trimmed the edges before loading wood into the cantankerous old woodstove.

The pie was just browning nicely when she heard their old pickup truck pull up outside. Sophie came in with a rush of cold air.

Oliva helped her with her heavy coat and gave her an ice pack for her aching back along with a quick hug, before pulling the pie from the oven. "I'm not sure dinner is fit for a dog", she said, wiping her hands on the threadbare towel.

"That's a medieval expression, you know." Sophie managed a small smile through her tiredness, ever the Middle Ages professor.

Olivia nodded and served up the pie, apologizing for the many necessary substitutions.

Sophie listened, then sputtered into her tea.

"Sophie? You don't have to eat it if you don't want to."

Sophie grinned. "What you just created, babe, is a medieval dish that the poorest of the peasants used to eat when they had nothing else."

"Well, we pretty much *are* peasants now, aren't we, living in the Trumpastrophe? But why are you looking so happy about it?"

"Because, Olivia mine, it tickled my funny bone. Ridiculously, hysterically, we are about to partake of something that orange-

haired clown in the White House would *never* consume in a million years—a little something called Humble Pie."

Olivia looked at the brown mess oozing out from the golden crust and then over at her lover's smiling face. She grinned in unison with Sophie, then began laughing until tears streamed down her face.

Buying Votes

by Don Noel

The revolution began with a *Washington Post* estimate that, collectively, presidential candidates and their backers spent $25 for each vote cast in 2016. A truck driver, Horace Smith, wrote the editor: "All that money to clutter my TV with attack ads? Just send us the money, please, and give us some peace! I'd sell my vote for $20."

Posted online, the letter went viral. A *HuffPost* blogger recalled an old movie whose television anchor urged viewers to shout out their windows, "I'm as mad as hell… not going to take this anymore!" Within the month, a half-million people had watched that *Network* scene on YouTube, and most had updated their Facebook profile pictures with selfies in open windows.

The *New York Times*, predictably, opposed the idea. "Tammany Hall Redux!" an editorial fulminated. "Ward heelers with cash in their pockets?"

Defenders included libertarians like Rand Paul, an influential Senate voice despite his presidential failure. "Scare tactics!" he

scoffed. "Americans have the right to use whatever criteria we want in casting votes. Nothing in the Constitution bars money."

When President Trump weighed in, the movement became invincible. "Hellbent Hillary set a new record for ugly television," he said. "I'm the most successful businessman in history, and I say it's time to apply ordinary business sense to elections."

Bills to let candidates offer cash incentives for votes were filed in Nevada and Iowa. Both proposed a trade-off: banning robocalls and all television, print and internet advertising. Within weeks, similar bills had been filed in Congress and in most states.

That got the American Civil Liberties Union's attention. "Buying votes may not be a civil liberties issue," a spokesman huffed, "but restricting speech would violate the First Amendment." Billionaires like George Soros and the Koch Brothers supported the free speech argument, but their support proved counterproductive: contributions to the ACLU plummeted.

Eager to avoid court tests, legislators gave their proposed laws titles like "limiting commercialization of electoral campaigns." There was precedent for curtailing commercial speech. The ACLU retreated.

The billionaires' intervention, meanwhile, had given politicians another rationale to champion the bills: "Don't let rich people buy elections." Incumbents and challengers assured voters that they hated negative advertising, had embraced it only in self-defense, and would welcome new restrictions.

Broadcast, cable and online networks' opposition was paid little heed; their clout was too diffuse to intimidate legislators. Respected economists across a wide spectrum predicted a boost for the national economy. "People will have extra money in their pockets," opined the Brookings Institution. "The airwaves will be freed up for goods-and-services ads at lower cost, stimulating buying." The consensus estimate was a two percent Gross Domestic Product boost .

Major hurdles remained: Candidates wouldn't pay voters without assurance they would "stay bought." Silicon Valley giants

volunteered, producing an eye-glazing twelve-page online contract. They knew most voters would jump down to click on "I Agree."

To assure that voters fulfilled their contracts, the cyberwizards established voting through candidates' websites; their algorithms would examine ballots for the sole purpose of recording votes and qualifying for payment, retaining no personal information. Money earned by voters would be deposited in their bank, Paypal or other accounts through a third-party website that would encrypt all information about which candidate authorized each payment.

Congress adopted new legislation in time for a pilot run in the next U.S. Senate elections. In deference to Citizens United, super-PACs could raise as much as they pleased, so long as all money was channeled to candidates and spent only by them. The identical Senate and House versions were co-sponsored by every member of each chamber.

The new system was tested to resounding public acclaim. All campaigning was barred until July 4, a hugely popular provision. Each candidate was then allowed to send a single monthly text message or e-mail to all voters, inviting them to request detailed information about views and platforms – and to submit bids for their votes. For the few then still without smartphones, tax preparers including H&R Block volunteered to serve as submission stations. Trucker Smith cast his vote that year at his public library.

Votes in tightly contested swing states were more valuable, so the system allowed competitive bidding. In a few hotly contested states, it appeared (the program permitted tracking aggregate amounts stripped of personal information) that most candidates accepted demands up to the $20 maximum established by the new law. In solidly Democratic or Republican states, surveys and polls indicated citizens had to promise their votes for less.

As soon as a candidate accepted a voter's bid and the online contract was signed, all further text, email or telephone messaging was barred. That provision alone prompted an avalanche of early decisions. Reminders to vote were allowed in the final week.

Letters to editors, Facebook comments, tweets and blog posts soon celebrated the summer's tranquility. A few complained that

television aired a flurry of ads for kitchen utensils, diet pills and similar low-cost merchandise usually seen only in post-Christmas weeks when advertising rates dropped. Most viewers preferred such ads to campaign rhetoric.

November turnout in Senate elections, held that year in twenty states, was a record-breaking 92 percent, even though all candidates spent less than in previous contests. The average contracts had been for $9.45 per vote in safe states, $19.21 in swing states.

As we all know, the new system has now been expanded to Presidential and Congressional races, as well as all state elections. Voters may demand as much as $25 for Presidential votes, no more than $5 in state legislative races. Most decide long before Labor Day, so are unbothered by campaigning until Election Week, although some spend the summer and fall in online dialogue with candidates, pressing their views on hot-button issues. With the airwaves, cyberspace and print swept clean of accusatory advertising to write about, news media focus on issues.

Trucker Smith, whose letter triggered the most sweeping change in American political history, is retired now, but proud of his role.

"Silence," he told the *Post*. "It's wonderful." He had bought a set of Ginsu knives with his latest election earnings.

The Impersonator

by Timothy O'Leary

Marcos nudged his Tesla around two tall panel trucks blocking the circular driveway, barely navigating the slim corridor into the garage between a bright yellow Hyundai he didn't recognize and his wife's Porsche. The caterers had arrived en masse to set-up the evening's festivities, and from the size of the army carting tables, cases of wine, massive silver bowls, and plates and utensils into his backyard, Marcos assumed the budget he'd established for the event had been ignored. But he wasn't surprised.

"Do you want the party to be average or out-of-this-world fucking fantastic?" his assistant Christina sarcastically queried in her charming English accent when he'd asked her and his wife to take charge of the affair. Christina had a fascinating way of manipulating language to make any idea she didn't originate sound ridiculous.

"C'mon Christina, you know Marcos only does fantastic," Marcos' wife Donna interjected on his behalf. "Honey, don't worry, we'll take care of it, and it will be the best fundraiser in the history of fundraisers."

"What's the price difference between average and fantastic?" he'd jokingly asked. "How about just great? I assume great is cheaper than fantastic?" But Marcos knew better than to negotiate. By turning the event over to Christina and Donna he'd be assured it would be top-notch, but at a price. He decided to grin and bear it, figuring there were worse investments than raising money to fight Parkinson's disease, and though he didn't like to admit it, he did want to impress the high-rollers that would be attending. It might be good for business.

He trailed a troupe of men hauling wooden folding chairs around the side of the house, where he discovered Christina and Donna perched on the elevated ledge of the hot tub, like generals controlling a battle from the bluff. Donna was holding a clipboard with diagrams scribbled across wide sheets of paper. "Tony, the champagne fountain needs to be moved back about six feet," she yelled at a man pushing a dolly balancing a dolphin-shaped contraption.

"Am I imagining things or was there a swimming pool there this morning?" Marcos asked, pointing across the lawn. Sheets of clear flooring covered the water.

"People won't be swimming tonight." Donna said, "This is an elegant soiree, not a Hugh Hefner affair. They'll want to dance. We'll turn on the pool lights, and the entire floor will glow a soft blue. It will be beautiful."

"And I assume that's the bandstand?" Marcos said, motioning at a large platform that had been installed at the back of the lot, where men on ladders were stringing floodlights. "Because we certainly couldn't just have a DJ, even though people love DJs," he said.

Christina leaned in, grabbed his arm and whispered into his ear. "Not a band, darling. An orchestra. A big one too. Twelve

pieces. With a singer who sounds just like Diana Krall. Hell, for what you're paying, it bloody-well should be Diana Krall."

"Wonderful," Marcos said. "Is the bar open yet, because I should begin drinking?"

"No, you have work to do before the cocktail hour officially begins. One of your impersonators has arrived. You need to brief all of them on what you want them to do tonight," Donna said. "You'll really get a kick out of this guy. I stuck him in the den."

It had been Marcos idea to sprinkle a few celebrity impersonators throughout the crowd. A year earlier they'd attended a function that featured a couple doing hilarious Sean Connery and Dolly Parton impressions, and it had been the hit of the evening. He'd hired three for tonight and planned to download funny details to each of them about guests they would roast.

"Great, is DeNiro here?"

"Nope, this guy is certainly not DeNiro," Christina said.

When Marcos walked into his den the man was standing near the window, holding a small Plexiglas display case to the light with both hands, examining the antique pistol inside.

"It's a Spanish Miguelet," Marcos said. "Circa 1780. Very rare. Are you interested in antique firearms?"

Startled, the man put the case down. "Firearms? Oh, you mean guns," he smiled. "Yeah, I love guns. Absolutely adore them. Used to own a lot of them. I kept an Uzi in the closet in my office. Years ago, I was sailing on Putin's yacht and we shot a Beluga whale with a 50 caliber sniper rifle from a quarter mile away. Unbelievable." The man moved closer and lowered his voice to reveal a secret. "One time on the way to dinner I was showing Regis Philbin the derringer I kept under the seat and accidentally blew the back window out of the limo. Scared the shit out of us. The driver thought we were drawing sniper fire." He chuckled. "I even tried to buy a tank. Thought it would be an interesting attraction at one of my golf courses. But of course, county regulators put the kibosh on that one. Hard to get anything done with all this government regulation," he said sadly.

Marcos laughed out loud. What an act! He could tell this guy was going to liven-up the party. "Yeah, what kind of government doesn't allow a guy to own a tank," he joked. "Thanks for coming," he said, walking towards the man and raising an arm to shake hands. "I'm Marcos Gallardo."

The man blanched at the site of the palm, as if he were being forced to touch infected meat, and slowly raised his own to deliver a quick, weak grasp. "Yeah, nice to meet you. Donald Trump."

"That's great," Marcos laughed. "I guess you guys stay in character the entire time?"

The man gave Marcos a quizzical look. "Wadda ya mean, stay in character?"

Marcos nodded, happy to go along with the act. "OK. Glad to have you here, Mr. Trump. I'm a big fan."

"Gallardo?" The man said, shaking his head in thought. "Italian?"

"Actually, Mexican," Marcos held up his arms in mock surrender. "My parents immigrated when I was three. Please don't deport me."

The man continued to look confused. "Wha... ? Oh, the Mexican stuff. Yeah, that was overblown. I actually love the Mexicans, and they love me. Just not the murderers and rapists, but who'd want those kind of guys for friends? Am I right? The press got it wrong, as usual." He scanned the room. "So you work here, or... " He shook his head waiting for Marcos to finish the thought.

"No, I don't work here." Marcos thought he might be taking the act a bit too far. "I own the place. I hired you."

"Oh," the man perked up. "Good for you. See what I mean? You're one of the good ones. Ever heard of Carlos Slim? One of the richest guys in the world. Mexican. He's a very close friend of mine. We need more of your kind in this country. That was always my point. You want America to be great? Just fill it with great people. Makes sense to me."

He moved towards the window. "Lovely place," he said, waving at the backyard. "Looks like you're going to have a hell

of a party. Glad to help out. Is that your wife?" He motioned at a heavyset Hispanic woman in a white uniform helping stock the bar. She was at least twenty-five years older than Marcos.

Marcos frowned, then decided to just roll with the gag. "No, *that's* my wife," he said, pointing at Donna.

"Wowee," the man said admiringly. "Look at her. Nice. You and I have similar taste in women. All legs and ass. I like that. She could be a model, and believe me, nobody knows models like I do. What nationality?"

Marcos smiled. This guy was playing Trump to the hilt. "American. She was raised in Santa Barbara, two hours from here."

"Really?" The man sounded surprised. "I would've guessed she was an import. She reminds me of Ivana when she was young. In any case, a really nice piece of ass." He cocked his head to look at Marcos. "Course, I bet you've had your share, a good-looking guy like you. You know, you resemble a friend of mine, Scott Baio. Remember him? He's Italian, probably why I thought you were too. But I think he played a Mexican. Chachi? That's Mexican, right? Italians and Mexicans. Both are swarthy. Easy to mix-up. Another friend of mine, Antonio Sabato, he's Italian, but a lot of people think he's Mexican. I used to say, hey Antonio, go clean my pool. You know, as a joke. He thought it was hilarious. Italians love me too. I used to tear it up with those guys. We'd go out on the town. They tended to draw the young bimbo types. The more sophisticated women, models and such, they'd be all over me. What a team we made. A three-man pussy patrol."

Marcos couldn't decide whether this guy was the world's greatest actor, or a complete moron, but he had to admit his resemblance to Trump was uncanny. He was the same height, albeit with the stoop of a man closing in on eighty. He wore his hair in thin bouffant, dyed the trademark pumpkin orange that somehow extended to his complexion. The suit, though a little threadbare and tight around the arms, was his standard charcoal gray with a red tie. If Marcos didn't know better, he would've guessed he really was Trump.

Nobody had really seen the Donald since his meltdown eight years earlier after losing the election in a landslide. The consensus was that he'd suffered a nervous breakdown, played out in his infamous rant for a few billion people to witness. He remembered Trump standing on the stage screaming, "Let the revolution begin, patriots. Storm the White House!" before falling to the floor and rolling into a fetal position.

Photos circulated a year later, when he was forced into bankruptcy, and sent to prison for eighteen months for tax fraud after his audit was finally completed. The repossessed properties rebranded, Trump Hotels now sported Hyatt logos and the golf courses were named for the new owner, Michael Bloomberg. Rosie O'Donnell had purchased the rights to the Trump brand for $3,000 at a bankruptcy auction and symbolically retired it by burning Trump clothing, diplomas, and menus from his restaurants in a bonfire held in Rockefeller Square and broadcast live on The Tonight Show. But the public's attention span was as fickle as a cat chasing a ball of yarn. Since he'd been released Trump had largely been erased from the public eye, his name morphed into a curious historic relic, the *Member's Only* jacket of politics. Every now and then he would be featured on sleazy "where are they now" banner ads, his face plastered between elderly cast members of The Brady Bunch, and photos of Steven Seagal and Burt Reynolds, the consensus being that he was either broke and living in seclusion, or had embezzled money and was ensconced in an island hideaway.

The man was examining photos covering a wall. "Beautiful family you have. Nothing more important than family. I hope to patch things up with my kids. I'm really sad I missed seeing Barron grow up the last few years, but after the divorce things were tough.Especially after Melania married that actor." The man bowed his head in sadness. "You know, Barron's eighteen now and off at college. Well, DeVry. I guess that's a college. Studying iPad repair. I think that's probably a tremendous field. Ivanka didn't take the jail thing too well. She won't speak to me. And when the oldest boys had to go out and get jobs it was somehow my

fault. But you know, I hear Don Jr.'s doing great. Enterprise Car Rental is a wonderful company. Families have disagreements.I'm sure it will all turn out."

He brightened up and pointed at diplomas behind the desk. "Well, well. Undergrad at UCLA, MBA from Stanford. Impressive. Those are pretty good schools. I'm a Wharton guy. I know some people call Stanford the Wharton of the West Coast. You should be proud."

Marcos decided he'd had enough of the Trump shtick. "OK," he said, motioning at a chair for the man to sit down. "Let's discuss a few of the guests. "I wanted to highlight a few of the big givers, provide a little background, and when they get here I'll point them out and you can kid them a bit. Pay extra attention to them. Maybe act like you know them. That might be funny." He pulled out several sheets of paper. "Our biggest donors are Allen and Beverly Lewin."

The man held up a hand in excitement. "Lewin? Jewish? Cause I gotta tell you, I do great with the Jews. Don't know if you're aware, but my daughter is technically part Palestine Indian. Married a great Jewish fella. You want to raise more money from the Jews, I'm your guy." Marcos was beginning to wonder if this was such a good idea. The man was beginning to seem imbalanced. "Actually, I don't think this crowd will find any of the racist bits funny, and don't worry about trying to raise money. I'll take care of that. Just go up to them, maybe say something like, "Hey Allen and Beverly, I haven't seen you in years. How's the dental supply business? That kind of thing. You know, just get a laugh. Tell a few of the people that they're fired. Harmless stuff, nothing too political."

The man looked baffled. "Racist?" He thought a second, then leaned-in as if a light bulb had illuminated in his carroty head. "OK, I see where you're going, but let me give you a better idea. What if I told you I could double whatever you planned to raise tonight? As I'm sure you've heard, I'm an absolutely fantastic salesman. I literally wrote the book on it. Many people say I'm the best that ever lived, and I'm confident I could get your guests

to give more. A lot more. Imagine if I could raise an additional million dollars tonight. Wouldn't that be something?"

Marcos nodded politely, anxious to move on. "Sure, that would be nice. But we've really got this handled... "

The man held up a hand to interrupt. "Think of it. I help you raise an additional million dollars, and my commission is only twenty per cent."

"No thanks," Marcos said firmly. "I really just want you to entertain people for a couple hours. Please, no fund raising, and we certainly don't pay commissions on donations. That would be unethical."

The man held up his hands in surrender. "Understood. Just trying to help. What about ten percent? Since it's for charity I'd be willing to do that. A good cause and all."

They turned when Christina gave a soft knock at the door and peaked in. "Marcos, just wanted to let you know that Robert DeNiro and Lady GaGa are waiting in the living room, and you also need to get dressed, as the guests will start arriving in less than an hour."

"Bobby's here?" the man said excitedly. "We go way back. New York and all."

"Just your fellow impersonators," Marcos said impatient-ly. "Listen, read through these guest bios, and Christina or I will point them out at the party. Make them laugh. That's all you need to do."

The man took the sheets. "Got it. Uh, if you don't mine, we might as well get the fee out of the way so you don't have to worry about it later tonight."

"Christina handles that. She'll pay you."

"Good enough," the man smiled. "This is going to be a tre-mendous night. Really tremendous. The best night you've ever had. Trust me."

Three hours later Marcos had to agree that it was shaping up to be a magical event. Donna and Christina had outdone themselves. The backyard had been transformed into an outdoor

Parisian nightclub. And from all the input he was receiving, the impersonators were also a big hit.

The woman playing Lady GaGa not only looked the part, but mounted the stage with the orchestra to perform a very passable version of Poker Face.

The Robert DeNiro impersonator, primarily channeling the actor from his *Goodfellas* period, added an edgy patina to the slightly conservative crowd. One of Marcos' biggest clients excitedly grabbed him while he was standing at the bar. "DeNiro was fabulous. I was talking to a friend of mine when he came up to me, looking pretty scary, and saying, *You talkin' to me? You talkin' to me?* It was great."

Even Trump's gruff persona seemed to be playing well with the crowd. Lowell Baker, the African American Chief of Oncology at UCLA Medical Center, had patted Marcos on the back while laughing. "The Trump guy is hilarious. He introduced himself, and when I told him what I do for a living he said, 'That's wonderful. You're a credit to your race. You're the kind of black guy I love. I needed more black guys like you when I was running for President.' He looks and talks just like Trump."

Marcos decided he could relax and enjoy the remainder of the night. By his third trip to the martini bar he was on a better plane, his trepidation for the evening floating away in a sea of goodwill and Stolichnaya vodka.

Then Christina, looking uncharacteristically frazzled, grabbed his arm and pulled him to a corner of the lawn. "Have you seen Trump anywhere?"

Marcos scanned the lawn, but saw no sign of the man. "Not for about a half hour or so. Last I saw he was talking to a group near the dessert table. He was cracking them up."

"Well, I can't find him," Christina said angrily, "and Marcos, I think I might have really screwed up."

Marcos couldn't recall every hearing Christina admit to a mistake. "Why? What's wrong?"

"I was in a rush at the beginning of the night, and he asked me to pay him, in cash. He told me he would collect for the entire group and take care of it for me."

"Cash? Why pay cash? Didn't you book him through a service?"

"No," Christina said. "I found him on Craigslist, and I agreed to cash. I don't even know his real name. He lined-up the other people. Said he had contacts, so I assumed he knew them. Told me they'd worked together. But DeNiro and Lady GaGa are ready to leave now, and asked for their money. They told me he found them on a Craigslist ad, and they'd never met him before tonight. He didn't pay them. I think he took off with all the money. Three thousand dollars."

"Jesus," Marcos said disgustedly. "OK, well, we need to pay them, and then we can figure out what to do tomorrow. We'll call the police."

"Marcos, it gets worse. Allen Lewin pulled me aside, and thanked me for the party. He said he had such a good time that when Trump hit him up for an additional donation he agreed to give another five thousand. He gave Trump his credit card to go inside and ring it up. That was an hour ago, and he asked me to get his credit card back, because he's ready to leave. Then a couple other guests told me the same thing. I think the Trump impersonator took off with several of the guest's credit cards."

"What?" Marcos began to shout, then quickly lowered his voice. "What are you talking about? You mean… ."

He was interrupted by Donna wrapping an arm around his waist. "Nice party, you two. The best we've ever had. Hey, have you seen Trump? The Standley's are ready to leave, and apparently he took their credit card for a donation. I didn't know you guys had the impersonators raising money too. That's brilliant."

Marcos looked at Christina with panic. "Check everywhere outside. I'll look in the house. Go talk to the valets and see if they saw him."

He rushed from room to room, finally ending up in the den, where he sensed something was wrong. Examining the credenza,

he realized that the antique pistol was gone. He frantically scanned the rest of the room for missing items, and that was when he saw the picture. An 8 by 10 photo had been inserted into one of the gold frames on the wall, covering a family photo taken a year earlier at the beach. Donald Trump, standing in front of a podium, wearing a red *Make America Great Again* cap stared back at him. It had been signed,

"TO MARCOS, ONE OF THE GOOD ONES. THANKS FOR A GREAT PARTY. DONALD J. TRUMP."

76 Trombones

by Anne-Marie Sutton

In all her years coordinating the Memorial Day Parade the mayor's secretary had never been so stressed as she was by having the responsibility to organize this new parade. Memos and directives flooded Connie Edwards' mailbox daily, and the arrival today of the large package containing The Official Guide to the Celebration of the Parade was the last straw.

Connie had organized Huddleston's annual Memorial Day Parade for the last fifteen years. It was a traditional event featuring the high school marching band, the Brownies andScouts, the DAR, the Women's Sewing Group and the Senior Men's Club. Each year the volunteers from Paws, the local animal rescue group, outdid themselves in dressing the shelter animals in patriotic finery.

At the head of the parade marched the color guard and the Grand Marshall, who was always an aging war veteran. Behind him - and three years ago they even had a *her*, a retired World War II WAC - marched the rest of the town's surviving war veterans dressed smartly in part or all of their original uniforms. Coming

next was always Mayor Weaver and the City Council followed by the town's police officers and firefighters.

But when Mayor Weaver called Connie into his office to tell her that she had to coordinate this new parade, his aide was very confused.

"We've never had a parade on Flag Day before," Connie had said. "On June 14 we always have a ceremony in front of Town Hall. Billy Silva over at the VFW post pulls it all together. Somebody gives a speech, there is the Pledge of Allegiance, we sing a few songs like *God Bless America*, and then the winner of the What The Flag Means To Me contest reads the winning essay. Why do we suddenly need a parade on Flag Day?"

"Because June 14's not going to be called Flag Day anymore."

"It's not?"

"No, June 14 is the president's birthday." Phil Weaver waved a sheet of paper. "And I have here a directive how it's to be celebrated in every city and town in the U.S.." The mayor stamped his hand on his desk for emphasis. "With a parade."

Connie hadn't voted for Donald Trump, a fact which only her cats knew, and she wasn't sure who the mayor had supported. Ever since Trump had taken office in January there had been a creeping awareness in the country that there was a new way of doing things. And now another new way of paying honor to the new president.

"I see," Connie began carefully. "Exactly how do you see this parade looking, your honor?"

The mayor waved his hand. "Oh, the usual way you do your stuff, Connie. No one can organize a parade like you." He laughed nervously. "I'm putting it all in your capable hands."

"But, your honor, I don't see how this birthday parade will be like the Memorial Day ones. Then we honor veterans. The whole point is to honor their sacrifices."

"The President is going to pick one parade to be the winner. Mrs. Weaver and I could get invited to the White House and spend the night in the Ben Carson Bedroom!"

Connie could see the mayor's blood pressure rising. Again, she tried to choose her words with care. "I understand, sir, but tell me exactly what is it we are supposed to do?"

"Really, Connie, you are not usually so obtuse. I said that we are honoring our President! What more do you need to know?"

"Nothing, sir."

"Good. I thought that's what you would say. Now I've sent in your name and email address to the government office coordinating the nationwide effort. You will receive all the information you need to follow the parade guidelines."

"Guidelines?"

"Yes," the mayor said, reading from the paper on his desk. "The Department of Honoring the President will issue guidelines which must be followed."

"Do you mean the White House?"

"No, it appears to be a new cabinet department set up under Chris Christie —" And here Mayor Weaver read from the sheet again. "– to honor and praise our new President for all his qualities, which are the best; and for his accomplishments, which are huge; and for his hands which are large."

Connie thought she didn't hear that last part correctly, but she decided not to ask for it to be repeated. Instead she nodded her head and left the room.

———

The first meeting of the President's Birthday Parade committee, chaired by Connie, wasn't going well. She had prepared an introduction to the parade and why it was being held which she hoped would tap into the community's love of a celebration. Marching bands, flags, songs. Connie had stressed that all would be included. What she had saved for the middle of the meeting were all the government's directives of what each parade must contain to be official.

And what the penalty for an unofficial parade would be, Connie didn't want to imagine.

"We've never had floats in a parade before," Jake Horner, the town historian, said. "I don't think we should start now. I say no floats."

Heads nodded around the table in support of Jake.

"I'm afraid we don't have a choice," Connie said. "Floats are part of the parade. I have here the list of all the must-haves, and then there are some free choices we can make if we want."

She read from the list in front of her. "We must have floats depicting the wall around Mexico, Hillary Clinton in jail, Trump University alumni, the six Steves from the campaign economic advisors committee, a putting green, and Don King." She stopped to take a breath, then continued.

"There should also be a Twitter float with someone dressed as the president tweeting on how great the parade is, several tall blond women who look like they could be Trump's fourth wife... a Fox News float." Connie paused. "Although I don't see why those last two couldn't be combined. I mean, it will be all blonds, right?"

"This is the craziest thing I've ever heard of," Tara MacKenzie complained. "I didn't even vote for Trump."

Everyone around the table shushed her. Tara looked alarmed.

"Oh," Connie said, determined to plow forward, "here's one I forgot. Real estate. There has to be a float with big gold buildings that all have Trump signs on them. That should be easy. I thought we could get Donny over at the hardware store to call in all the local builders to come up with something nice."

"Is there anything else?" Lizzie Freeman asked irritably. "I didn't vote for Trump either, and I'm proud of it."

Once again shushing sounds came from around the room.

"Listen, guys," Connie said. "I know this is the first time we've done anything like this, but let's take it as a challenge, OK? Remember we don't want to be losers." She smiled at the tentative faces around the table. "Good, you're all with me. Now who do we know in town who looks like Don King?"

Steve Latham from Public Works usually worked with Connie to coordinate the Memorial Day Parade, so she called him in to

help with the Trump parade. As soon as he sat down at her desk outside the mayor's office, she began.

"Steve, I was thinking that you could head up the Six Steves float. Could I count on you for that? You'll have to decorate it, of course. But nothing elaborate. Just some big bags with dollar signs on them to look like money bags. You could get some play money and the Steves could throw dollar bills to the crowd from the float. The kids will love it. Maybe get some beads as well. Like Mardi Gras."

"I had a feeling you were going to ask me to do this," Steve said glumly. "I guess I don't have a choice."

"No, you don't," Connie said firmly. "Although you do look a little like Vladimir Putin. I was thinking one of our free-choice floats could be The Dictators Trump Admires float. There's that new doctor in town who's Korean. He could appear as Kim Jong Un. I'm sure he would see it as a great advertisement for his practice. And the mayor's father-in-law looks a lot like Saddam Hussein."

"He's Italian," Steve pointed out.

"We'll get him an old khaki uniform and he'll look just fine."

"You're really into this, aren't you, Connie?"

"I have no choice. It's my patriotic duty."

"That doesn't sound like you."

"You should read these emails that I get every day. Do you know we're not allowed to wear any Make America Great Again merchandise anymore?"

"Why?"

"Because since Donald Trump has been President, America has become great."

"Wow."

"There was a new email this morning about the food booths allowed on the parade ground. By order of the President, every-thing we serve must be free, to be called a birthday gift from Donald Trump."

"What about our usual vendors? On Memorial Day people always sell ice cream, peanuts, lemonade, bottled water. They're going to be pretty pissed to be frozen out of a pay day."

"Well, there's an official list of food and beverages now. I asked the mayor to put a request into the Department of Honoring the President for reimbursement, but he got a letter from Secretary Christie that said we had to think of the expense as Huddleston's birthday gift for the President."

"So what do we *have* to have?"

"Trump water, for a start."

"They don't make Trump water anymore."

"A company in upstate New York has started bottling it. We have to buy what we need from them."

"A company?"

"Yeah, I read online that it's owned by Rudy Giuliani."

"That doesn't surprise me. They're making Trump wine again, and it's being bottled in California by Scott Baio. He bought Francis Ford Coppola's winery. I heard he made him an offer he couldn't refuse."

"Too bad for Francis, but I've got problems of my own."

"I'm sorry, Connie. You don't deserve this. What else can I help you with?"

Connie shuffled through papers. "Here's one a new one I'd like to get someone to take over for me. We've got to have a float of Trump Impersonators." She looked across her desk at Steve. "Interested?"

Steve shrugged. "I guess that couldn't be too hard. We'll put something in the paper, and people will show up dressed as Donald Trump, right?"

"Yeah, but bear in mind that this is the President of the United States they are impersonating. Everything about him has got to be very wonderful. Trump's got to look his best."

"I think I can handle that."

"And, we have to follow the directives to the letter." She withdrew a diagram from her folder and passed it to Steve. He studied it.

"What's this?"

"A diagram of the size of hands each impersonator needs to have to be eligible."

"These hands are huge."

"The meeting of the President's Birthday Parade committee will come to order," Connie said from the head of the table. "Let's go around the room and see what everybody has. Victor, why don't you begin."

"Well, I've been working on getting Trump University alumni. I couldn't find any in town, but there is a guy over in Weston who went bankrupt after giving all his money to take classes there. He said he'd appear for $500."

"We can't pay $500," Connie said.

"Oh, don't worry about it. The Mayor gave me a check."

"All right. Does this guy have a school sweatshirt he can wear?"

"No, but I figured I could get the sewing group to make one. I can't find any logo for the school, so I was thinking a little leprechaun standing by a pot of gold. A nice forest green color shirt with gold lettering."

"Terrific," Connie said making a check mark on her list. "They've got to figure the first year there will be some glitches. Next, Lizzie?"

"The putting green's no problem. I got the gals from the country club. It's all looking good. We thought we'd dress in Scottish kilts."

"Do women wear kilts?" Connie asked. "Oh, never mind." She made a second check and went to the next name on the list.

"Tara, I know you were less than enthusiastic about this assignment, but how are you coming with getting blonds for the Fox float and the Fourth Wife float?"

"I got a list from Gerri over at Hairway to Heaven, and she gave me the names of all the blonds in town. It's just been a matter of emailing them to see who's available that day."

"Now, wait a minute. How old are these women? They've got to be young."

"Oh, I don't know about ages," Tara answered. "Gerri just gave me her color list."

"Then you have to ask them. Nobody more than thirty-five."

"All right," Tara said with a frown. "If you say so."

"Thank you," Connie said, another check made. "This is all going so well. Can I just take a moment to say how much I appreciate everyone for your cooperation. You'll see how it will pay off in a great parade."

Jake Horner cleared his throat.

"Yes, Jake. What's your report?"

"Well, I took the jail float with Hillary Clinton. I can use one of Lizzie's blonds who are too old to marry Trump."

"That sounds fine," Connie agreed. "What will the float look like?"

"I went over to the historical society and got some stocks out of one of their exhibits. We'll put Hillary in stocks. She'll be wearing a Hester Prynne costume."

"Hester Prynne," Connie repeated. "You mean with a scarlet letter A?"

"Yes. Except the A will be gold of course."

"But what does the A stand for?"

"Adulterer's wife."

Connie opened her mouth to speak, but decided against it.

"I've got great news on the wall float. It's already built. My kids and I did it."

"Good, Gary," Connie said turning to the voice coming from her left. "You've made a float with Mexico and a wall around it to keep people inside the wall."

"Mexico? I thought you said New Mexico."

"You built a wall around New Mexico?"

"Yeah, I've got a big New Mexico border sign and everything. My wife and my four kids are playing New Mexicans."

"You do know that New Mexico is a state, don't you, Gary? It's next to Arizona."

"It isn't the same as regular Mexico? Like a newer part of it?"

That night in bed with her cats, Connie ate an entire pint of Ben and Jerry's Chunky Monkey ice cream. After she ate out all the fudge chunks and nuts from the container, she alternated letting Pickles and Skittles lick the ice cream. It always amazed her that they had a taste for bananas.

That afternoon she had listened to the presentations for the food. Buying the Trump water had exhausted the parade's budget. She was happy she didn't have to buy Trump wine. No telling what that would cost a bottle. And she could only imagine how much wine the townspeople of Huddleston could consume.

A meat company had offered to supply Trump-branded fried turkey legs, the letters of his name stamped onto each leg's skin. Connie nodded and ordered them. Trump pizza was a no-brainer. The topping was chunks of Kentucky Fried chicken.

She had also given the go-ahead to suppliers of Trump French fries, Trump taco bowls and Trump cotton candy colored orange. It had been a long day.

Connie rubbed Skittles's ears and wiped off some wet Chunky Monkey droplets from Pickles' whiskers.

"You guys don't know how lucky you are that you don't have to celebrate President Trump's birthday."

The week before the parade was a busy one. Connie decided to review the progress of the floats being constructed

She gave a reluctant OK to the five blond forty something women chosen to be on the Fox float after Steve argued *some of those women on Fox are fifty if they are a day*. Around the back of the news set were to be three younger-looking women in bathing suits wearing beauty contest sashes which read the 4th, 5th, and 6th Mrs. Trump.

Joe Dyson, the editor of the newspaper, was an African-American, and he had agreed to teasing his hair into a Don King style to portray the boxing promoter on the condition that there would be no selfies taken. Connie assured him that was fine as long as he kept smiling.

One of the skinheads who hung around the downtown convenience store, wearing his own fatigues and boots, made a perfect Vladimir Putin. He stood proudly side by side with Dr. Park and Vince Grimaldi.

Maddie Horner, Jake's teenage granddaughter, and some of her friends had made the gold Twitter float. She became upset when Connie told her she couldn't portray President Trump because she was a girl.

"Why don't you play the First Lady?" Connie suggested. "You can get your hair straightened over at Hairway to Heaven and have some highlights put in."

"Who's going to pay?" Maddie asked narrowing her eyes. "That costs a lot."

"Tell Gerri to bill the mayor's wife. I happen to know she has an account there."

There was only one decision left to make.

From the beginning of her assignment to organize the President's Birthday Parade, Connie had anguished over who was the right person to serve as Grand Marshall. She had made lists of names and poured over them, crossing each one out in turn. It was important that she got this right, someone who symbolized all the qualities everyone recognized in the country's new leader.

Her selection was a long time in coming, but when she finally made it, the former major league pitcher turned bankrupt entrepreneur, who was fired as a baseball analyst from ESPN for inappropriate tweets on Twitter about transgender people, couldn't have been more eager to accept Connie's invitation.

Curt Schilling jumped at the chance to be the Grand Marshall of Huddleston's inaugural President Trump Birthday Parade.

Connie was pleased with her choice. After all, wasn't this was the man who in 2010 had burned through $75 million in taxpayer money while developing 38 Studios, a video-game company which he promised would be the *greatest* in the world?

Didn't he default on guaranteed loans from the State of Rhode Island? Wasn't he the man whose lawsuits were still in the news?

And, most Trump-like of all, wasn't this was the man who had stopped direct depositing his 38 Studios employees' pay checks while he let them continue to come to work, not bothering to tell them that he didn't have any money to pay their salaries?

His presence would make Huddleston's parade very great.

Curt Schilling's selection as Grand Marshall was perfect for a parade celebrating the birthday of the man elected president by the half-witted voters of the United States of America in 2016.

The mayor might just get to make that trip to Washington.

The Divine & Infernal Top-Secret Mission to Stop the False Apocalypse

by Joshua James Jordan

The bureaucracies of the afterlife pale in comparison to the US Federal Government but still impress in both size and torpidity. Sitting in her office at the Bureau of Apocalyptic Planning, an Angel of the Year award, circa 205 BC, hanging on the wall next to a picture of her shaking hands with Mother Mary, Veronica combed through the white feathers of her wings with care while watching the 2016 election news for the Presidential race of the United States of America.

She laughed to herself and shook her head slowly. Those guys down in Hell were well ahead of the agreed upon timeline, when the plans of Heaven and Hell would converge into one mighty doomsday. She would have to move up the schedule of the Almighty in response but she had to give them a hand for their initiative. Angels had stereotyped demons as these lazy

good-for-nothings but here they had put their pieces on the board in advance. Well done (also how demons liked their flesh).

After Election Day, when a certain candidate won (here's a hint, it rhymes with Trump), Veronica called down to Hell's Center for the Strategic Annihilation of Mankind to congratulate her old friend Jason on a job well done.

"What do you mean?" he asked. "You mean, he's not one of yours?"

"No, he's not one of ours," Veronica said. "Have you seen that thing on his head?" She shifted the phone onto the other ear to raise a hand above her head and wiggle her fingers. "I thought that he was hiding horns underneath."

"We thought that tan was a dead giveaway for an angel. You guys all have that orange thing going on and the wrong color around the eyes, like a radioactive raccoon or something," Jason said.

Veronica looked at herself in the mirror hanging on the wall across from her desk. She did look like that. It was from all that ambient light in heaven, baking them from every direction, and wearing sunglasses all the time.

"Alright, Jason. Meet me in Limbo. I'm worried someone is going to hear this conversation." Veronica hung up the phone, opened her window, and jumped out with more certainty than a stock broker on Black Monday. She plummeted hundreds of feet before spreading her wings and catching the breeze of heaven, swooping up just in time before hitting the ground.

She generated a rush of air that rustled up the papers of St. James' latest detective novel he had been working on. "God damn, angels," he said, gathered up the hundreds of pages scattered around his bench, and then got back to penning his work with an ink well.

The elevator to Limbo had a single guard that snoozed while standing, his flaming sword drooped dangerously close to his own leg. "Great job," Veronica said, patting him on the back. Startled, the angel flailed, the flaming sword catching his robe on fire.

There were three buttons: H, L, and B. The B was not just a euphemism for Hell but actually a basement where they kept all the forgiveness or virgin tears or whatever. Hell was in another building.

The doors opened to the purple landscape of simultaneously mild satisfactions and unpleasantries that made up the eternal existence of Limbo's inhabitants. One man ate nonstop, his pants buckle undone, belly distended, groaning in pain from eating. Another woman popped giant pimples on her face, feeling the pain and brief satisfaction from each. Someone else watched Oprah.

She found Jason by their normal meeting spot, underneath a beautiful tree with low hanging durians, their disgustingly pungent odor showing her the way. Jason wore a Hawaiian shirt and black cargo shorts.

"Why do we come here again?" she asked.

"Because nobody else would," Jason said.

"Right that makes sense." Veronica tried her best to keep her wings tucked behind her back and under her jacket. "So what are we going to about this...this problem we have? Have you talked to Satan yet."

"Satan hasn't been in Hell for decades."

"What?"

"He possessed Dick Cheney and has had so much fun he hasn't come back yet."

Veronica rolled her eyes. "Just great. Think he has any idea what's going on?"

Jason shrugged. "If he did, I'm not sure he'd care. But I do know that Belzebub expects for me to have my operation under control so I can't go telling everyone that some regular human might actually start the apocalypse. We're training the four horsemen right now."

"Isn't one a woman now?" Veronica asked.

"Yes, we traded out Pestilence for Women's Wrath. For diversity, you understand," Jason nodded.

"For diversity," Veronica agreed. Tacitly, they both knew that Women's Wrath would be the most brutal and unforgiving of the four horse*people* of the apocalypse. "Here's what we're going to do. I'm going to go talk to your boss, make it seem like this was my fault and maybe get some help."

"This idea is terrible already," Jason said. "What am I gonna' do?"

"You, my infernal companion, are going to take the nukes away before that planet becomes a crispy radioactive ball," Veronica said.

"Sounds about right, let's get to it," Jason said.

"God bless," Veronica said.

"Whatever," Jason said.

———— ‖ ————

Jason arrived at his office in the Pentagon wearing a dark suit and a trilby hat like some kind of gangster from the 1930s. Maybe it had been too long since his last field mission. Now the men wore these bright suits like peacocks and the women wore the dark suits. At least the classic, sharp looking military uniforms would look the same...

A pair of Army officers turned the corner of the hallway and marched towards Jason. They wore powder blue uniforms that made them seem like they just joined the Key West militia. One of them noticed the quizzical look on Jason's face and said, "New standard issue. By order of the President," and continued on down the hallway.

Entering his office, Jason shook his head. If that was the worst of it then that wasn't bad at all. The apocalypse wouldn't start just by changing some traditions, right?

He removed his hat and jacket and looked out of the window that faced the internal courtyard of the pentagon. His glossy reflection revealed that he had forgotten to put away the horns on his head that had been hidden by his hat. Jason grunted and wheezed loudly as the horns sunk into the skin when a man entered the doorway.

"Them noises best saved for the restroom, I reckon. Maybe the hospital."

Jason spun around to greet the Secretary of Defense, Arnold Drumpf, a distant cousin of the President. "Ahem, excuse me, sir. Just feeling a bit ill." He rubbed his forehead to hide the small bit of still receding horn.

"Don't suppose you's Jason, the new man set to head up our new nuclear weapons operatin system?" Arnold asked. Jason nodded. He knew that the Pentagon still used floppy disks for its weapons of mass destruction targeting system since everyone had been too afraid to update it for decades. Leave it up to the new Commander and Chief to bravely lead them...somewhere.

"Well, I hope you ready because they gonna be some great big changes," Arnold said.

"Oh really?"

"Yes, my boy. We'll be fighting the terrorists and the illegal aliens and those communists all at once. While removing the national debt. How's that sound?" Arnold asked.

"Oh God," Jason said.

"Oh God indeed," Arnold said.

Jason's skin sizzled at the frequency that the G word had been dropped in his presence.

"Let me tell you all about it, son," Arnold said. "Have a seat, go on." Jason sat down in the black executive chair and swiveled towards the window. "You ever heard of those travel websites where folks will bid on the price of a hotel and such? Get real good deals on it."

"Yeah, I guess," Jason said.

"That's the new nuclear program," Arnold said.

"What?" Jason couldn't hide his confusion.

"You know the President is most familiar with the real estate industry so this was a rather appealing idea to him. As such, we are bidding out the targets for our nuclear strikes. In the event of an all out nuclear war." That time Arnold said nuclear like 'nuke-u-ler'. We got wealthy folks just outside of Moscow.

Paris. London. You name it. Except they're all bidding to not be bombed. It's genius, really. We target the lowest bidders."

Jason sat, speechless.

"So we need a live bidding site where these guys can all bid against each other to not die after the bombs go a flying," Arnold said.

"Seriously?"

"Do I look like I'm joking with you?" Arnold asked. That's when Jason noticed his jowls hanging down, shimmering with a light layer of sweat.

"No, you look deadly serious," Jason said and shifted awkwardly in his chair.

"Good, then let's get to work." Arnold started to walk out of the office. "And just remember, when the bombs go a flyin, the poor start a dyin."

Truly, this was so nefarious that Jason was jealous. He wish he came up with it. But now, he had to think of a way to stop it.

Dick Cheney gripped the handles of the machine gun mounted to a green camo jeep while a fat slobbered-on cigar rested between his lips, the sleeves of his shirt rolled up to his elbows. "What doyou want now?" he asked to Veronica as she approached the jeep.

"We need to talk," Veronica said.

Dick Cheney sighed. "Fine, get in."

Veronica climbed on the back of the and held on to one of the roll bars as the jeep's engine roared to life and they bounced down the dirt road to only God and Satan knew where.

"It's about Trump," Veronica had to yell to overcome the wind and the whining of the jeep's suspension. "He's not one of heaven's."

"I know," Cheney said.

"You know?" Veronica asked.

"Oh I know. He's not one of mine either. But the chaotic randomness of creation has given to me another wonderful opportunity," Cheney yelled.

Veronica grimaced. This wasn't going well already. Satan fired the machine gun randomly into the surrounding pine trees and laughed maniacally.

"He's going to start the engines of the apocalypse too soon. Neither side has enough souls yet," Veronica reminded him.

Cheney waved his hand as if pushing aside a plate of food he didn't want to eat. "Don't care about that. Trump's made me head of Special Projects."

"Which means...what exactly?" Veronica asked.

Just then they turned a corner in the road and Veronica could finally see their destination: Tall chain-linked fences with barbed wire lining the top. Endless rows of tents and latrines. Thousands of people in brown rags.

"Hell on Earth!" Cheney raised his hands into the air like a referee motioning for a touchdown. "Again!"

———

Arnold Drumpf sat at the head of the conference room table with half a dozen other suits. Jason stood at the front of the room with his powerpoint presentation. He actually invented the powerpoint himself under direction of Satan for a way to torture humans and everyone was quite pleased with it.

"So what's this genius idea of yours, Jason?" asked Drumpf.

Jason had tried dozens of ways to stop the nuclear program but nothing worked. He put in a virus to stop the nukes from firing entirely but when it was discovered they blamed the Chinese and almost fired all the weapons on the spot. He almost didn't stop them in time. But this idea...this one had to work.

"Tom Cruise," Jason said.

The room sat in silence. "Okay?" Drumpf raised an eyebrow.

"John Travolta. Nicole Kidman." A picture of each celebrity went across the screen. Jason raised his hands in the air and wiggled his fingers.

"Where are you going with this?"

The Moon appeared on the screen. "They all own property on the Moon. And you know what? They don't pay into our nuclear program. Not a dime. They need to bid too. How can we let these Hollywood liberals get away with freeloading on the backs of all the other rich people!"

Drumpf raised a finger thoughtfully to his chin. "So what you're saying is, we add the Moon to the bidding war and the targeting system."

"Exactly," Jason said and pointed at Arnold Drumpf with two fingers. "Think of all the extra revenue to eliminate the national debt."

Arnold Drumpf thought about it for a second before his eyes rose up to meet Jason's. "Do it."

"You got it, sir," Jason said. So he added ballistics and coordinates for the Moon and maybe, kind of, sort of saved the Earth from nuclear catastrophe. For now.

Veronica buried her hands into her face which made her hard to understand but Dick Cheney's ears were particularly acute to hearing anguish. "I thought we agreed that concentration camps took things too far. The mortal plane is for acts to determine their eternal judgement, not for an existence like heaven or hell."

Dick Cheney spat out his cigar. "That Truce got thrown out the window with air conditioning. Now they've got non-stop entertainment at their fingertips. What's next? Blowjob robots?" Cheney asked.

Veronica rolled her eyes. Besides, those robots probably did exist already.

"These idiots are already living in heaven. The game is scrapped. I've got to bring hell to them now otherwise they'll never have it," Cheney said.

"How can you possibly get away with this?" Veronica asked.

Cheney smiled. "Patriot Act mostly. We started with hipsters. Nobody minded when we were just putting them in here, but

now I pretty much snag anybody and call them enemies of the state or what not. Terrorists" Cheney put a fist over his heart. "God bless America," he said, his skin sizzling.

Veronica stood there, eyes wide open, horrified. She didn't know what to do, couldn't really think. Then her body took over, some deep down sense of angelic justice overriding her logical programming.

She ran over to the gate and surged with heavenly strength, kicked it in the center and the gate fell over along with a great deal of the fence. "Run!" Veronica yelled. "Escape now!" Most of the people stood there for a second but once a few brave souls started to make a break for it, the rest joined.

"No!" screamed Cheney, a deep satanic howl fowling suit. His muscles surged with otherworldly strength. Veronica jumped onto his back and wrapped her arms around him, pinning Cheney's arms to his sides as he struggled to get free.

More and more of the prisoners escaped. "Shoot them! Kill them all!" Cheney yelled. Soldiers lifted their rifles but didn't fire. "Do it!" One by one they dropped their guns, looking around at each other.

"Argh, damn you all to hell." Cheney surged with power and threw Veronica off of him. He pulled a radio off of his hip and pressed a button. "Fire them all. The whole payload. Every last missile!"

The Earth shook as missiles the size of buildings lifted slowly out of the ground at first but then faster, raising up into the air. Cheney laughed maniacally. Veronica sat on her knees, the feeling of dread and failure washing over her.

But the missiles just kept on going up and up and up and up towards a faint white ball in the sky.

"Why aren't they turning? Ballistic! Ballistic missiles! Not straight up missiles! Ugh, what are we North Korea?" Cheney marched around like a toddler when a giant orange pickup truck with huge longhorn steer antlers attached to the front.

George Walker Bush got out of the driver's seat, wearing a bulletproof vest with a giant white cross and holding a shotgun.

A half dozen cowboys with similar crosses on their hats got out of the truck bed.

"Heh heh heh, I finally found ya, Satan," Bush said.

Dick Cheney held up his hands innocently. "What are you talking about, George? It's me, Dick. Your old shadow President."

George shook his head. "Been looking for you ever since I left office. Little did I know you was hiding inside my friend. Now it's time to set my friend free. Had this buckshot blessed and glazed over with holy water this morning."

"No George, this is murder. You can't."

"I can. I'm the decider, Dick."

That's when George Walker Bush shot Dick Cheney in the face with a shotgun.

Veronica accepted her Angel of the Year award with grace, as any celestial being would. She got off the stage and shook hands and kissed cheeks with hundreds. While the masses began to mingle and celebrate another successful year, she spotted a dark cloaked figure out of the corner of her eye. "Jason?"

Jason pulled down his hoodie and smirked. "Hey Veronica, couldn't miss your big day." They gave each other a small hug which caused heaven to tremble slightly like an aftershock.

"Congrats on the promotion. How's life as the new Satan?" Veronica asked.

Jason shrugged. "Fine I guess. Think I'll be taking a bit more of a subdued approach than previous management if you know what I mean."

"Can you find a place for Trump down there?" Veronica asked.

Jason shook his head. "I don't want him. Maybe we can find a place for him in Limbo."

Veronica nodded. "Oh I have just the thing, an eternal twitter battle with Elizabeth Warren about Star Trek versus Star Wars."

"Sounds good to me. Just as long as nobody else has to read it," Jason said.

"Deal," Veronica said.

And that's how heaven and hell stopped the false apocalypse and they all lived happily ever after. Until the real apocalypse anyway.

About This Book

The typeface in this book is 11.5 Garamond and Helvetica (for the headings). It was laid out using Adobe InDesign software and converted to PDF for uploading to the printing facility.

About Darkhouse Books

Darkhouse Books is dedicated to publishing entertaining fiction, primarily in the mystery and science fiction field. Darkhouse Books is located in Niles, California, an inadvertently-preserved, 120 year old, one-sided, railtown, forty miles from San Francisco. Further information may be obtained by visiting our website at www.darkhousebooks.com.

Made in the USA
San Bernardino, CA
30 September 2016